the
photographer's
practical
handbook

the photographer's practical handbook

everything you need to make a success out of your photography

paul harcourt davies

D&C
David and Charles

A DAVID & CHARLES BOOK
David & Charles is a subsidiary of F&W (UK) Ltd.,
an F&W Publications Inc. company

First published in the UK in 2005

Distributed in North America
by F&W Publications, Inc.
4700 East Galbraith Road
Cincinnati, OH 45236
1-800-289-0963

A catalogue record for this book is available from
the British Library.

ISBN 0 7153 1795 4 hardback
ISBN 0 7153 1798 9 paperback

Printed in Singapore by KHL Printing Co Pte Ltd
for David & Charles
Brunel House Newton Abbot Devon

Desk Editor Lewis Birchon
Art Editor Mike Moule
Production Controller Kelly Smith

Visit our website at www.davidandcharles.co.uk

David & Charles books are available from all
good bookshops; alternatively you can contact
our Orderline on (0)1626 334555 or write to us
at FREEPOST EX2 110, David & Charles Direct,
Newton Abbot, TQ12 4ZZ
(no stamp required UK mainland).

Dedication

To Lois, whose deep love of Italy infected me and
went on to change life dramatically for both of us.

Introduction 6

Working indoors 24

Moving outdoors 68

The darkroom 90

Techniques and suppliers 131

contents

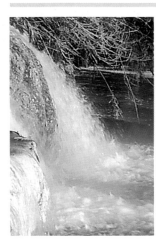

Thermal springs and tufa pools near Saturnia, Tuscany, Italy.

So, what exactly do you want a camera for? That might seem like a silly question, but your answer will determine what sort of camera, lenses and accessories you are best off buying. The fact that you are reading this book suggests that you take your photography seriously. For that reason, this book is not simply a guide to different makes of cameras, but is intended to make you really think about what you need. We all need to be kept on the straight and narrow and let pragmatism be our guide, as detours can be costly. It is easy to be seduced when reading brochures and magazine articles in which every new gadget and gizmo is touted as being essential. Try to see beyond the marketing, however, and consider how many wonderful photographs were successfully taken before any of these new devices appeared.

It is easy to be caught out when you see superb pictures and read the captions specifying what equipment was used to capture the shot. Usually, just a few makers' names predominate, and you might start thinking that you could produce work of such quality if only you owned that equipment. This is not the case: Paganini could have played a piece of barbed wire and still have done better than most of us on a Stradivarius violin. The cameras used by photographers of the calibre of Ansel Adams and others were far less sophisticated than those available now – yet look at the results they achieved. Always remember that you can obtain great results from relatively modest equipment, especially if you take care of it.

Never be afraid to buy secondhand equipment. Just think that someone else tired of it, perhaps after using just a few reels of film, and that the gain is all yours. Also, now that so many people are switching to digital cameras, there are a lot of 35mm film systems available secondhand. These are often a wonderful bargain, and they are versatile: you can always add a digital body later.

In this book, cameras are treated as tools to do a job, and that job is to take pictures that turn your vision of a scene into something permanent and worthwhile. Digital and film-based systems both have their uses in achieving this. Digital offers an immediacy and a level of control that film does not: you can see and change the result in seconds. Then again, making full use of a digital camera's potential means having a suitable computer, monitor, printer and software. The cost of those ancillaries is appreciable – though often a home computer serves the purpose admirably.

Just a short time ago, the arguments for quality were firmly in favour of film; now they have tipped the other way. You can always choose a 35mm outfit where a suitable digital body can be added later: prices for digital 35mm systems are coming down all the time and are fast approaching the level of 35mm film camera systems.

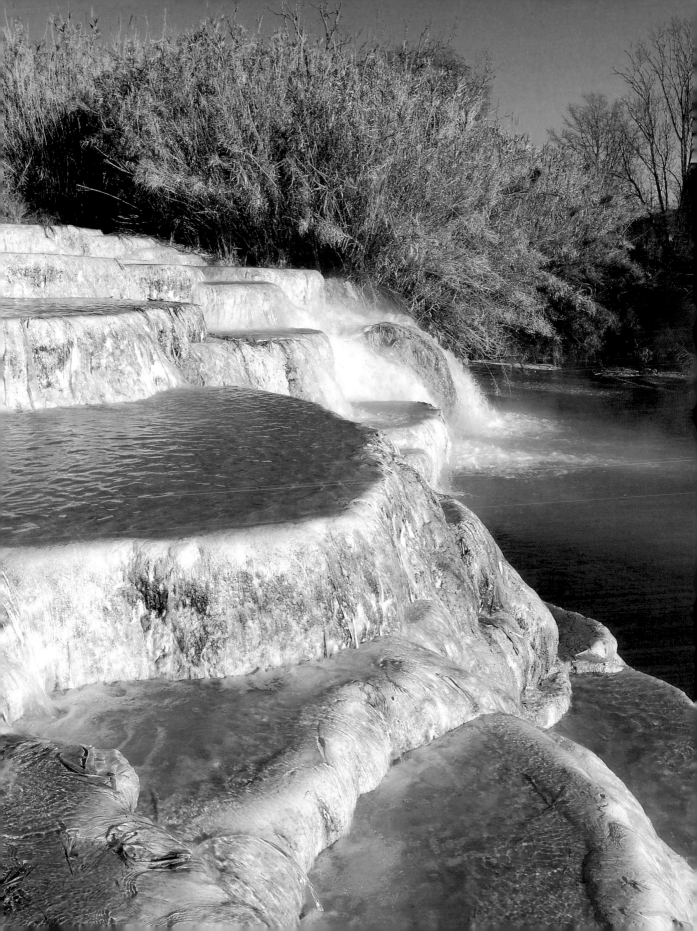

Camera types

If you are enthusiastic about photography, you will want a camera system that can grow with you as your interests flower and your ability develops. There are several options to consider, depending on your requirements and budget.

Compact cameras Compact cameras are an ideal way to start out in photography, allowing you to learn the basics and then move on. Both film and digital compacts are great for casual picture-taking such as recording holidays or family get-togethers.

35mm SLR In terms of price, availability of lenses and accessories, and sheer versatility, it is hard to beat a 35mm single lens reflex (SLR) system or its digital equivalent. This is the format used by many professional photographers. The arrival of high-resolution digital SLR cameras has made this even more the case, as digital SLRs are compatible with accessories manufactured for 35mm film systems.

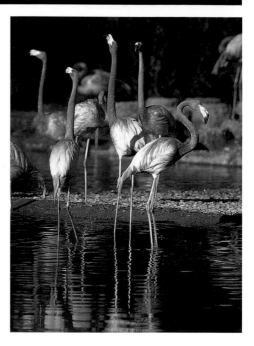

▲ *A compact camera with its inbuilt zoom lens allows a photographer great flexibility when the zoom goes from wide angle to telephoto. The definition is surprisingly good and the flamingos here were sharp enough to enlarge to an A4 print.*
Olympus Compact with Fujichrome Velvia

Roll-film SLR Roll-film SLRs offer superb quality, and the equipment is prestigious and versatile – although lenses and accessories are more costly than for 35mm. You should make the jump only if you are sure that you need the benefits of a larger transparency area and potentially better detail capture. Some buyers of photographs insist on this, but often out of ignorance regarding the quality that can be achieved with 35mm.

Rangefinders Photographers often lust after Leica rangefinders because they epitomize mechanical and optical excellence. Rangefinder cameras are quick to use and unobtrusive. The between-the-lens shutters are very quiet and the absence of a mirror enables rear lens elements to be positioned closer to the film, giving extremely sharp and superbly corrected results.

▶ *The SLR is a supremely versatile camera in its film or digital form – its versatility is the key to its popularity. Here, the photographer is using her arms to brace the camera and reduce the risk of vibration.*
Nikon F4, Nikon 28–80mm f/2.8 AF, f/11 at 1/125sec, Fujichrome Velvia

However, rangefinders are not as versatile as SLRs, and parallax errors are a problem in close-up work where the viewfinder and the camera lens do not see the same thing.

Another option is the Hasselblad XPan, a rangefinder camera with an interchangeable lens that enables you to switch between the standard 35mm frame and the increasingly popular 64x24mm panoramic format.

Medium-format rangefinders have become popular as travel cameras, producing roll-film quality in an easily portable format. The Mamiya 7II, for example, allows you to use the 64x24mm format using a film adaptor for 35mm.

Large format 4x5in transparencies look wonderful on a lightbox and are unbeatable if your market is posters, huge enlargements or studio work where you need camera movements to correct for converging verticals or create great depth of field (see pages 56–57). However, unless you are an experienced photographer and have cracked the business of getting exposure

spot on, then the format is expensive and the cameras are heavy, and it is really not for 'point-and-shoot' photography.

Increasingly popular are cameras such as the Fuji 617 that create wonderful 17x6cm transparencies – with just three or four to a single roll film. Several manufacturers of view cameras provide backs to use roll film and create such images.

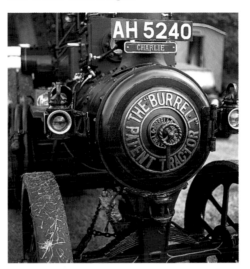

◄ *With medium format you can capture the maximum detail on film – it is favoured by card and calendar producers because of the sheer quality. This traction engine was originated on 6x7 roll film with a rangefinder camera.* **Mamiya 7 II, 80mm f/4.0 lens, f/8 at 1/60sec, Fujichrome Provia 100F**

Useful features

Cameras come with all sorts of features and functions: some of these you can well do without, but those listed below are genuinely useful.

• Through-the-lens (TTL) metering
TTL metering is so good these days that many photographers trust the internal metering completely and demand it as standard in 35mm cameras.

• Switchable meter functions
This is useful because you can switch between spot metering, which meters a small central spot, to matrix metering, which assesses brightness from various parts of a scene to achieve a compromise (see pages 20–21).

• Mirror lock-up
This function appears only on top-of-the-range cameras. It is a simple but useful function when working with long exposures (for example, in close-up work, low light or when photographing with a tele-

scope) since mirror 'bounce' creates noticeable blurring.

• Autofocus
This is standard in 35mm format and very useful now that modern mechanisms operate quickly. It can be of limited appeal (or a downright nuisance, in fact) if you are doing close-up and macro work.

• Interchangeable viewfinder screens
Viewing screens with focusing aids such as a central rangefinder surrounded by a microprism ring can be difficult to focus. A fine ground-glass screen (with a grid if you like) is easy and clear to use. When interchangeability is not possible, you can obtain a Beattie screen for most models; ask a camera repairer to fit it.

• Depth-of-field preview
This is essential when checking depth of field as a lens is stopped down.

• Exposure modes
Many cameras sport several exposure modes. These modes might include manual, shutter priority, aperture priority, and program. Manual is essential for complete control; aperture priority is ideal for close-up work (the shutter speed is set by the camera for the aperture chosen); and shutter priority is ideal for action (the lens aperture is set by the camera for a chosen speed). Program modes represent a manufacturer's idea of what is useful. Some cameras have an extended 'custom' range allowing you to create programs: with a little photographic knowledge you can get better results without using this.

Lenses

It is good to have a wide selection of lenses, but it is not essential. You can get by with just a couple of lenses – maybe even one, if you have a good zoom with a wide range. You can do a great deal with just one lens and changing position. On the whole, you need to encompass a range from wide-angle through medium to telephoto. If you are interested in landscape, you might find an ultra-wide angle useful, and for wildlife photography, a long telephoto.

Iris diaphragm This consists of a series of overlapping blades that open and close to give a larger or smaller hole. This 'hole' is known as the aperture.

Aperture The aperture is denoted by a series of numbers, which are referred to as f/numbers. The higher the f/number, the smaller the aperture. The usual aperture range of a lens runs as follows: 1 (the largest aperture); 1.4; 2; 2.8; 3.5; 4; 5.6; 8; 11; 16; 22; 32; 48; 64. F/64 is generally the smallest aperture available. However, it is possible to get smaller apertures in close-up work and pinhole photography: 90; 128; 180; 256.

Stop When referring to aperture, a 'stop' means moving from one number to the next in the aperture range. For example, from f/11 to f/8 involves 'opening up' by one stop; and reducing the aperture from f/2 to f/2.8 is called 'stopping down' by one stop. The amount of light passing through the aperture doubles when a lens is opened up by one stop, and is halved when stopped down by the same amount.

The aperture size not only governs the amount of light entering the system; it is also linked to the depth of field (see pages 60–61). The smaller the aperture, the greater the depth of field at a given magnification.

▶ *The job of a lens is to produce a faithful two-dimensional image from a three-dimensional scene. To do this without distortion of any sort and without those lens defects termed 'aberrations' is no mean feat for the lens designer. These days, with computer-aided design, we get results that once could only be dreamed of.*
Nikon D100, 180mm f/2.8 Sigma AF macro lens, f/8 at 1/125sec, ISO 200

The jargon of lenses It will be helpful if you become familiar with the special language that is associated with lenses.

Depth of field: should you maximize it or not?

The aperture on a lens controls the amount of light and also the depth of field: the smaller it is, the more will be in focus from front to back of a scene. This is particularly noticeable in close-up work, where it is often seen as a problem. It need not be, however. In the right-hand picture, shallow depth of field, at f/4, is a useful artistic tool, whereas the left-hand picture, at f/16, reveals more flower stamens in focus.

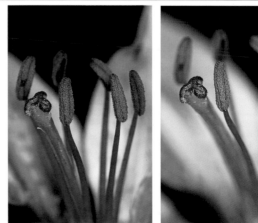

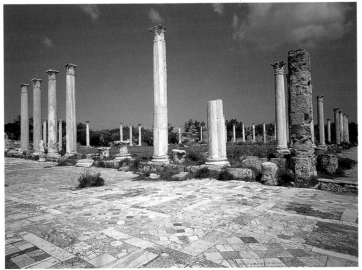

Focal length With a simple lens, focal length is the distance behind the lens at which parallel rays (those from a distant object) come to a sharp focus. Camera lenses are more complex: they have a 'back focus' distance from lens flange to film (or sensor in a digital camera). This distance is exactly the same within a manufacturer's range of lenses (and independent lenses for the same camera). There are slight differences between Leica and Nikon, for example, that make it impossible to fabricate adaptors allowing you to focus on infinity when using one make of lens on a different make of camera.

Angle of view The angle of view is measured across the diagonal of the field. This might seem confusing, but it looks better on paper because it is larger than the horizontal view angle. (This is similar to computer monitors: there also the size of a screen is measured along the diagonal.)

Specialist optics A useful addition to any camera bag is the so-called macro lens. Macro lenses are highly corrected for work at close quarters: many offer 1:1 reproduction (lifesize magnification) as standard. There are three focal length ranges: 50–60mm (like an old standard lens); 90–105mm (the portrait focal length); and 180–200mm (tele-macro). For occasional use, go for the middle and choose 90–105mm – this gives you a better working distance than the 50–60mm and is much cheaper than a tele-macro.

Zoom or fixed focal length? Once, fixed focal length lenses were supposed to be sharper than zooms; the latter were more complicated in construction and had a greater number of glass elements, thereby needing more correction. That is no longer true: modern zooms give a staggering performance and are more convenient than fixed focus equivalents. They are great for framing, as you adjust them to fill a frame to the extent you want.

▲ *Salamis, Northern Cyprus. The greater angle of view of shorter focal length lenses lets you capture a wide expanse in any scene. To add impact with a wide-angle lens, it is important to lead the eye into the frame. Here, the low viewpoint and the foreground columns do just that.*
Sigma SD10, 15–30mm Sigma f/3.5–4.5 AF DG, f/16 at 1/30sec, ISO 100

Focal lengths and formats

Some lenses and equivalent focal lengths in various formats. The nearest practical equivalent of each lens is given, together with the angle of view measured along the frame diagonal.

35mm format	35mm (62°)	28mm (74°)	24mm (84°)	20mm (94°)	18mm (100°)
6 x 4.5cm	55mm (65°)	45mm (76°)		35mm (90°)	
6 x 6cm		50mm (75°)	40mm (88°)	38mm (90°)	
6 x 7cm	75mm (61°)	55mm (78°)	45mm (89°)		
5 x 4in	90mm (58°)	65mm (76°)			

Camera supports

To obtain sharp, clear photographs, a camera body has to be held steadily. For unbraced handholding, a useful guideline is to set a minimum shutter speed that is the reciprocal of the focal length in mm: in plain terms, that means using a 500mm lens at no slower than 1/500sec when handholding. Some sort of support is essential at slower shutter speeds for all lenses; ways of improvising in the field are given later (see pages 82–83).

Tripod mounts You can get the best out of an indifferent tripod by realizing how and why a camera must be balanced. All cameras have a tripod mount set into the base. If you are using a long telephoto, however, this is not the best place to offer support: such lenses put enormous strain on the camera lens mount and the slightest breeze can set it vibrating. A tripod mounting collar is a much better option, as this supports the system at its centre of gravity (strictly speaking, its centre of inertia). Many better-made lenses come with this already fitted. The collar rotates, thus allowing you to switch easily between landscape and portrait formats.

Many telephoto and zoom lenses have an integral mount, but a few specialist engineers (such as SRB; see pages 136–45) can make suitable mounts given the measurements of your lens.

If you want to attach extension tubes to a long telephoto lens, then all you need (as you will find with all construction projects in this book) is the ability to saw and drill accurately.

First 'weigh' the lens plus the camera in your hand to find the rough balance point. The lower bar has a slot or series of screw holes that are tapped and threaded so that you can vary the support point according to the lens used. The design shown assumes that the lens barrel is not lower than the camera base; with a long tele, the lens barrel might be lower than the camera base, in which case the support can be tailor-made in two parts.

Tripod heads You should buy the most solid, well-engineered tripod head that you can afford, whether it is a ball and socket or a pan and tilt.

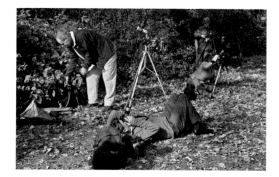

▲ *Photographers need to be versatile and flexible in order to hold and brace cameras. Here, a course led by the author shows a collection of people doing just that.*

A homebuilt camera support

This design shows a simple support bar constructed from aluminium alloy, which is a readily available material. When a lens does not have an integral mount, you can either choose to buy a commercially made unit or fabricate your own. As with all the designs that are described in this book, assembly and fixing is achieved by drilling holes of the right size, tapping a thread and then screwing the parts together.

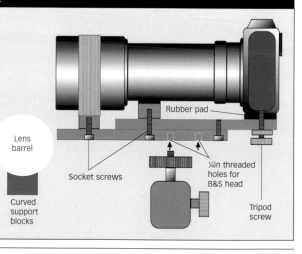

Lens barrel

Curved support blocks

Rubber pad

Socket screws

¼in threaded holes for B&S head

Tripod screw

▲ Better tripod designs have a removable central column that lets you position your camera directly over a subject. Here, it was essential to make sure the camera was held firmly and that its back was parallel to the floor to avoid distortion.

▼ This owl was photographed in low light. With an exposure of 1/2sec, a tripod was essential.

Ball and socket heads These offer limited movement provided by a heavy metal ball sitting on a camera platform: a thumb-screw arrangement forces the ball upwards and clamps it rigidly. A rotating base with a circular scale and spirit level attached is a useful feature. The camera mounting platforms fitted vary from a simple round plate (with a 1/4 or 3/8 standard Whitworth camera thread) to a more complicated set-up involving tilts in two planes. Each has its aficionados. In the excitement of getting a shot, it is easy to forget to tighten the screws and have the camera fall over, so the fewer adjustments the better.

Pan and tilt heads These are easy to use. The fluid-damped variety heads offer pre-

cise control, but might be a luxury you can do without. One essential, however, is a bubble spirit level so that you can get horizons straight or make stitched landscape pictures from accurately gauged sections all taken on the same level.

Tripod quick mount For field work, equip your tripod head with a quick mount: the convenience of being able to take a camera off and on without unscrewing it is of inestimable value. Manfroto hexagonal plates are well engineered, tough and well priced, so you can afford several for different camera bodies and tele lenses. And the same plate will suffice for roll-film cameras, too.

Focus slide For precise adjustment, fit a camera to a focus slide. Pricier models have either a screw drive, or they have rack and pinion in order to provide smooth and precise adjustment.

◄ Save time and effort by fixing a quick mount to camera base and tripod. This Manfroto design is fixed to a copy stand. It relies on a hexagonal mounting plate and is sturdy enough for a roll-film camera.

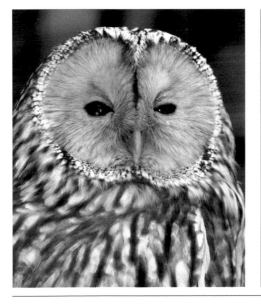

The advantages of using a pan and tilt head

A pan and tilt head lets you move quickly to frame a shot and to create slight variations to get the composition you want. With a ball and socket head, it is not so easy to move from one position to another or to follow a scene in which there is movement. You can lock a pan and tilt head so that it stays at the same horizontal level. This is essential in creating 'stitched' landscapes.

A visit to any good camera store or a browse through a camera catalogue will reveal a myriad of goods that you are made to feel you must possess in order to become the photographer you aspire to be. Opinion as to what accessories you really do need inevitably varies, but the following items are well worth considering as needs arise.

▲ *Warm-up filters create their effect by reducing the proportion of blue light. With a digital image you can do the same via the curves control in an imaging program.*
Nikon D100, 105mm f/2.8 Sigma AF macro, f/11 at 1/125sec, ISO 200 RAW mode

Flashguns A small flashgun that can be used off-camera is worthwhile if all you have is an integral camera flash-mounted one. Larger flashguns and even specialist units such as macro flashes can be bought as need dictates – but only if you feel you can justify the purchase. Lighting with flash is considered later (see pages 32–33).

Cable release This is a simple accessory either in its mechanical form, with a plunger, or as an electrical cable, with switch and plug for some cameras. For any sort of long exposure, this eliminates the need to press the shutter directly – an action that moves the camera noticeably and causes blurring. Buy cheap ones – they all have a conical thread that tends to work loose: mine have been unintentionally scattered in various countries around the world. Some people buy cables with a plastic covering of one colour (for example, white) and then tape with a bright contrasting colour. This works better but the threads still tend to work loose eventually.

Filters You can either purchase filters set into a ring that can be screwed into the lens front, or invest in a 'universal' system with adaptors for different lens sizes, such as those made by Cokin or Lee Filters. Most keen landscape photographers go for the system with adaptors since it allows the greatest flexibility. These square filter elements must be handled with extreme care since, apart from the polarizers, they tend to be made from an optical resin that can be easily scratched and damaged.

A basic filter outfit should include polarizers, warm-up filters and a few graduated filters. The polarizers and grads are useful for digital work, too; the warm-up filters are less useful since you can use the digital camera's white-balance control instead (see pages 22–23).

If you own a range of lenses then you need filters in several different thread sizes. This becomes expensive, so buy the largest size that you will need regularly and then use reducing rings. This principle does not work the other way because filters that are too small will produce vignetting – this is the disconcerting darkening at the edges of the frame.

▲ *Polarizers cut water surface reflections and intensify the blue of the sky. This is most pronounced with the sun low in the sky and with the camera facing a scene at right angles to the sun.*
Sigma SD10, 30–50mm, f/3.5–4.5 zoom 1/125 sec with circular polarizing filter

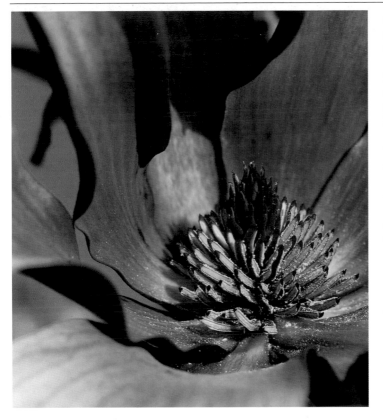

▲ *Close-up lenses give very good results and are easy to carry for the occasional close-up. Their only drawback is that infinity focus is lost. A high-quality two-element design used at small apertures will give excellent results without the light loss you get with extension tubes.*
Nikon F4, Sigma 70–210mm F/2.8 AF zoom with +2 dioptre close-up lens

Lens hoods The manufacturers of 'system' filters produce telescopic bellows hoods, which are good for a range of different lenses. These days, manufacturers such as Sigma always supply a suitable lens hood even if some of the camera manufacturers don't offer them.

Close-up lenses Close-up lenses (also called diopters) that fit the filter thread offer the simplest way of getting close without suffering the light loss associated with lens extension. The best are the two-element achromatic lenses that control achromatic aberration. The simple ones are cheaper and work well as long as you use

them with apertures smaller than f/8 so that light rays are restricted to those from the lens centre where correction is best.

Extension tubes and bellows These offer the 'traditional' way of getting higher magnification by introducing a separation between lens and film (or sensor). You 'lose' light, but since most cameras have TTL metering this is not a problem. A single extension tube offers an excellent way of improving close-focus with a telephoto lens (see pages 62–63). Most offer automatic meter coupling. Some (very expensive ones) will allow autofocus as well – though this is usually a waste of money, since in close-up work you will often switch autofocus off.

Bellows come into their own in the studio, where you can fit a lens of one make to one end and the camera body of a different make to the other. Make sure that any bellows you buy are rigidly made with smooth focusing. In time the mechanism can become sloppy, but it is not hard to tighten if you are handy with a jeweller's screwdriver. Beware holes in an old bellows. New ones can be bought from the Camera Bellows Company (see Suppliers).

The most useful filter: the polarizer

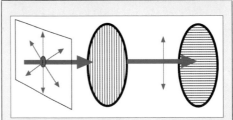

Associated with all light waves is an electric field that vibrates in a plane perpendicular to the direction of travel – in non-polarized light this field varies in all directions. A polarizer acts as a gate letting light through as long as its field is in the right direction. The filter can be rotated to the find the optimum angle to cut out unwanted light causing glare and reflections, and will signicantly increase the clarity and colour saturation of an image.

Lighting principles

You can take great pictures knowing nothing of the nature of light, but some knowledge can go a long way to helping any practical photographer solve problems, and to be that bit more adventurous. Light is, after all, the medium of photography.

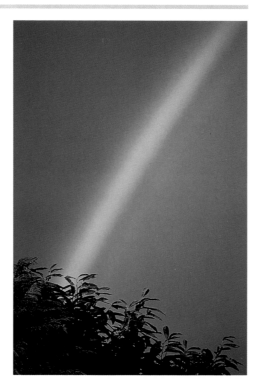

▶ *After a rainstorm, droplets of water in the air act as tiny prisms and split the light into its constituent colours. The light undergoes both reflection and refraction with dispersion in the drop. An extra reflection creates the secondary bow that you sometimes see where the colours are mixed, and are not well defined.*

Nikon D100, 180mm f/2.8 Sigma AF lens, f/8 at 1/60sec, ISO 200

The nature of light In school science classes, you encounter light as a form of energy. Visible light is a type of electromagnetic wave, all of which have the remarkable property of being able to travel across a vacuum at 300 million metres per second (3×10^8m/s). Light has a dual nature. First, it can behave as if it is a wave. It is through this aspect that we can understand how lenses work or explain diffraction (the spreading of light) by the edges of small apertures. Second, light has a particle nature, where it acts as small bundles of energy (photons). This explains how light reacts with the silver crystals in a film or generates pulses of electric current in a digital sensor.

Wave characters Waves can be characterized by either frequency (the number of complete cycles per second) or wavelength (the distance occupied by one complete wave). As one goes up, the other goes down, since they are inextricably linked by the formula $C = f \Lambda$, where C is the velocity of light in a vacuum and its value is the same throughout the known universe, as far as we know.

At one end of the electromagnetic spectrum are radio waves, with wavelength measured in metres. At the other end are gamma rays, which are measured in billionths of a billionth of a metre and less.

The visible spectrum

Visible light (the colours visible in a rainbow) occupies a very narrow window in the radiation spread known as the electromagnetic spectrum, where the wavelength ranges from about 650nm at the red end to 400nm at the blue end (nm = nanometre where 1nm = 10^{-9} m or one billionth of a metre). Outside that range lie the invisible radiations: infrared (IR) and ultraviolet (UV) respectively.

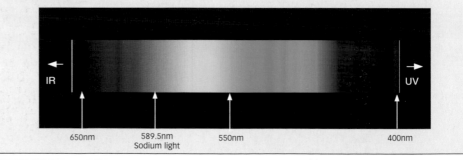

IR → ← UV

650nm 589.5nm 550nm 400nm
 Sodium light

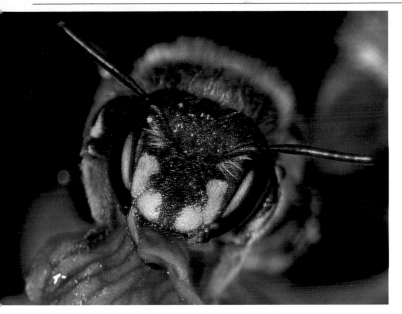

▲ *Many insects see further into the blue end of the spectrum than we do: when shot under UV light, some flowers show patterns that are visible to bees as landing guides but not to us.*
Nikon D100, Sigma 105mm, f/2.8 AF macro, 1/125sec with SB29s macroflash

Light waves are measured in nanometres (1nm = 10^{-9} metres). They occupy a very small 'window' on the electromagnetic spectrum called the visible spectrum. Red light (700nm) lies at one end of the visible spectrum, and violet (4.5nm) at the other.

Colour and perception Our visual system creates the sensation of colour to distinguish different wavelengths of light. When white light is split by a prism, it forms a 'rainbow' – the visible spectrum that extends from red at the long wavelength (low-frequency) end through orange, yellow, green, blue and indigo to violet at the short wavelength (high-frequency end). Beyond this lies infrared (which has a longer wavelength than the colours in the visible spectrum) and ultraviolet (which has a shorter wavelength). Both of these affect photographic film to some extent in that images can be created with UV and IR light as they can with visible light.

Our visual system, films and digital sensors all respond to or perceive colours in different ways. For this reason, it can be hard to get film and sensors (with their ancillary software) to produce colours that we regard as a realistic representation of what we actually saw when we took the picture.

Humans perceive objects as being white even when they are illuminated by light sources that have a definite colour cast that is detected on film. Whereas special films are designed to cope with different light sources, digital cameras do this through a function called white balance (see pages 22–23).

Just what concerns us as photographers is how much light there is in a scene (exposure); the source of the light (see colour temperature, pages 22–23); and the way in which we use it to illuminate the subjects and scenes we want to capture.

Light fall-off Light intensity (the light energy falling per square metre of surface) falls off rapidly the greater the distance from the light source. In fact, like all forms of electromagnetic radiation, it obeys the inverse square law. Double the distance and you will get a quarter of the intensity; treble the distance and you will get a ninth of the intensity.

Lighting angles and relief

The angle at which light hits a surface creates tiny shadows called 'relief', and this helps accentuate surface detail. The more oblique the lighting, the longer these tiny shadows. When taking photos late in the day, the sun's light creates relief because of its low position. This means you get better detail on sculptures and buildings.

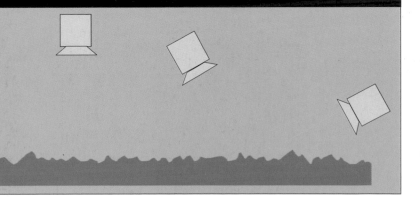

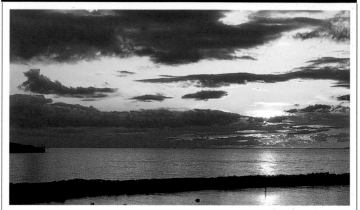

A single very bright source like the sun can fool an exposure meter. In this sunset scene, open sky and clouds with water beneath present a wide range of brightness levels. You can achieve good results by taking a spot reading from an area you think is neutral grey. Taking the exposure from an area of sky away from the sun, the result is darker but dramatic.

The sun as a light source Sunlight, the most familiar light source, produces very different effects according to where the sun is in the sky, and also whether there are clouds. Knowing how this works helps us to get the best from outdoor photography, and it also helps us when we are arranging lights indoors.

Shadows and detail In any photograph, shadows are important to accentuate detail and enhance the way we see things. Landscape and architectural photographers often work late in the day for two reasons: the first is the attractive warm light available at that time; the second is that the lower position of the sun then creates long shadows. These long shadows enhance a landscape by revealing the contours, creating relief or, on a smaller scale, the shadows on stones that enhance the texture.

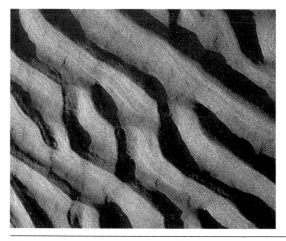

▼ *At low tide, there are sand ripples at the water's edge. The angle of light either late or early in the day accentuates these, and the interplay of shadows and highlights makes pleasing compositions.*
Mamiya 645 Pro, 80mm f/4.0 macro lens, f/11 at 1/60sec, Fujichrome Provia 100F

In a studio, the lighting position makes a great deal of difference in what is revealed. Straight-on lighting gives a flat feel; side-lighting creates shadows. This is ideal when you are photographing textured surfaces such as stone, but when you are shooting portraits, side-lighting will enhance details such as pock marks, hairs and other blemishes that your sitter might not thank you for revealing.

Broad and point sources When the sun behaves as a 'point' source, the lighting is stark. If you take photographs with a bright sun overhead in a clear sky, any shadows will be sharp and your camera (whether digital or film) might not be able to handle the contrast difference between bright and shadow areas.

Clouds in the sky act like secondary light sources, reflecting light into the hard shadows created by the direct sun and softening the effect. A light, all-over cloudy sky produces what is called a 'broad' light source with light coming from all directions. Imagine it as multiple light sources where light from one source spills into the next, and you can see why shadows are soft. In the studio, diffusers and umbrellas create the same effect.

Range of film/sensors Human visual perception does an amazing job in allowing us to distinguish colours in low light. It can also handle a contrast range from bright white to featureless black with a subtlety in recognizing fine differences in shades of colour that no film or digital sensor can match. In photography, we can compare different films and also types of camera system using the idea of 'stops' to register the range between what is registered as deep black and brilliant white: with colour transparency film this is 5 stops; with black and white film it is 6 stops; with digital it is about 7 stops. The wider the range, the greater the subtlety in capturing intermediate tones and shades of colour. All printing methods condense things into smaller ranges and never look as bright because you view them by reflected light. Part of the skill in studio and outdoor photography lies in being able to harness the lighting

range so that highlights are not burned out and detail is retained in dark shadows.

Reflection and refraction When placing lights and reflectors there is a simple law to remember – a light ray will leave a flat reflective surface, as shown in the diagram. This lies at the basis of the way shadows are created and how we can place a reflector, effectively creating another light source, to throw light back into a shadow. When light travels from air into a solid transparent medium, its velocity changes – it slows down and is bent (this is called refraction), and when it emerges it is bent the other way. Sometimes moving from a dense to a less dense medium (glass or water back into air, for example) light bends so much that it is reflected back inside. This internal reflection creates the sparkle in gems. This is also something that lens designers try to combat, and they do this by coating lenses, since internal reflections soften images.

Colour confusion When dealing with photography where we are using light of various colours there is often some confusion over what, exactly, primary and secondary colours are, simply because with paints (which are viewed by reflected light) yellow is regarded as a primary colour (along with blue and red).

When you mix three discs of light, one each of red, green and blue, at the centre you see white (if the filters are pure). Where they overlap you will see the complementary colours magenta (red light +blue); yellow (red + green); and cyan (green + blue).

Just as red + green + blue light makes 'white', so does magenta + cyan + yellow: really this is red + blue +green + red + blue + green, so is effectively two lots of red + green + blue.Most photographic colour printing and transparency films work using cyan, magenta yellow and black – a

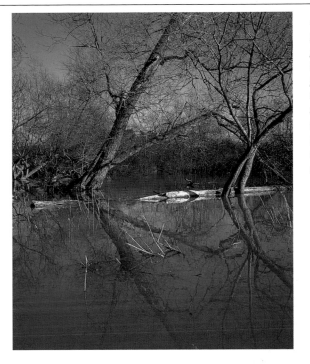

◄ *Reflections can become an important part of a composition. Here a flooded river produced opportunities to picture trees seemingly growing from the water.*
Mamiya 7 II, 43mm f/4.0 lens, f/11 at 1/30sec, Fujichrome Velvia

process called 'subtractive colour': commercial printers also work with CMYK (K stands for black) processes, whereas with television monitors and digital cameras, we tend to work with red, green and blue (RGB). They build colour from different amounts of the three basic colours in phosphors (in a television screen) or sensors (camera). This is known as an 'additive' process.

Some wave properties of light

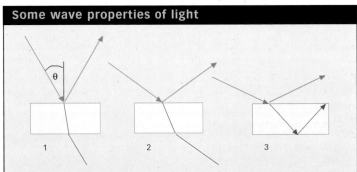

Light waves have a number of characteristic properties, of which reflection and refraction are important to a photographer. The first occurs at surfaces and creates highlights. The second is the process in lenses where light is transmitted and bent; if the light enters at a large enough angle (3), it can be reflected back inside a transparent substance. This creates the internal reflection that produces the sparkle associated with gemstones.

Exposure

Mastery of exposure is central to successful photography. The designers of film and digital sensors work on the basis that a certain amount of light energy uniformly distributed over film or sensor produces a 'correct' result. The trouble is that the most interesting scenes will often exhibit different levels of brightness and tend not to be the 'average' scene that an exposure meter has been designed to read as 'correct'.

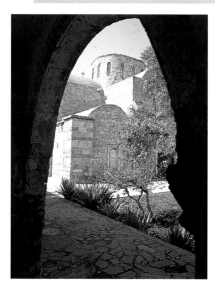

Exposure meters We all want to believe what an exposure meter says, especially after we have paid a great deal for the instrument. Understanding what an exposure meter does (and when it performs best) can help you make those small adjustments that ensure that the result you obtain is what you actually envisaged. All it takes is the readiness to make some sample exposures to ascertain how a particular exposure meter behaves. Never see this as 'wasteful': it will save you countless exposures later on.

▲ *Areas of light and dark in strong contrast will fool many exposure meters. Here, there was no attempt to capture any detail within the arch because its shape was used simply as a frame and the exposure made for the scene beyond.*
Mamiya 7 II, 43 mm f/4.0 lens, f/11 at 1/125sec, Fujichrome Velvia

Exposure for neutral and bright tones

Traditionally, 'correct' exposure is obtained by metering the light reflected from an 18% reflectance grey card. Many natural tones, such as green grass and the blue of the sky away from the sun, also provide the same neutral tone.

You can evolve a very accurate method of metering based on an appreciation of the fact that an exposure meter will see something and try to produce it as a neutral tone. This is fine if the object *is* in fact a neutral tone, but what do you do about bright yellows or whites? This is where the meter can let you down unless you take charge. An exposure meter will try to reproduce yellow as a neutral flat yellow – all the vibrancy is lost. If you slightly over-expose by, say, ⅔ stop, that yellow will retain all the vibrancy of the original. Similarly, white needs to be overexposed by between 1 and 1½ stops.

My favourite method of exposure does not involve trying to find a suitable neutral tone. Instead, I use the camera's spot meter and select the subject that I want to meter. If that is bright yellow then I know my camera will give the perfect result with the ⅔ stops extra exposure. How do I know? Well, I shoot a film with different settings either side of what the meter recommends. Every camera body you

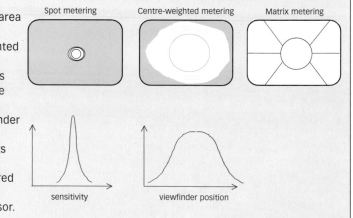

Metering patterns

A spot meter takes its readings from a small area at the centre of the screen. A centre-weighted meter typically takes about 70 per cent of its reading from within the circle shown. Matrix meters divide a viewfinder into five or more segments, so take readings from these and weight them according to stored meter patterns in the camera's microprocessor.

Spot metering

Centre-weighted metering

Matrix metering

sensitivity

viewfinder position

Tone control

By taking a meter reading of any colour and then opening up or closing down the aperture (or using the compensation dial) you can control how that tone will appear. For example, metering a red object gives a 'medium' red: close down 1 stop to get dark red, or open up 1 stop to get light red. The grey scale shows how white would appear if metered directly: opening up by 1½ stops gives very light grey which will retain detail; increasing exposure to 2½ stops gives burned out, featureless white.

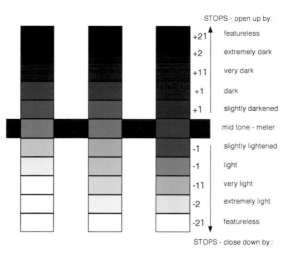

STOPS - open up by:

+2½	featureless
+2	extremely dark
+1½	very dark
+1	dark
+1	slightly darkened
	mid tone - meter
-1	slightly lightened
-1	light
-1½	very light
-2	extremely light
-2½	featureless

STOPS - close down by::

▼ *Any exposure with light and dark tones is inevitably a compromise. Here, the camera's matrix meter effected that by comparing the scene with results stored in its memory to produce a result that is as good as anything that manual exposure might achieve.*
Mamiya 7 II, 43mm f/4.0 lens, f/8 at 1/125sec, Fujichrome Velvia

have will be slightly different, so you need to check each one. With care, you need never have a duff exposure again – or very few, anyway.

Digital cameras Many photographers used to the accuracy of a film camera with a matrix meter have found that digital SLRs can give erratic readings, and these differ wildly when the camera is used in shade or bright sun. Some metering modes with film SLRs – notably TTL flash – make use of light reflected from a film surface (OTF). However, a sensor surface is completely different and reflects little light, so clever methods have to be used to fool it. However, the digital camera offers the advantage of visual confirmation of a scene to check the exposure – all it takes is to make sure that the LCD screen records a result as you see it. Sometimes the screens are much darker than the result you see when you download the image. In this case, you might need to take some shots and change the screen brightness.

You can use the camera's meter as a rough guide and then fine-tune visually, particularly with demanding situations such as sunsets with silhouettes. This is ideal for tricky indoor situations with a number of different light sources – for example, candles in a church with tungsten lights and stained glass windows. The practice is analogous to the Polaroid shot that many pros take of a scene in a studio in order to check lighting balance.

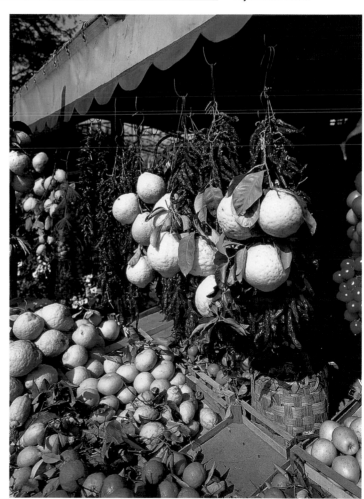

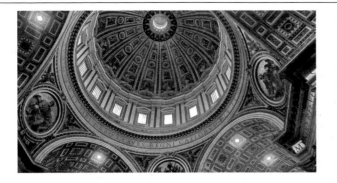

▲ *The filtered daylight in the cupola of St Peter's in Rome is mixed with internal lighting. When using daylight film, the bright incandescent lights add a warm yellow tone.*
Sigma SD10, 15–30mm Sigma f/3.5–4.5 AF DG, f/8 at 1/8sec, ISO 400, white balance at auto

Meter calibration You can ensure the accuracy of a camera's TTL meter by comparing it to a top-class handheld meter, or spot meter. You usually find the exposure shifts are consistent; maybe a ⅓ to ½ stop over- or underexposure. You can change the ISO setting, especially if you like saturated results. Many people feel that Fuji's ISO 50 for Velvia is optimistic and rate it at 40 or 32. Others use Kodachrome 64 at ISO 80.

You don't have to do what you are told – it is much better to use the manufacturers' settings as a guide and then accept that personal interpretation and camera affect this. You may well find that each camera body you use performs slightly differently.

A practical check: the sunny f/16 rule
This is a useful check when you think that a meter might be giving erroneous readings. A film is designed to give correct

▲ *The ochre cliffs of Roussillon in Provence reveal the richness of their hues in the late afternoon light, when the higher red and yellow content accentuate the natural colours. A polarizer intensified the sky to produce the dramatic colour contrast.*
Mamiya 645 pro TL, 45mm f/4.0 lens, f/11 at 1/125sec, Fujichrome Provia 100F

exposure in the temperate zones on a bright sunny day with the sun high in the sky, with the aperture set to f/16 and the shutter speed as close as possible to 1/ISO rating. This is the sunny f/16 rule. For an ISO 25 film, this would be 1/25sec. To cope with the fact that an ISO50 film has no 1/50 speed equivalent, use 1/60sec and, if necessary, open up by ⅓ stop.

Exposure and time of day One problem for colour photography is that different light sources have varying proportions of red and blue light in their spectrum – in fact, the higher the temperature of the light-producing source, the 'bluer' the light. There is a way of describing light sources in terms of 'colour temperature' that

White Balance

A typical digital camera gives options for different light sources when you select white balance. Each setting corresponds to a different colour temperature. With this system, there is no need to use warm-up filters or change to special films.

Camera info	Auto	
	Sunlight	- 5400K
White Balance	Shade	- 8000K
Set Custom WB	Overcast	- 6000K
Date/time	Incandescent	- 3150K
Language	Fluorescent	- 4100K
Quick Preview	Flash	- 5850K
Preview style	Custom	

◄ *The colour balance changes quickly from the cold light before dawn with its high blue content to warmer tones after sunrise. The slower colour films such as Fujichrome 50 produce a warmer, more intense result when you underexposure slightly, which is a boon.*
Nikon F4, Nikon 24mm F/2.8 AF, f/16 at 1/30sec Fujichrome Velvia

relates to the temperature in Kelvin (K). Daylight is 5500K; a blue sky 10,000K and more; and a tungsten lamp is 3400K. Our eyes adjust under different light sources so that we perceive a white object as recognizably white under sources that may have a distinct colour cast. Film cannot do this, so we have to use daylight-balanced film to cope with sunlight and flash, and tungsten-balanced film under artificial lights.

The other choice is to use colour compensation filters to allow daylight to be used with tungsten lamps and vice versa. This change in colour temperature is a boon in many cases – late in the day or early morning, the preponderance of yellows and red in the visible light spectrum gives a pleasing warmth to a scene (when the colour temperature is about 4000K).

White balance Users of digital cameras have an amazing level of control through the white-balance, a metering system that can be set to cope with different light sources. The white balance program varies the response to blue and red tones appropriately: it can do this from a menu, or gauge it automatically. For complex situations, you take a grey card and assess it through the 'custom' function. If you shoot in RAW mode, then most image-capture programs allow you to change the result on the computer's screen when the files are downloaded.

Colour Temperature

Light source	Colour temp (K)	Conversion filter for daylight balanced film	Exposure increase in stops
Clear blue sky	10,000–15,000	orange 85B	2/3
Open shade in summer sun	7,500	warm-up 81B or 81C	1/3
Overcast sky	6,000–8,000	warm-up 81C	1/3
Sun overhead at noon	6,500	warm-up 81C	1/3
Average daylight 4hr after sunrise to 4hr before sunset	5,500	none	
Electronic flash	5,500	none	
Early morning or late afternoon	4,000	blue 82C	2/3
1hr before sunset	3,500	blue 80C	1
Tungsten photopearl	3,400	blue 80B	1 and 2/3
Quartz bulbs	3,200–3,400	blue 80 A	2
Tunsgten photoflood	3,000–3,200	blue 80A	2
Household lamp 100W	2,900	blue 80A + 82C	2 and 2/3
Golden sunset	2,500	blue 80C + 80D	
Candlelight or firelight	2,000	Blue 80A + 80B	

working indoors

*Baptistry door detail,
Florence, Italy*

Working indoors allows a photographer to take complete control of the business of picture-taking. Sunlight is a wonderful light source, and arguably the best in many circumstances, but having exactly the lighting conditions you require when you need them, or eliminating the movement from wind and other negating weather factors means moving indoors.

Portraiture, extreme close-up, still-life and product photo-graphy all require ancillary equipment that it would be impracticable to shift each time you wanted to take pictures. Until you have experienced having dedicated studio space with the items you regularly require already set up and ready to go, you do not realize what you have missed. For many keen photographers, the business of getting equipment out and setting up is a deterrent to the kind of approach that allows you to take spur-of-the-moment photographs – which are often your best.

Few of us have unlimited space at our disposal, so a little improvisation is usually required: the corner of a desk, a garage, an attic, or a shed can all be used. Few of the people who look at my pictures of macro subjects or still-life shots have any idea of the bits of wood, Blu-tac and metal that lurk out of sight. The sleight-of-hand approach works at any scale, and no one knows that the 'studio' is really a kitchen table.

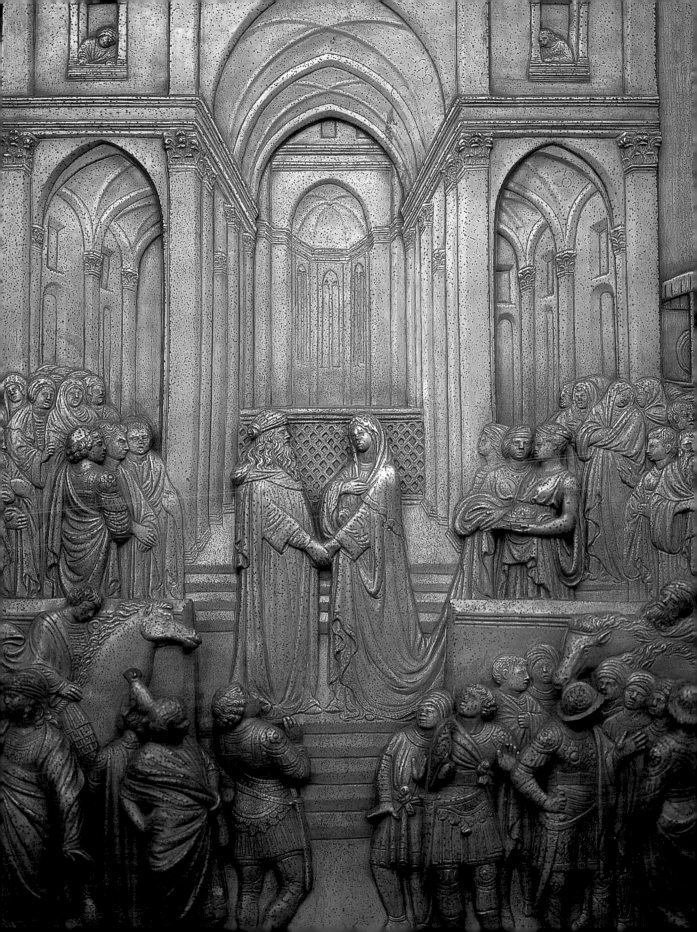

Setting up a studio

The type of studio facilities you set up will be dictated by what sort of photographic work you want to tackle. When you are trying to find space for your studio, it helps to work from the ideal: start with an idea of what you would like and then re-jig your scheme to suit the space available.

▲ *Portrait photographer Sian Trenberth advocates simple, informal sets and tried and tested lighting. She uses lighting panels and reflectors to provide a soft light from below and spots for detail.*

Possible studio requirements If you are a dedicated landscape photographer then you will simply need a darkroom – either for traditional 'wet' chemistry, or a space for your digital manipulations. For close-up, still-life and general table-top work, you can work wonders with an area the size of a dining table. Portraiture requires more space – you cannot simply fit a wide-angle lens and move closer as this causes a fore-shortening of features that does not flatter any subject. In this case, a spare bedroom can provide the space you need, with

backdrops and lighting gear stored in a wardrobe where it can be taken out with minimum fuss and set up quickly.

Width In assessing the width of a space, you need to allow for both the subject and the space for you to move around. With a table top, for example, you need a metre or so at either side so you can move comfortably to reposition objects or try different camera angles. By the time you add some storage space at the sides, you are approaching a requirement of 4m (12ft), and that is not always easy to find in modern houses. A garage or basement conversion might give you this width more readily: with lofts, the placement of roof trusses can often pose problems, and available spaces tend to be small unless you resort to drastic restructuring.

Length For portraiture, you need to allow a minimum of 2m (6ft) between camera and subject so that you can use a portrait lens in 35mm and keep a pleasing perspective. Then allow 1m (3ft) for space behind the camera for you to move without knocking over tripods, and another 1m (3ft) as space for the subject. This means that 4m (12ft) have already been taken up, before you add a minimum of 1m (3ft) between subject and backdrop, and a further 1m (3ft) or so for backlighting. This 6m (18ft) is what you need for seated portraits – if you have another metre and a shorter focal length lens then you will be able to take full-length shots. To have a permanent studio of this size in any home is often not possible, so many photographers convert a bedroom for temporary use, or set up studio conditions on location.

Height If you want overhead lighting – a softbox for still-life and product shots, for example – then you can cope in an ordinary room with a little ingenuity by setting

◄ *Here the floor serves as platform and background. The bare spaces do not distract the sitters and Sian develops an essential rapport where clients of all ages get to enjoy the process – and it shows in the results.*

things up on a lower table or floor with a baseboard. Ideally, if you need a softbox for portraiture then around 3m (9ft) is the minimum room height. For practical rather than aesthetic reasons many photographers are forced to dispense with overhead lighting and use light bounced from white ceilings. With practice, you will know exactly how much light you need and at what angles for optimum effect.

Storage Studio equipment takes up space. There are not just lights and cameras to consider; you will very quickly accumulate painted backdrop boards and rolls, to say nothing of props. You can never have too much storage space.

Changing and make-up rooms If glamour work is your interest, then you will need to provide somewhere comfortable for models to change and apply make-up. What suffices for a partner prepared to co-operate will not be acceptable for a professional model. In fact, quite a few enterprising models set up their own home studios with appropriate lighting.

Corners and coving
Corners in rooms tend to show up in photographs, so one trick you can try in your studio is to fit coving and paint it the same colour as the walls. The smooth-curved corners create an 'infinity cove', and anything you photograph then seems to hang in space. On a smaller scale, you can arrange backgrounds into smooth curves like this, too.

Blackout
If you are working by artificial light, you need to keep all daylight to levels that will not affect exposure or create colour casts when using tungsten-balanced film. Blackout curtains or blinds need to be fitted to windows – although you don't need the degree of light-tightness that you would in a colour darkroom.

Decor
Reflection from walls can be difficult to control, and coloured walls can impart strong colour casts to pictures. In theory, you can achieve the best control with black walls and then directly light everything that you want illuminated. Then again, black-painted walls can be oppressive and depressing. Neutral backgrounds work best with whatever props you accumulate to create your set.

Unwanted objects
Sooner or later, all of us find a set of overhead cables in the frame of our landscape

shots. You only notice them after the picture comes back, but then you learn to check for them, almost subconsciously. The same happens with interiors: pictures on walls, switches and electric sockets can be disconcertingly invisible when you look at the scene through the viewfinder. These days, however, removing such unwanted features is very easy with a digital file.

Power supplies

Any studio should be generously equipped with power points on a ring main. Avoid adaptors and trailing wires whenever you can; tape them to the floor with gaffer tape if you cannot avoid having long leads. Remember that Watts (power) = Volts x Amps, then work out what power you can take: for example, on a 240V supplied with a 13amp fuse this allows you to draw just 13 x 240 = 3124Watt (3.14kW). When using powerful lights and heating this limit can soon be reached so you, or your electrician, will need to install some separate wiring for extra sockets. Powerful flash units produce a pulse that lasts a fraction

of a second, but the current drain can be high when the unit is charging. If you can work out your power requirements then by all means do it yourself. If there is any doubt, then get an electrician to calculate and set things up for you.

Heating

In any studio, particularly if you are working with models, you will need to ensure that you have adequate heating. Bright photoflood lamps have a strong heating effect that is useful on cold days. If you just use flash then you will need some ancillary heating. In summer, powerful lights soon become uncomfortably hot so you will need a fan and, if possible, air conditioning.

Moving the studio

If you have no room for a studio at home, then joining a camera club with studio facilities is one solution. Working on location is another idea. Corporate photographers do this all the time, using a set of lights and backdrops to make a space into a studio wherever they are.

A table-top studio

Much of our professional work is outdoors. My studio needs are specific – I need a space where I can work with an optical bench and other devices. We have the capability for film to 6x7cm, but now work entirely with digital bodies where trials can be evaluated and pictures downloaded to computer and sent off to clients.

Lighting equipment

Many photographers never get to use studio lighting because they work outdoors and, when indoors, resort to a single flash. If you cannot justify the expense of buying a set of lights then it is worth joining a photographic club, where studio facilities are shared, or hiring an equipped studio when you need to.

What lighting you might need If you decide to invest in some lighting kit, it is a good idea to visit a small working studio or

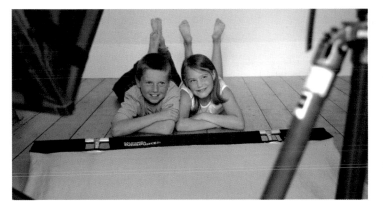

▲ *The large surface area provided by the reflector on the floor creates a broad light source and this gives a 'natural' mode of lighting without harsh shadows.*

▼ *Reflectors come in various colours and can be held and moved until the lighting effect they produce is just right and are generally more manageable than lights on stands.*

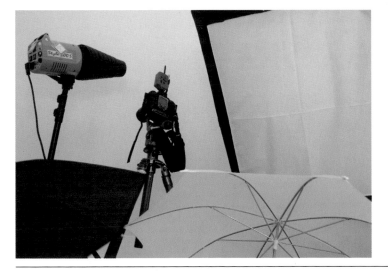

to hire one before spending money on your own lights. Remember, too, that most working professionals use just a few familiar lighting set-ups that they change only slightly from sitting to sitting. To learn what set-ups might suit you, take the opportunity to talk to people who use studio lighting, and to play with some set-ups yourself. Build your set-up slowly; start with just a couple of stands, a main light with an umbrella and a fill-in lamp. Several manufacturers offer an introductory kit in a carrying case.

Don't be intimidated by any apparent complexity in diagrams showing lighting set-ups for portraits or groups. For all central interest in a scene there is only one light: the main or 'key' light. Everything else is there to help you control the main source: fill-in lights to lift shadows and reduce contrast; rim lights to accentuate edges of hair; background lighting and so on.

Key light This is the main light, often used with a 'fill' to soften shadows to the required extent. Many people use a key on its own, diffusing the light so that shadows are softer. This is not done directly but by pointing the flash backwards to a reflective umbrella so that the source effectively becomes a 'broad' one (see pages 18–19).

Fill Fill-in lights illuminate the subject from the opposite side to the key. Fill lights can be another make and model of lamp, but it makes sense to use the same model for both key light and fill but with the fill set further back or diffused. You can easily switch a flash to a lower power, but an incandescent lamp will have a lower colour temperature and in essence will provide light that is more yellow.

Bounces/reflectors You can create another light source using a large reflector. This produces a diffuse light source and is usually held close to the subject (it can even be held by the subject) and just out of frame so that it throws light back into the shadows created by the key light. Use any large white surface – plywood painted a

bright matt white; large white card (rigid enough to withstand use); or polystyrene sheets. Lastolite reflectors are excellent in the studio as well as outdoors (see page 70). In many studios you will find black bounces; these are used to absorb light and prevent reflection. You can paint your reflector boards matt black on one side and white on the other.

Fluorescents Flicker-free tubes are often used in broad panel-light sources: they give a soft light and are less costly to run than tungsten filament versions.

Controlling shadows and creating balance If you set out to create mood with harsh shadows, then point sources are best: the beam they produce should be focused and not spread. A redundant slide projector works well and is much cheaper than a focusing spot.

Any fill light should be used just to lighten shadows. It is easy to use too strong a source that creates shadows of its own – look for the tell-tale cross-shadows in a picture and move the fill away (or move the main light closer) to reduce them.

Lighting jargon explained

Lighting professionals, particularly those involved in film-making, use an enormous array of lights and employ a special vocabulary of their own. You might know what a softbox is, but what are flags, snoots, gobos and cookies?

Flag
A flag is a panel used to shade off a part of the subject.

Cookie
Also known as a gobo, a cookie is a flag with holes used to create dappled lighting.

Snoot
A snoot is a type of directional light: it is cone-shaped with the pointed end removed to restrict light.

Honeycomb
A honeycomb is formed from metal grids with hexagonal mesh that clips to the front of a reflector and makes light harder.

Scrim
A scrim is a fabric screen used to soften and diffuse light.

Softbox
This is usually a large reflector lamp with a square or oblong diffuser fixed to the front, which gives a square metre or more of illuminated surface.

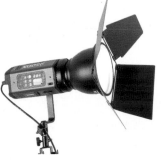

Barn-door
The closeable flaps of a barn door attachment allow the light to be precisely shaped, directed and masked off as required.

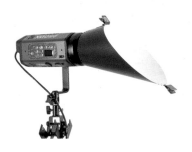

Scoop
This attachment can be used to create interesting oval shapes with the lighting

Triflector
A triflector wraps light around a subject in a flattering way to reduce the telling shadows under the chin and nose that tend to be ageing. Three reflectors – a central one with two wings – are used on a lighting stand and illuminated from an overhead key light. Many high-street portrait photographers use a triflector for getting reliable results each time with a minimum of set-up and fuss.

Effects lights When you have the basic set-up established, there might be aspects of the subject that you would like to emphasize. Various spotlights can be used to pick out jewellery or any other shiny object dulled by diffuse light. A favourite effects light is a rim light placed behind a subject and to one side, but well out of frame; this backlight picks out hair and makes it glow. You can achieve the same effect outdoors using the sun as the rim light but lifting lighting on the face with fill-in flash (see pages 72–73) so you don't end up with a silhouette.

Cabling You can never have too many sockets in your own studio space. These should be wired in professionally when the facility is set up. When working on location, you can use multiple sockets on extension cables (use one lighting plug per socket: do not double up with adaptors). If you use cable reels, make sure these are opened out; they can get surprisingly hot when they are rolled on the drum, to the point even of melting cable – with disastrous results.

Tangles of wires are not only unsightly but potentially hazardous. Run cables under mats and, if necessary, tape leads to the floor with gaffer tape if people are moving around freely. Where several leads travel together, fix them with cable ties rather than sticky tape, which leaves a messy residue when you try to take it off.

Light meters By far the easiest and most reliable form of metering in a studio is a handheld incident light meter; you simply hold it near the subject and its diffusing dome is lit as the subject is. It is worth getting a meter that will respond to flash as well, since this is the best way of assessing exposure when you have an arrangement of various lamps – TTL lighting is impractical with studio flashes in most cases because many of the lights will not be controlled from the camera. If you are working with a single diffused flashgun, then TTL

will give good results, but it is much better if you can check it with a digital camera body.

Stands With stands as with tripods (see pages 12–13) you should avoid the flimsy. Modern stands from many manufacturers of lighting equipment have telescopic centres and trip bases; they also fold down for easy transportation. For any form of overhead lighting you will need a boom, where a counterweight balances the light on the other end. Your stand needs to be substantial enough to hold this.

Secondhand lighting units
There are problems in getting lighting units of too great a vintage unless you are proficient enough to change wiring and fittings. Metal covers on old lamps can become very hot, so if you repaint them you must use paints that can withstand such heat, and always make sure that all metal-part covers and stands are earthed. Carbon-arc lights are now best consigned to a cupboard and are of historical interest only. They are very bright, draw heavy currents from special supplies, and unshielded, produce large amounts of ultraviolet light, too.

◀ *Incident light metering is nowhere more useful than in the studio where the meter can be held next to the subject, whatever the array of lights, and a test exposure made – the flash meter can be coupled to the lamps to give a reading or be triggered by them.*

Basic tool kit

Whether your studio is fixed at home or you travel to different locations, you will need a basic tool kit for all the situations that arise when working in unfamiliar environments. The following items will prove useful:

- Adhesive tapes, including gaffer tape and electrical insulating tape
- Adhesives, including super glue and quick-setting epoxy glue
- Screwdrivers, both flat-point and cross-point
- Allen keys, both metric and imperial
- Pliers (pointed nose)
- Mole grips

- Hammer
- Hack saw
- Battery-operated drill
- Wire cutters and strippers
- Boards and card
- Foil, both silver and black
- Spare lamps, cables and cable ties
- Swiss army knife or leatherman (if you carry nothing else then always take these).

Studio flash

Flash is momentary, giving all that is needed to light large areas and create a picture in short, action-stopping times. Using flash indoors is portable and convenient. The disadvantage can be the small size and reduced coverage of most handheld units. There are two remedies: bouncing and diffusing. Both techniques light the background (so reducing fall-off) and produce a softer light so shadows are less harsh.

▶ *The rear of a studio flash houses controls that allow output to be adjusted and test flashes made. Smaller units contain the capacitors and tubes needed to produce the discharge – with large units a floor-based power unit is used to fire a number of units.*

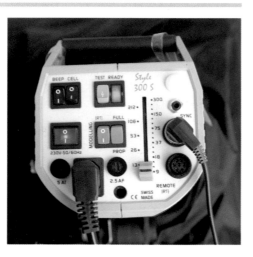

Mixing flash and available light In many large rooms you can often use daylight from large windows and mix it with flash as the fill-in light. The technique is the same one that is employed with outdoor shots (see pages 72–73), where both light sources have similar colour temperatures and can be used together without creating colour casts.

On location To use a single flash for location work, you will need something more powerful than an in-built flash: it is useful to be able to use the unit off-camera with an extension lead, since the top-of-camera position is not the optimum one.

Some camera systems allow you to use several of the manufacturer's guns coupled together with leads: one flashgun becomes the main unit and the others can be set to act as 'slaves'. The Metz adaptor system

allows you to do the same with virtually any camera make (both with manually controlled flash or TTL if you have it). Another way is to use flash triggers. They plug into the co-axial socket of older flashguns and trigger the 'slave' flash when the main flash produces a pulse of light. In this way, you can use a separate gun when you know its guide number but cannot couple it to a TTL system – I often use an old Metz CT1 gun to light my backgrounds.

Guide numbers and power Single-unit flashguns have a guide number (GN): professional units have a 'power' output that is quoted in joules. Guide numbers can be ignored when you use a camera's TTL system because that measures light output compensating for filters and reflection from walls.

The guide number is a device that lets you work out what aperture to set or where you should put a flash in relation to a subject at a particular aperture. You make the calculation as follows:

- Aperture to use = GN (metres) ÷ Flash-to-subject distance (metres)

- So, for GN 32 (metres) and a flash-to-subject distance of 2m:
 Aperture = 32/2 = f/16

This is usually quoted for ISO100, but if you use another film – ISO50, for example – remember that doubling (or halving) the ISO rating is equivalent to a one-stop change, so you open up by one stop to f/11. Similarly, for ISO200 (a common rating with digital cameras), you need to close down by one stop to f/22.

Measuring guide numbers Quoted guide numbers are often optimistic. The solution is to measure your own unit's output in a typical room that you might use. Take several exposures over a range of apertures with a flash-to-subject distance of 2m (6ft) – some direct, some diffused so you get two different values. Choose the one with best illumination; then using this aperture,

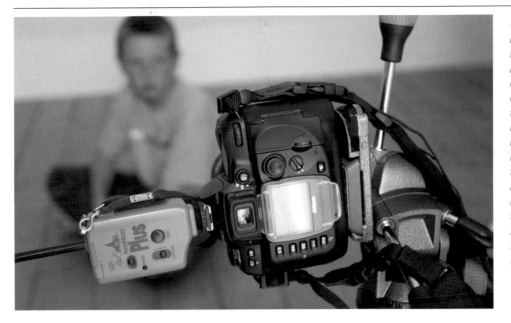

◀ *Lighting systems can all be triggered from the camera, and many can be controlled via the cameras own TTL system – however, in using digital cameras many photographers have resorted to using the camera to trigger, and a separate flash-meter. The camera is then set manually because of the limitations of the TTL system in many models.*

multiply by two and you will obtain the guide number for the film used. With bounce flash, you either guess or experiment first with a typical ceiling height.

The Versatile Single Flash

A single flash can be surprisingly versatile used on camera and even more so if you can detach it and use it on a cable – the diagrams show several ways of using it.

Top – the unit is used directly and can, as a single light source, produce heavy shadows.

Centre – many flash units have an inbuilt diffuser or can be fitted with a 'softbox' and this produces a broader source and a generally more flattering light with softer shadows.

Bottom – A white ceiling or wall can be used for 'bounce flash – light is reflected from the surface, which acts as a broad source. It can be a challenge to select a camera and subject position to allow you to do this – use a TTL flash to avoid having to make calculations that allow for the 'bounce'.

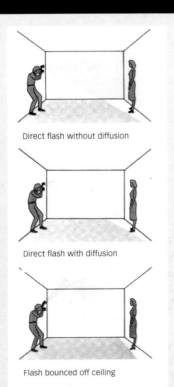

Direct flash without diffusion

Direct flash with diffusion

Flash bounced off ceiling

Flash power When it comes to flash power, there is often a slight sloppiness when talking of 'power' and Joules. The figure quoted in Joules is a measure of the energy that is discharged through the tube to create the flash. Power is a measure of energy flow in joules per sec (Watt). For a 150J unit discharging in 1/1000sec, this is $150 \div 1/1000 = 150,000$ Watt or 150kW (a thousand times the power of a 150W bulb).

Many larger flashguns have an integral diffuser that effectively spreads the coverage while at the same time reducing intensity (the light energy falling per square metre). Accessory hoods vary, from the Stofen unit (you can do as well with the diffusing material cut from some slide boxes) to larger Lastolite diffusers. Coloured surfaces will give a colour cast, though with cream or other slightly warmer surfaces this might help, rather than hinder, picture-taking.

Studio units consist of flash heads with an integral power source (larger ones come with a separate pack) that charges them and gives much faster recycling times than a battery-powered unit. Monobloc heads have an integral photoflood bulb with a circular flash tube wrapped round it. The photoflood light is used for setting up shots and adjusting lighting effects; the flash tube makes the exposure.

Backgrounds

A complex subject generally needs a simple background. With a simple subject you could use a more complicated background. Brightly coloured subjects are immediate attention-grabbers. The effect can be further strengthened by setting such subjects against backgrounds that are darker or of a complementary colour. For natural subjects, a neutral background of natural shades works best.

Black backgrounds A black background can enhance any subject since there is nothing to distract the eye from the subject. Strong colours also become more vibrant when set against black.

When you need a truly black background, black art board or card will not do; it appears grey under bright lights, especially flash. The best black for large areas is

◀ Photographic fashions come and go. Here a portrait of my mother's late sister shows a stylized approach to portraiture in the 1930s: a side view with a black background and backlighting to accentuate the hair. Although the representation is dated, many photographers use well lit subjects against a black background as the ultimate form of emphasis.

▶ When setting up this shot of the violin for a still life, some velvet clothing was used. The folds of the material suggest a luxury and warmth that clearly attracted the onlooker, too.
Sigma SD10, 105mm f/2.8 Sigma AF macro, f/11 at 1/125sec, ISO 200

obtained from black velvet or black felt. On a smaller scale, you can use black velour. Such backdrops have to be carefully brushed as they pick up bits of fibre and dust that catch the light.

You can always paint black backgrounds, but be aware that many black paints rely on a series of dyes to create a surface that absorbs light of all wavelengths and so appears black: these paints are not always true black and some have a surface sheen even when sold as matt. For small areas you can use matt car enamels (I use Humbrol Matt Black, the blackest one that I have come across). Car enamels are effective but are expensive if you need to paint a large area.

Background sheets If you do a lot of portraiture then you will need backdrops that are not obtrusive. Soft greys and cloud-type backgrounds are favourites, but it is important to ring the changes and not become clichéd. There is a huge range available, and catalogues from firms such as Lastolite make fascinating reading. Backgrounds are not cheap and need to be stored rolled or hanging so that they do not crease or become marked – another reason why you need adequate storage space in your studio. You can create a seamless background

by curving sheets of card behind your subject. You have to check the viewfinder and adjust the camera position to make sure you do not see the edges of the sheets.

Making your own backgrounds The common fault with many homemade background sheets is that they use shades that are too bright and shapes that are too well defined, producing disconcerting patches in the viewfinder. In painting a natural green background, for example, you might start with a soft foliage green or a greyish-green as an overall colour wash, and then add other greens using a sponge to dab on the colour. A softening brush can then be used to remove any hard edges. Similarly with cloudy skies: a pale blue colour wash forms the basis, and a sponge can be used to create the texture and wispiness of clouds.

Backgrounds for natural subjects

Natural subjects often look better in studio portraits where there is a soft background of blurred greens and light browns. In the field, the background arises naturally from grasses and plant stems, positioned far enough behind the subject so that they

▲ *The drape is just a mosquito net – both a source of fascination for this kitten and an effective background since it does not distract from the main subject. In general, complex colours or patterns need a simple background.*
Sigma SD10, 105mm f/2.8 Sigma AF macro, f/11 at 1/125sec, ISO 200

▲ *Natural backgrounds thrown out of focus can produce pleasing effects. Here, the interior of the cave became the backdrop for a hibernating bat. Earth tones are easy on the eye and can be used for both natural and 'contrived' portraits.*
Nikon D100, 105mm f/2.8 Sigma AF macro, f/11 at 1/125sec, ISO 200 with on-camera flash

appear out of focus. This effect is enhanced if you shoot plant portraits with a telephoto lens. In the studio, you can create the same effect by placing a clump of grasses in a tray behind the subject. If you use a main flash, the background will appear darker but still retain colour and accentuate the subject. Alternatively, you can light the background separately with a slave flash. When using incandescent, you employ three or four lights: main, fill, background and rim light (to create a degree of backlighting and pick out leaf and petal veins or plant hairs.)

◄ *This 'portrait' of the author at work has the complex backdrop of a whole field of sunflowers, but they become blurred with distance.*
Sigma SD10, 15–30mm AF, f/11 at 1/125sec, ISO 100

Portraits

Portraiture has always been one of the great photographic themes. It is something we all want to attempt at some time, but it is not nearly as easy as it seems to produce that special portrait, one that brings out character in a face and captures the identity of the sitter. Explained below are some of the most common lighting arrangements for portraits.

Available and balanced light Light from a large side window can be used for indoor portraits, but a reflector or flash will have to be used as a fill-in for shadows on the opposite side.

▲ *The stronger lighting from the right imparts a certain moodiness to the picture in keeping with the seriousness of the teenage subject. Some reflector fill from the left softens shadows that would otherwise be too harsh.*

Diffused window A soft, diffused light can be obtained on a bright sunny day by placing tracing paper over a window. Overhead roof windows can also produce good lighting though a large reflector.

Umbrellas The effective surface area of any light source is increased by using an umbrella – the light is softer and ideal for portraits.

◀ *Here, strong side light caught the subject's hair but left her face with just enough light for this soft outdoor portrait. It was not prepared since we were working in the field at the time and the sitter is not usually compliant, being happier behind a camera, too.*
Nikon D100, 28–80mm F/2.8 AF, f/11 at 1/125sec, ISO 200

Spot Focused spot lamps can be used to add detail to your basic lighting set-up. They might be to create strong shadows that determine mood or to pick out jewellery or some other adornment that your sitter is wearing.

Lighting the face Young faces with smooth skin can take hard lighting. Most people want to be flattered by a portrait and not want every blemish and line revealed, so it is often best to use a softer, more diffuse light. Male sitters might be prepared to let the lines be revealed, believing that it shows ruggedness or character. As we get older, we have to learn to accept our wrinkles, and old faces reveal a great deal with harder lighting.

Make-up for lighting Professional models know all the tricks of make-up for use under lights. In colour photography, make-up can quickly date a picture as fashions change, so it should be minimal and unobtrusive. Under hot lighting, many people will perspire, so some translucent powder is useful to dull reflections. Foundation can be used to conceal blemishes.

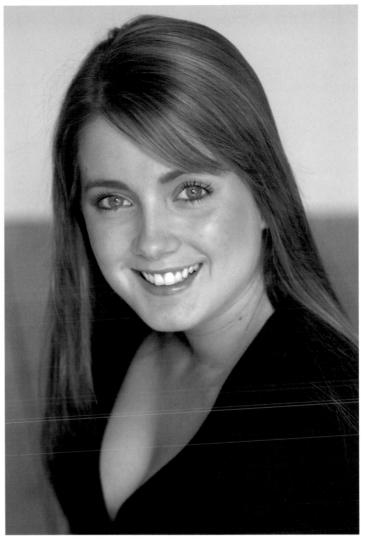

▶ *Sian's method of using a wide light source, such as a large reflector placed in front of and below the subject, produces a gentle quality of light with no harsh shadow but plenty of tonal difference to make sure a face does not look too flat.*

The beauty of symmetry: an experiment

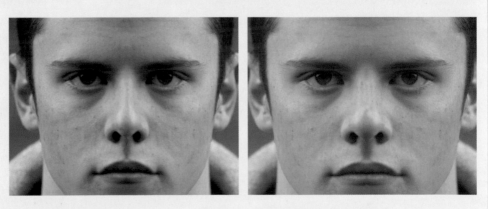

Humans are tuned to the fine differences that make faces distinct. Studies have shown that we find beauty in symmetry – although most of us have slightly 'wonky' faces and have to be content with just being interesting. Here, the subject's right-hand aspect has been reversed to create perfection. The other picture repeats the exercise with the left-hand aspect of the face.

Lenses for portraits Long lenses treat faces more flatteringly because they condense perspective to give a 'flatter' feel. On the downside, using a long lens puts you far away from the subject and destroys the rapport between you. In 35mm, focal lengths from 90mm to 150mm are ideal, but in a small space you might have to use a lens of shorter focal length. This is where you have to be careful, as shorter lenses distort the perspective of people's faces, exaggerating the nose in particular.

Focus for portraits If you decide on a close-cropped frame and move in to the subject, then focusing is critical: the closer you move, the shallower the depth of field. It is essential to get the subject's eyes in sharp focus, even if the rest of a face is not, as the eyes are our point of contact with others and the picture will not look right if they are out of focus. It is better, too, to get the nose and front parts of a face in focus. If the eyes and nose are not central, and you are using an autofocus camera, it might lock focus on whatever other feature is central to the frame. In this case, either use AF lock or focus manually.

Formal or informal poses Informal shots capture a subject at ease and relaxed, and are, on the whole, easier to take – the sort of shots you will make of family and friends, for example, where there is a bond between subject and photographer. The best portrait photographers are able to

▲ *This shot was taken in the evening light from a window high above a medieval street in Bolsena, Italy. I caught these old friends unawares with a 180mm telephoto, which gave 270mm equivalent on the D100.*
Nikon D100, 180mm f/2.8 Sigma AF macro, f/8 at 1/30sec, ISO 200

Taking series of portraits

It is impossible for most of us to take a single shot and get it 'right' when our subject is conscious of the presence of a camera. If you have the time and the consent of your subject, they will soon get bored with you and act normally, freeing you to take any number of pictures and choose the best one. Here, I started from one side and tried different framing, guitar finger positions and so on. Most worked, but some were better than others.

◄ Here, with the attention of both subjects elsewhere, I managed to capture a spontaneous expression from my partner Lois while she was in conversation with a newly acquired kitten.
Nikon D100, 105mm f/2.8 Sigma AF macro, f/11 at 1/125sec, ISO 200 with on-camera flash

create that bond with their subjects in a formal sitting. A full-length portrait needs either more space between you and the subject, or a wide-angle lens – though you must be careful of the possibility of distorting features.

Portraits in context Many people who are sitting for a portrait find that a photographic studio is an alien environment. You can often obtain better results by working on location in someone's home or work place, where they are in familiar surroundings and more likely to be relaxed and natural-looking. If you photograph someone in their usual context, you stand a better chance of capturing something that encompasses their personality. If your subject is working, you don't even need to photograph their whole face: photographs from the side, from behind, or even of parts of the face and just the hands can all provide you with dramatic and informative portraits. You can ring the changes by moving in close or zooming in on the subject to isolate them from the background, or drawing back to set them in the context of a background. Again, you can try exploring unexpected camera angles.

► From an early age, my nephew Andy, now a virtuoso bass player and guitarist, has been umbilically linked to a guitar – just like his father, my brother Peter, before him. When he plays he is away in another land – which is when I photograph him. Keep it in the family if you can. Model releases are automatic, and being well fed is the payment!
Nikon D100, 105mm f/2.8 Sigma AF macro, f/11 at 1/30sec, ISO 200

Portraits of babies Any parent knows that babies have characters from the first minute of their lives, and it can be very rewarding trying to capture this. As soon as the smiles and laughs start, then having a camera to hand will provide you with a wonderful source of shots. Toddlers have disproportionately large heads, so if you photograph from above the foreshortening emphasizes this. Try to photograph from the same level or slightly below. Features such as the tiny fingers or hands of babies are intriguing subjects, especially when wrapped around those of an adult. Shots of babies with parents can portray a touching intimacy. In order to obtain a look of utter devotion you need the mother there with small babies – that tends to be a fact of life; as a devoted dad I only got that look at a later stage.

▶ The appeal of Sian's shot lies in the simplicity – no props, just the baby softly lit and attentive. It looks deceptively simple and yet the hidden element is the ability to create a rapport with the young subject.

▼ A sleeping baby soon exhausts the photographic possibilities as I found with my young niece. The tiny hands have always intrigued and here they are shown entwined with the fingers of her mother.

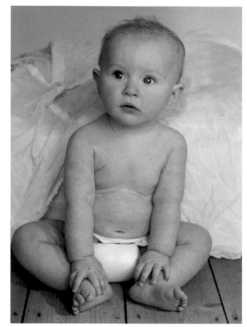

Keeping the baby occupied The attention of a baby can be drawn by the movement of brightly coloured objects such as a mobile – or an adult prepared to make funny faces and noises just out of camera view. Just putting a baby down on a set of cushions and hoping for the best won't work. Someone has to play with them to take attention away from all the lights and move far enough apart to be out of camera shot. Any parent soon realizes how short a baby's attention span can be and how one small human can fully occupy two adults: have everything set up and work as quickly as you can.

Lighting for babies Diffused daylight or a flash with softbox produce unobtrusive lighting that is most suitable for photographing babies – a battery of flashheads going off is at best disconcerting and can terrify a child. The perfection of a baby's skin can even accept hard lighting that would be unkind to any adult face.

◀ Here Sian shows that props are not needed, and a plain wooden floor provided the background – children are often very relaxed sprawling in some way and this can be exploited to advantage in order to photograph them in a posed but relaxed way.

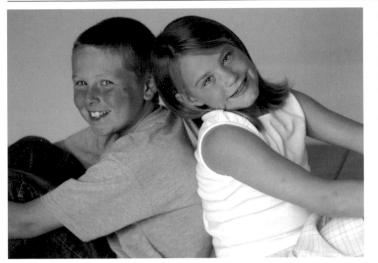

▲ *Moments of closeness between couples can make sickly sweet compositions; with siblings the closeness can look forced. Here, back to back, Sian's picture shows great warmth between the subjects – but no 'uncomfortable' cuddles for the subjects that the camera would then capture in the body language.*

▶ *Any visit from two-year-old Isobel involves a dash to the piano – she is delightfully camera-aware.*

Portraits of children Most children have a low boredom threshold and are generally not as biddable as adults when it comes to directing your shot. Have your lights and studio set up in advance so that you can work quickly whilst interest is there. Props such as toys can help to capture a child's interest. If you do a lot of child photography then you will need to make regular visits to toyshops to kit yourself out with some suitable props.

At home with your own children you can involve them in the process and even get them to look through the camera and photograph one another – if they are used to the camera then they quickly forget your presence and get on with more 'important' things. Be prepared to make children laugh and keep shooting – one of those frames will be what you want.

Practical tips Perhaps the best way to photograph children is when they are absorbed in some activity such as reading or playing by themselves or with friends. They are oblivious to you and your camera – although they are sensitive to the slightest click of a shutter. When children are playing outdoors, then working indoors through an open window makes you less obtrusive. If you use a medium telephoto (80–200mm) zoom you can isolate single heads or back off to capture interaction between children. The art lies in anticipating the moment and capturing it.

Warning note Sadly, we live in a fear-ridden world and however delightful children can be a person with a camera might be regarded as a threat. To avoid misunderstandings, only photograph your own children, or those of friends or relations: by all means expand the circle but only with the full knowledge and the approval of parent or guardian.

Nudes Black and white pictures of the human form emphasize textures and shapes and are often the most artistically powerful. But before you embark on any form of nude photography make sure that both you and your model are happy with it or it will show in the awkwardness of poses and approach.

Fashions in nude portraiture change fast: there are no hard and fast guidelines for nude poses, so it is worth exploring the work of the masters in the field and 'adapting' where you can – you will also get hints for lighting. For example, spot lights are often used to create dramatic shadows to emphasize body shape, and in the case of males (particularly, though by no means solely) to delineate muscle lines and curves.

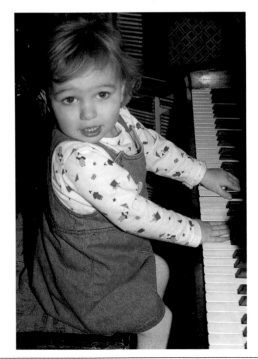

Group portraits

A group can be anything from a couple to a photograph of a sports team, wedding group, company or school. As with portraits you can use a formal or an informal arrangement, but the more people the greater the challenges.

▶ *A staircase seemed a sensible prop to use in order to stage this family shot of Hannah, Rhodri, Chris, Hari, Andy and baby Caia at their grandmother's eightieth birthday celebration.*
Sigma SD10, 15–30mm Sigma f/3.5–4.5 AF DG, f8 at 1/30sec, ISO 400

Lenses for group shots When photographing a structured group it is essential that you maintain a rapport with them, so you must not be too far away, nor too close. However, with a candid shot (see below), closeness can impinge on the subject(s) and ruin the photograph you want to take. A medium to wide zoom (say 24–80mm) is ideal for a formal or informal group shot because it can be adjusted to cater for the size of group. If there is enough room then use the longer end of the focal length range to avoid wide-angle distortion (particularly for people near the edge of the frame). Small spaces, though not ideal, often promote a closer group structure and suggest 'intimacy'. When working indoors you will usually have to adjust to the space available.

Composing group shots It is never easy to arrange groups. Some wedding photographers do it by force of personality and are totally in control. Often you have to keep taking pictures and hope that in one of them everyone is looking your way with

▼ *In the aftermath of a May Day picnic lunch, a group of friends talk while the photographer clicks away.*
Nikon D100, 24mm f/2.8 AF, f/11 at 1/125sec, ISO 200

their eyes open. In desperation, you can always clone a face into the final shot. If you are photographing family members or friends, keep the group structure and that will automatically convey the closeness of the bonds between the subjects. With family members of differing ages and statures then go for an arrangement with some people sitting and some standing. Having the youngest members sit on the floor at the front provides a way of tackling the geometric problem of coping with a disparity in heights. Traditionally in a group with ranks, the tallest is put in the centre at the back and the structure descends from there. Another solution, if there is a considerable disparity in heights, is to have the tallest people sitting down. Victorian portraitists often arranged the men to be seated and the women standing.

Often with a group there is banter between the members, and this helps to relax people, especially if you become part of it. Watch, wait, and take one photograph, and then a whole series when no one is waiting with a fixed unnatural grin for the shot.

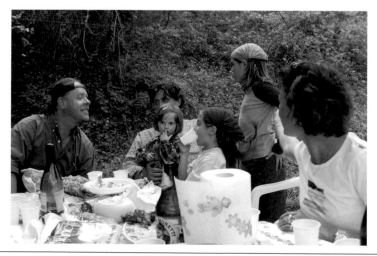

▲ *Not everything we do is of high artistic merit, but if you like something, that is all that matters. This is a personal shot of my children Hannah and Rhodri with their partners Kevin and Fran.*
Sigma SD10, 15–30mm Sigma f/3.5-4.5 AF DG, f8 at 1/30sec, ISO 400 bettermade

Lighting for group portraits If you want to use daylight indoors, then your group should be close to a window. Check carefully to see that no individuals are in shadow. Unless the group is small, even a large reflector will not throw enough light into the shadows on the side opposite the window. If you are shooting indoors with a portable flash used either as the fill-in or the main source, you can either bounce it from a white ceiling or use a large softbox diffuser to give greater coverage.

If the group is small and the members positioned close together, then you can treat the group as a single subject for lighting purposes. However, if you are photographing a couple, place one person slightly behind the other in order to avoid creating more shadows.

Candid shots If people are conscious of your presence you can be sure that at least one will turn your way as you take the photograph and spoil the intimacy – although this can also be used as a feature. I have a great love of markets and in old market halls there is often a balcony from which you can work unobserved with a moderate zoom-telephoto lens as people interact with one another. In such circumstances, you will have little control over lighting –

make sure that there are no great contrasts in lighting by using tight focus on the principal characters.

You should always be discreet and thoughtful when it comes to taking candid shots. A photographer who wanders around thrusting a camera into the faces of 'foreigners' deserves any antipathy they get: in some countries local taboos will bring you overt hostility if you try to take photographs. People must never be regarded as objects – human dignity is too precious, especially when some have so little to cling to.

Body language People have become much more conscious than they were about body language, thanks to the books and popular magazine articles – even at a subconscious level we read signs that tell us how people in a group relate. It comes down to what story you want to tell – real or imagined. You might have to encourage people to move closer than they normally would, to suggest a degree of intimacy. If the group members are wearing similar clothing (uniforms or suits, for example), this helps to convey the link between them, as do props, such as the instruments in a picture of a group of musicians.

◀ *I hate intruding; my place is the background, and I never push a camera in anyone's face. Here, street musicians entertained customers at a café in the Piazza Navona in Rome. My camera, placed on a table pointing in the right direction and set on autofocus, caught the scene as we sipped an evening Prosecco for artistic inspiration.*
Nikon D100, 24mm f/2.8 AF, f/5.6 at 1/30sec, ISO 400

Weddings I have great admiration for those who make their living from good wedding photography. The responsibility is immense and there are others there who are also taking pictures and could reduce your sales. The ability to shoot digitally and have a display on screen at the reception and print off there and then is a great boon with wedding photography.

If you have agreed to photograph a friend's wedding, then take it very seriously if you want that friendship to last. There will be

▲ *Sian Trenberth's informal approach extends to wedding photography, too. After a formal sitting, she continued clicking and captured this very happy group of ladies. You too can work in this way, capturing things unobtrusively in a way that formal arrangements miss.*

certain shots that you are expected to get: the bride at home in the latter stages of preparation; the bride getting into or out of the car; walking into the church; standing at the altar; exchanging the rings; signing the register and so on.

Practical considerations Not all churches are photographer-friendly, with large yew trees shading a porch, for example. A reasonably powerful flashgun (say GN30m or more) with a softbox diffuser can be either your fill or in some case the main light, and it can be used indoors and out. If the bride is wearing a traditional white dress and it's a sunny day, the contrasts are hard for colour film to handle – a dull day with fill-in flash is better for the photographer. A dull day will also mean that no one squints at the sun, and by keeping compositions tight you will be able to exclude any possible white or grey from background clouds.

Visit the church beforehand to assess the best areas for backgrounds, or talk to the vicar who will know where other photographers tend to pose groups.

Remember that you will be expected to set up various groups, from family to friends, and to take pictures at the wedding reception. Make a checklist of shots and discuss it with the bride and groom beforehand.

Most of us will attend weddings as guests and many professional photographers stand back after a group has been set up and let the guests have their turn. Do remember that this is their livelihood and their skill, so respect that and don't see yourself as undercutting the 'pro'. As a guest you have a marvellous opportunity for moving around taking informal shots; people will often form impromptu groups and you get another side to the occasion that will be gratefully received.

◄ *I took this picture as I walked along a road in Turkey on a festival day: I held the camera at my side and clicked but the group was intrigued by a stranger – later I became the subject of a Turkish camera to everyone's amusement and my own.*

Musicians Any lover of rock music, who also happens to take photographs, can be forgiven the twinge of envy when they see the officially credited photographers near the front of stage moving freely to get pictures. For the rest of us the deterrents are the 'No photography' notices and the minders barring access to the stage.

You can risk photographing in this situation, but do nothing to draw attention to yourself: use a digital camera set at a high ISO rating to cope with low light – never use flash. Digital cameras such as the Nikon Coolpix give fabulous results, are unobtrusive and from a distance do not look as if they are professional, which an SLR with a long lens does. However, restrictions on privacy and what images you can publish without permissions make it hard to use such images as you get for anything other than personal mementos.

It is often a good idea to seek out local bands. The venues will be smaller, and the atmosphere more intimate in a pub or club (do seek permission from the owners as well as the band), and you can get much nearer to your subject. The possibilities of

pictures are endless, from faces to equipment to group shots in the widest sense.

Lighting is tricky. If you get a spot light in frame it will affect your meter readings, and even under such light, faces and clothes still need lengthy exposures. The answer is a fast film (one balanced for tungsten light and uprated to around ISO800) or a digital camera where you can test your camera under the lights beforehand, setting ISO rating and white balance. When you have secured those digital files this is one area where you can seldom underplay manipulation – it goes with the territory.

▲ *The reason for my personal interest in this band? My son Rhod is the vocalist as a welcome release from being an academic philosopher at Oxford University.*

◄ *It is surprising what you can capture with point and shoot if you need to. The light source here was the on-camera flash with a Nikon F80 used to capture the performance of student band Kids Who Tell On Other Kids Are Dead Kids. Black and white somehow captured the raw essence of the performance better than colour did.*

Traditional still-life shots are often assemblages of objects, some natural and some not, arranged in a way that the photographer finds pleasing. Almost any object can constitute part of a still-life arrangement: shells, flowers, pottery, foodstuffs of all sorts. Sometimes it is the pattern that appeals when geometric shapes are emphasized. Sometimes it is the texture of the objects that provides interest, or an unexpected view of familiar objects.

▼ *Strong sidelighting was set up to create shadows and emphasize texture for this ammonite. The viewpoint is not quite dead centre. This view fits the shape better and emphasizes the start of the spiral moving in from the bottom third of the picture.*
Nikon F4, 60mm F/2.8 macro AF, f/11 at 1/30sec, Tungsten desk lamp, Fujichrome 64T film

Composition Some people seem to have a good 'eye' when it comes to making arrangements that have impact: even if a set of objects does not look particularly photogenic you can zoom in on groups of objects to emphasize such aspects as curves, textures or colour contrasts, to great effect. There are some guidelines for composition, but remember that the most effective pictures are often those that break rules. There are some classic guidelines, such as the rule of thirds. Imagine the frame divided into thirds by two horizontal and two vertical lines. They intersect at four points – a subject at one of these points has great impact. Another effective composition is to arrange your subjects along a diagonal. This can impart a sense of movement even into inanimate objects in a still-life composition.

Viewpoint Viewpoint concerns where you should place the camera between the two extremes of directly above the subject, direct centre or from below for a worm's eye-view. You never know before you try, and it is essential to move around with a camera, and to capture anything that looks appealing to you.

Capturing shadows Shadows are very important in still life to emphasize parts of shapes or to create moods: experiment is essential and for much still-life work at home, all you need is a few desk lamps – the main and fill lights, a rim light, and a backlight.

Textures The surfaces of materials such as canvas, wood and sand have textures that can be an important element in any still-life composition. If emphasizing texture is your intention, then consider using monochrome film so that colour and other aspects do not distract. In addition, use a strong side light to create the small shadows that provide 'relief'.

Colours Colours can make or break a still-life composition because they can dictate mood, from brash, happy bright colours to sombre browns and soft dreamy pastels. You can learn a lot by looking at paintings and seeing how artists use tones in subtle ways: if you ask yourself why you like a painting or why it suggests a particular mood, it often comes down to colour. The colour of the background is as important as the foreground.

Backgrounds Having a good selection of backgrounds and backdrops (see pages 34–35) is central to successful still-life work, and an otherwise promising composition can be ruined by the wrong choice. Over time, you will accumulate backgrounds of all colours and textures, not only in card or material but pieces of roughened wood, driftwood, cork and

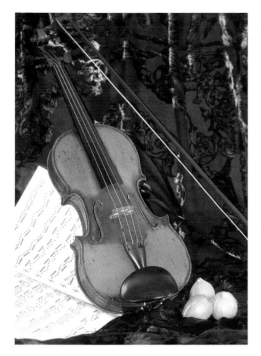

for a great deal of table-top photography, is
all you will ever need. You will also need to
recognize and control the highlights that
can add 'life' to a picture.

Hard shadows are never easy to control
and you will always need to experiment
with your composition. It is easier to work
with an incandescent lamp such as a spot
lamp that you can focus and then to use it
from some distance away as a point
source. Large undiffused hammerhead
flashguns will do the same. If you don't
have a Polaroid back or digital camera to
enable you to get a preview of the shot,
you will have to guess the result unless
your flash tube is part of your lamp. For
occasional use, a slide projector provides a
good bright source that can be focused.
You can add coloured gels if you need to.

For close-up lighting, a fibre-optic lamp is a
great boon because there is often little
room to work between camera and subject;
these lights, especially those you can
focus, can throw light exactly where you
want it.

Product shots With shots of products for
advertising purposes, the aim is often to
eliminate any strong shadows using a soft-
box above the subject and/or a Perspex
table. Focused spots can be used to create
shadows and highlights – although most
catalogue photography would not allow this
since a clear representation is demanded.

stone. Strong colours benefit from a plain
neutral or even a black background – a
complex subject gains from a simple
background as it is better to use nothing
to distract the viewer.

Lenses for still lifes Much still life is in
the close-up and macro realm. A lens of
90mm–105mm focal length in 35mm format
will suffice because it provides a pleasing
perspective. A wide-angle lens gives an
exaggerated perspective that is very effec-
tive for flowers, one of the most popular of
all still-life subjects.

Camera position Simply moving around
the table changing camera height and
angle makes a great deal of difference, as
does using a zoom that allows you to crop
and fit more or less into a frame. If your
subject has considerable depth, this is
where a tiltable back can be useful (see
pages 78–79).

Lighting The type of lighting you use will
make or break a still-life shot. Learning
through play is not only confined to chil-
dren – one of the best ways of learning
what lights do in terms of position, angle
and types of source comes from experi-
menting with a set of desk lamps which,

Creating still-life work on a shoestring

The diagram shows a simple approach
to still life. With a second lamp, shadows
can be controlled and a third can provide
an element of backlighting. The camera
on a tripod allows you freedom
of choice for position. The
background is a single curved
sheet of coloured card to eliminate
joins. Fabricate this in coloured
acrylic and light from behind and you
eliminate all those crossed shadows
that are anathema in product
photography. This set-up works
well for all small-scale work.

When shooting with any professional aim in mind, exposure consistency is essential, particularly in background tone. To ensure this 'professional'look, colour film is used because films from the same batch will produce identical results whereas 'amateur' films show slight changes. This is not essential outdoors, but any picture editor will expect it from you for product shots. Much of this kind of work is now done with roll-film formats fitted with a digital back – the high cost puts them out of the reach of most amateurs. The work is essentially repetitive with a standard lighting set-up: the consistency offered by digital backs, the ease with which you can tweak things, plus the speedy throughput in a busy studio, justifies the professional expense.

Photographing flowers Flowers, like human subjects, often have a 'best side' because of their three-dimensionality. It is

◀ *For some time, with old friend and fellow author Robert Mash, I have been working on a book* Sex and Plants *– a history of aphrodisiacs. Asparagus tips are supposed to be aphrodisiac, and it was decided that I should photograph things suggestively whenever possible. It is all in the eye of the beholder…*

▲ *When my partner first used a ravioli maker, the results looked great – the camera was on the table and, almost as a joke, I took this shot.*

worth spending time rotating or moving a bloom in a vase or clamp to see the effect. One useful trick is to employ backlighting to some degree, as petals are usually translucent and can be made to glow to reveal the vibrancy of their colours.

Getting the message across It is said that a picture is worth a thousand words, but a photograph used to make a point or a sequence of pictures for instructional purposes has to do so clearly to be of any value at all.

We all criticize the way instructions are seemingly written in gobbledegook. When I recently assembled a bandsaw (from a set of Italian instructions), six pages were devoted to 'health and safety' (don't put the moving blade in your mouth, for example) and a small paragraph to the box of bits….. However, in these litigious times, could we do any better? (by the way, don't drink the toners on page 105).

More than most people, I stick my neck out, because I love photography and try to explain it. I get pleasure from what I do and my enthusiasm does not dull because the variety is boundless.

However, when you know a subject well, there is a danger that you emphasize the wrong things and miss the points that others find difficult. I try to get someone without deep knowledge to check what I have written, but beware, because they become less use as they learn more. If you have to use too many words then your picture is not making a point. Keep things simple and uncluttered, and move in close to exclude the extraneous.

Food There is a myth about food photography that it can only be done by a team of

▶ *My father passed on his tools and his passion for woodworking to me. I had been working on some old doors, filling cracks with strips of seasoned chestnut. I cannot help but play at arranging things: pattern is an obsession and a diversion from manual labour.*

▼ *Order and pattern are always appealing in a photograph – after taking several 'full frontal' shots of jars zooming in and out to frame different numbers and arrangements I moved to the side to create diagonals and another shape in the pattern.*

appetizing nature of food. Set it on a marble slabs, a wooden board or an old-fashioned heavy table (with or without a cloth). Always be careful with plates; they must be clean (no food drips or smears – unless you want to show a finished meal), and unless you have a good eye, use plain colours and not patterns. White is always a good standby and does not detract from the food that is displayed on it. A little decoration can be used to enhance the picture: to this end cut segments of tomato, peppers, scattered herbs, and so on.

In Italy where I now live and work, food is a joy that is central to all socializing and the topic of much conversation. The quality of the ingredients speak for itself, and should do so in your food pictures. On warm days market-stall holders liberally sprinkle their wares with water to keep it looking fresh. You can do the same with food in the studio. Traditionally, a mix of 50:50 water and glycerol has been used to film 'wet' food since it creates the effect of droplets of 'dew' and does not evaporate as quickly under hot tungsten lighting as water does. For flash and most studio (and outdoor) work, water alone works fine.

stylists and food technicians working with a director and knowledge of secret tricks. This is not true, however. By using fresh fruit and vegetables, and cheeses with items such as wicker baskets and professional chef's knives, you can emphasize the

▲ *Mediterranean markets are a magnet for me and the stalls piled high with colourful aubergines and peppers are too much to resist – stallholders will often use a mist spray to keep that produce looking fresh. Most displays will be in shade to avoid the direct sun – here the on-camera flash in a Nikon D100 was used to boost the light.*

Making copies

Making detailed and accurate copies with a camera is a worthwhile skill to master, as only the best and most expensive scanners can rival a transparency made on roll film. A copy stand is extremely useful and you can get everything you need in a home-built one.

▶ *By varying the angle a lamp makes with a coin surface, from along the axis to oblique then glancing, you see different effects. Here, a coin was photographed with the light from a single desk lamp set at about 60 degrees to the vertical.*
Nikon F4, Nikon 60mm f/2.8 AF, f/11 at 1/60sec, Fujichrome Velvia, single SB23 flash

Copy stands A baseboard and column from an old photographic enlarger are ideal for making your own copy stand. Good photographic enlargers appear for sale in secondhand stores, car boot or yard sales and on the internet. You may find a really sturdy enlarger stand – especially one with a faulty head – at a bargain price. Dispense with the head and you have an ideal copy stand; it needs just a right-angled bracket or quick mount from a tripod.

Check with a tri-square that the column is set at right angles to the baseboard. If it is not, use thin metal shims between baseboard and column before tightening and trying again. Now you can fix the camera

with its back parallel to the baseboard for geometrically perfect copies with no 'keyholing' as edges converge or diverge.

The size you can cover will be determined by the lens on the camera. Macro lenses are ideal because of their close correction, but don't neglect moderate wide-angle lenses, particularly in larger formats, when you need to cover bigger documents or prints and the column in the macro would not be long enough.

Working with glass When copying old photographs or prints in frames you often do not have the choice of removing the glass because it is sealed in the mount. However, if it is old and dirty, it is better to remove it if possible. A sheet of clean glass will also keep a print or book page flat when copying, though be careful to support the spine of an old book so that it does not crack under the weight of the glass. One of the best ways to do this is using a lab-jack – a support easily adjustable for height via a screw mechanism.

Reflections from a glass surface or bare varnished surface can be reduced if your lights are arranged at the side so that illumination is about 45 degrees or more to the vertical. By working with a polarizing filter you can reduce surface reflections further. If you use cellophane or some other plastic films the stresses will show up under polarized light: the effect is pretty but disconcerting.

▶ *A stand is a useful addition to the studio. They can be bought as a readymade unit, or you can use a sturdy old enlarger stand, as I did with the addition of a quick mount to a Durst enlarger.*

A polarizer is also essential when photographing paintings on walls in order to cut out as much surface reflection as possible from the other light sources around. Most art galleries will only allow accredited photographers to take pictures, but if you photograph paintings in your own home or for friends the copy-stand principles apply. If you can, arrange lights at 45 degrees to the side and make sure that the camera lens is on the same level as the picture centre, and that the camera is not tilted in any way. A spirit level will ensure that the camera back is vertical so that there is no keyholing effect.

Copying transparencies It is not that slide-copying adaptors do not work – they do – but unless you use copying film then all slide films produce increased contrast. If you can, then make copies in your camera at the time of taking. This is easy enough with still subjects, but is impossible with moving ones.

Commercially made copies on to 6x9cm film are the best for precious pictures. They are particularly good if they are made with a process that uses an oil to fill scratches; you can even use them like 6x9cm originals when you have used Fujichrome Velvia.

The Bowens Illumitran The Bowens Illumitran is an 'old faithful' unit with camera stand and lighting unit that allows you to give a pre-exposure to white light –

about 6 or 7 stops underexposure that produces a less contrasty result when the copy is made. These units are available secondhand at a fraction of the original cost and are very worthwhile if you have a lot of copying to do. Using a six megapixel digital SLR with a bellows, I have made very convincing copies of film transparencies – as good as most scans, in fact. The camera can be set so as to give slightly lower through its shooting menu (or in Photoshop) and to use any light source (through the white-balance control).

◀ I am an admirer of the beautifully detailed prints of Victorian traveller David Roberts, but I could not afford my own. However, a friend who owned a set let me copy them. This was done using a copy stand and Fujichrome 64T tungsten-balanced film with the camera back carefully set parallel to the print. A3 prints from the resultant scans were made on Lyson 310gsm art paper and look superb.
Mamiya 645 pro TL, 80mm F/4.0 macro lens, f/11 at 1/125sec, Fujichrome Velvia

Copying from books

There is a problem with getting books to lie flat, and you do not want to force them and damage the spine. Scissors jacks (the sort used for supporting laboratory equipment) can be set at different heights, and a glass sheet, carefully cleaned and dust-free, placed to keep the pages flat. Two desk lamps set at 45 degrees to either side produce shadow-free uniform illumination.

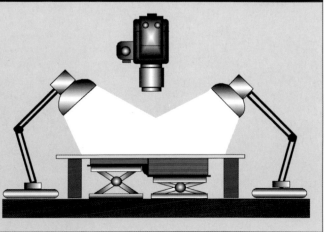

Light tables

Good light tables are surprisingly expensive to buy, but they are relatively easy to make, which is a much less costly option. If you make your own then you can have a much larger one than you might otherwise be able to afford. You can even set it into a desktop that is capable of holding several hundred slides – this is useful when sorting illustrations for books or magazine articles, for example.

The light source Fluorescent tubes with standard fittings are used as the light source for light tables: incandescent lamps run much too hot, and they will quickly damage any transparencies that are laid on the light table.

You need 'daylight' tubes or, better still, those made especially for light tables so as to assess colour balance and accuracy in slides. For slide sorting, however, ordinary daylight tubes will do. These also work well for photography, especially if you have a digital camera and make a custom white-balance assessment.

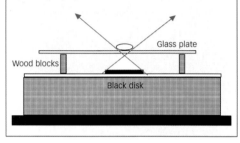
Making a lightbox Proprietary melamine-faced boards in a 15cm (6in) width make ideal sides for the box. If you have a router and can groove to fit a base then this helps rigidity. The tubes are mounted inside and an opalescent Perspex (acrylic) top fitted. Try talking to a supplier and tell them what you want – they might have some Perspex offcuts that will fit the bill. Fit a mains on/off switch into the box side and wire the tubes in parallel to this.

Backlighting A light table is ideal for creating backlit shots of translucent subjects such as leaves and gemstones. The objects are simply set on the table itself, or, with jewellery and glass objects, supported just above it on a sheet of carefully cleaned glass (backlighting shows up blemishes and smudges like nothing else).

Dark-field illumination Your light table can also be used to create a less well known but rather beautiful form of lighting called dark-field or dark-ground illumination. This works well with macro shots and also with a microscope. The principle is quite simple: light spills around the edge of a black disk and translucent subjects appear backlit against a dark background. When used in microscopy (see pages 64–65), the light is further concentrated by

Lightbox

A lightbox is a box with daylight-balanced fluorescent tubes and a diffusing acrylic cover on which you place transparencies to view or transparent and translucent objects to photograph. Get someone competent to wire in the tubes plus their starters and a switch. Don't use filament lamps: their heat will damage negatives and trannies.

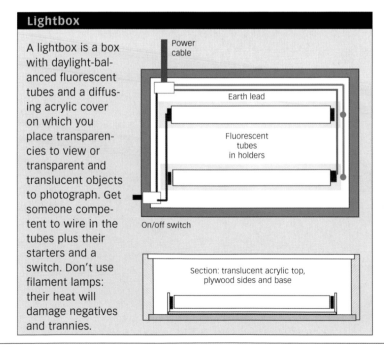

Power cable

Earth lead

Fluorescent tubes in holders

On/off switch

Section: translucent acrylic top, plywood sides and base

▲ *It can be difficult with stained-glass door panels to exclude outside detail (here, it is just visible). Your camera meter might tend to underexpose in such cases, and slight overexposure is needed to give the required luminescence.*

Shadowless lighting Much small-product photography utilizes shadowless lighting or transillumination. If you light from above with a softbox there will still be some shadows showing that there is a background. The answer is to illuminate the background and use the same principle as the infinity cove (see pages 27 and 34–35) to create a seamless background. Light tables for this kind of work are available in a shallow S-shape: there is a lip at the front; a flat area for the subject; and a gentle curve to provide the background.

Commercial tables are expensive, but you can make your own from a Perspex (acrylic) sheet. Some fabricators can heat-bend this for you or, provided the sheet is thin enough, you can glue it to a former, avoiding curves that are too sharp. If the table is to carry any weight then thicker Perspex must be used and bent by the supplier. Acrylic sheet scratches all too easily and these scratches show in photographs. To protect the Perspex and to provide you with a matt, blemish-free background, use fresh drafting sheet (an upmarket form of tracing paper), available in rolls from office suppliers and art shops. You can project on to it from the rear. You can obtain coloured backgrounds using gels fitted into transparency holders and placed in the carrier of a 35mm slide projector. You can even project skies, pebbles, or anything else that you have created to get a textured effect without the shadows that frontlighting creates.

a condenser that has a central stop to create the dark background.

You can use small, low-powered desk lamps for assessing lighting and then use flashguns in the same position when dealing with living subjects where brighter incandescent lights would generate too much heat.

Transillumination

For product shots where you need to eliminate shadows on the background, it is best to photograph against an illuminated translucent background. The diagram shows a set-up that can be made with a table of thin Perspex curved to provide a shallow S-shape. You can light from the rear with coloured gels or even a slide projector, with or without a slide.

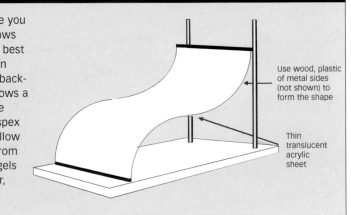

Use wood, plastic of metal sides (not shown) to form the shape

Thin translucent acrylic sheet

Sets and aquaria

The main obstacles to overcome for successful aquarium or vivarium photography are the distracting surface reflections in the glass of you, the camera, and the lights you are using. Some naturalists build a set with a moveable front glass panel to eliminate the reflection problem, but this has its downside – whatever you are photographing might try to escape. There are several methods for trying to reduce reflections, as set out below.

▲ *Small, colourful frogs make great subjects for photography, but the unpredictable movements of agile creatures such as this red-eyed treefrog are best restricted by a tank that forms the vivarium.*

Black velvet drape or card Use a black velvet drape or a card covered in matt black velour with a hole cut in it to allow the lens to poke through. This is set up as in the diagram in front of the tank.

Custom-built lens hood When it would be inconvenient to use a drape, such as in a large public aquarium, then a large lens hood that is pressed against the glass works extremely well and cuts out reflections completely.

If you are of a practical disposition, you can custom-build a lens hood. I made one from the rain collector from a drainpipe top. I sprayed it inside and out with a primer so the paint would 'take' on the polystyrene surface and then sprayed it with matt black paint (Humbrol is the most matt that I have found). You could even coat the inside with flock paper if you wanted.

In use, the lens hood is pressed up against the glass surface and the flashguns held outside the hood and to its side. A zoom lens with a good close focus is ideal because you will have to follow and frame creatures intent on coming to see you and then moving to the back of the tank.

Polarizer Surface reflections from glass can be reduced by using a polarizer. This works best with tungsten lamps or daylight,

Microaquaria

For microaquaria, glass slides for microscopists are perfect. Separate them with Perspex sheets in which a well has been cut, or use a bent length of clear plastic tubing of the sort stocked by an aquarium shop and hold the glass slides or plates with rubber bands.

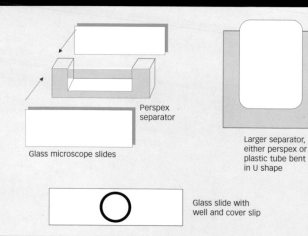

Perspex separator

Glass microscope slides

Larger separator, either perspex or plastic tube bent in U shape

Glass slide with well and cover slip

Tank lighting

For aquaria, tungsten desk lamps are ideal. You will not use them for long enough to warm the water too much, so the heat risk they pose is not what it is for insects. Continuous lighting helps you focus and see what is happening.

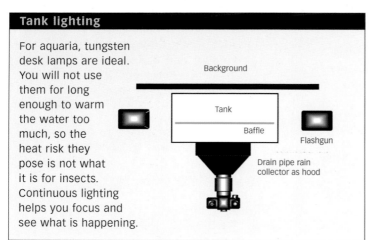

Background

Tank

Baffle

Flashgun

Drain pipe rain collector as hood

photography. Any aquarists' suppliers will have aquarium cements that bond glass/Perspex surfaces and create a waterproof seal. You will need to cut glass strips accurately for sides and the base, and glass sheet for the front and back. You can do these yourself with a diamond glass-cutter if you are competent, but if in doubt get a professional glazier to do it.

Normal picture glass has good, but not perfect, clarity, so you might like to make the front window from special optical glass. These panes are obtainable in small sizes from optical suppliers, but are not cheap.

For a small aquarium, thin picture-frame glass works perfectly well – a couple of the borderless frames will provide cheap glass panels. If you don't want to cut glass sides then use other materials such as Perspex strip, or buy aluminium sections (either flat or channel) from a DIY store.

Care Tropical lizards and reptiles positively relish tungsten lights and will bask in their heat – doing little until food is given. And a word of warning – with venomous creatures, always use an assistant who knows what they are doing at feeding time: a snake that appears to be torpid can act at amazing speed and you do *not* want to be in its way.

Limiting movement In a large tank, you can gently limit the movement of fish by inserting a glass plate as a baffle to bring the back wall forwards without squashing the occupants or causing them distress.

since you can see the effect; with flash you just have to guess – unless you have a digital body and can check the shots in the viewfinder.

Designing aquaria for photography
Anyone who is reasonably practical can produce their own aquaria in which fish and other small creatures can be placed for

▶ *In this backlit image of the tiny marine colonial animal Gorgonia, the light spills right around the edges of the disk, creating a beautiful quality of illumination.* **Sigma SD10 coupled to Canon 20mm f/3.5 macro set on an optical bench. Lighting from a pair of flashguns used manually. Exposure by trial and error flashes at 1/4 power lens at f/5.6 effective aperture with extension around f/128.**

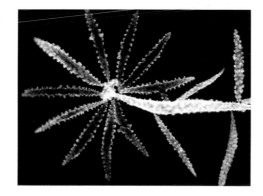

Dark-field lighting effects in the aquarium

With a small purpose-built aquarium, it is easy to set up a form of dark-field illumination using a circle of card as shown to provide a black background. You could try blue-coloured gels, as they work well lit from behind with translucent animals such as medusa jellyfish and hydra.

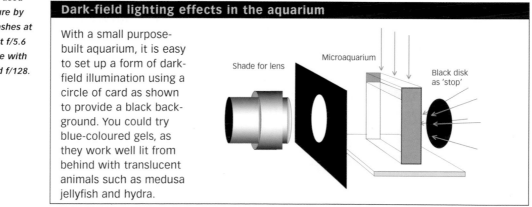

Shade for lens

Microaquarium

Black disk as 'stop'

Reflective objects

Reflections are the visual elements that give both shiny and transparent objects their sparkle. When taking pictures of metallic or glass objects, the skill is to capture just those reflections you need and not unwanted ones of you and your camera. There is no single way to photograph shiny metals, gems or glass; each time you can start with a few basic techniques and set-ups, but will then have to experiment. The first step is to use a diffuse light source.

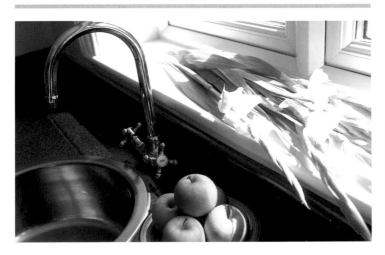

Lighting tents Shiny metallic objects can be surrounded with light from a lighting 'tent' (see pages 70–71). This need be little more than a cone made of tracing paper that is lit at several points from the outside and has a side hole though which a camera lens can be poked. At a macro level, an eggshell can be used in the same way.

Ordinary desk lamps can be heavily diffused with sheets of drafting acetate in cardboard frames, or translucent Perspex.

Glass Glass is a challenge to photograph well. The aim is not just to show the object itself, but also to reveal its transparency. You will often find when arranging lights that the slightest movement of lamps to correct one set of surface reflections will create others.

▲ *A window can provide a diffuse light for large-scale shiny objects. Here, the stainless steel was not polished enough to image the window.*
Nikon D100, 24mm f/2.8 AF macro, f/11 at 1/30sec, ISO 200

Glass is also notorious for showing up any scratches or blemishes such as chips and greasy finger marks, all of which you may well overlook. Clean glass well before you start; household detergents often leave smears (whatever manufacturers claim), but lens cleaners work better. Wipe them with a linen cloth (it does not leave deposits) and then handle the object with white cotton gloves.

Glass looks good lit from below and you run less risk of surface reflections than with side- or tent lighting. The kind of transilluminated background described on pages 52–53 can be used for small glass objects. Sometimes it is useful to set them on a sheet of clean glass or Perspex held above the table on small blocks.

If you use a diffuse light, from a large softbox for example, it is very hard to remove

Lighting for transparent objects

Here, a large overhead softbox light provides the main light. From beneath a sheet of Perspex, a second light can be used to emphasize the transparency. Such set-ups provide a good basis, but great care is needed to remove unwanted reflections and create the ones you want with a finely focused spot.

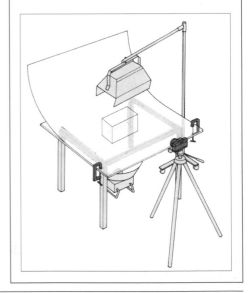

◄ *For detail on this silver belt and buckle, a tent surround was created from translucent drafting film and a series of desk lamps arranged outside until the result looked as it was wanted. Before taking the picture, the belt was polished with a soft cloth to remove any finger marks and the grime.*
Mamiya 645 pro TL, 80mm f/4.0 macro lens, f/11 at 1/30sec, Fujichrome 64T, three desk lamps

square highlights: you can create small highlights by using a focused spot lamp.

Metals With coins, bracelets and rings, a good polish with a soft cloth is essential to remove grime and finger marks. Silver, brass and copper objects tarnish, so you might have to clean these with a suitable impregnated wadding and use an old toothbrush for ingrained dirt. Dulling sprays are available that can be used with silverware, but you can tell they have been used when you move in close, and you have to clean the item afterwards.

The side-lighting used to create 'relief' on a coin, medal or decorated box will also show up every scratch. You can either regard these as part of the character of the picture or drive yourself mad trying to remove them later in Photoshop. Again, broad (diffused) sources work best with metal objects. There will still be highlights, but simple shapes such as squares and rectangles make less disconcerting highlights than more complicated shapes. Simple tent lighting with a diffusing paper cone will often provide a good result with metal objects.

Gemstones and jewellery In any jewellers' window you will notice small tungsten halogen spot lamps used to light displays. These create sharp reflections as the facets pick up the light and sparkle.

Sparkle is essentially dynamic – you can hint at it in a photograph, but not recreate it. The brightness of gems is a mixture of refraction (to bend light rays) and internal reflections, emphasized by the way facets are cut and the high refractive index of gem materials.

In contrast to the spotlights used for display, a large broad source is often used when photographing gems and jewellery. Most jewellery shots lie in the close-up and macro realm and you will thus show details, not only of the object but of the background on which the piece rests. Simple textures such as stone, driftwood or plain cloth work well. If using velvet for a 'traditional' look, then carefully brush the fabric with an antistatic brush to remove any bits or loose fibres that will show up under the lights.

When you are photographing crystals and uncut gems, a balanced mixture of frontal lighting and transillumination from a lighting table (see page 53) can help to emphasize the transparent quality of the subject and also establish the regular form of the crystals that is always part of their attraction.

Close-up and macro

Common usage means that often everything involving photography at close quarters gets called 'macro'. True macro, however, begins at lifesize reproduction and covers up to about 25x magnification, after which microscopy takes over. In practice, the term 'macro' seems to be used with anything from about half lifesize.

▲ *In close-up work outdoors, there always seems to be a breeze blowing. Focus is most easily achieved by switching off autofocus and moving camera and lens bodily. Here, an aperture of f/8 was used to create a soft background with a telephoto macro lens.*
Sigma SD10, 180mm f/3.5 AF macro, f/8 at 1/250sec, ISO 200

Close focus Many lenses offer a close-focus facility (some manufacturers call this macro – noticeably when it comes to selling zoom lenses), and those that do not can be made to give larger images on film or sensor and in the viewfinder in one of two ways:

■ By introducing some extension between lens and camera through the use of extension tubes or bellows. The disadvantage is that at lifesize you have essentially lost 2 stops worth of light:

Magnification (M) = extension (d) ÷ focal length (f)

■ By using supplementary lenses. This means that the image stays bright and all lens functions are retained. You have to pay for quality, though, and use two-element lenses.

Selecting a macro lens Many people buy a macro lens simply because it is superbly corrected for other work, too – though this level of correction is reflected in the price. Manufacturers' own lenses are often a premium price, although those from Sigma are cheaper and at least as good. Secondhand, the Tamron SP90 is a superb lens.

There are three main ranges of macro lens:

■ 50–60mm. This is great for static subjects, but the front element is deeply recessed and you are very close to the subject.

■ 90–105mm. This gives that bit more distance between you and the subject. It is great for photographing insects, and makes the most useful general macro lens.

Maximizing depth of field

In close-up photography, depth of field is shallow, so it is necessary to maximize depth of field by trying to get a subject in a plane (A) parallel to the camera back (B). When you are photographing the open wings of a butterfly, this is the way to produce sharpness from wing-tip to wing-tip, but you have to manage to orient the camera back by changing position without scaring the insect.

- 180–200mm. This is extremely useful with wary subjects and is a joy to use, but unless your interest lies specifically in close-up work with insects and mammals you can live without it.

Focus with macro lenses Autofocus is almost a nuisance with a macro lens, since the slightest movement of camera or subject makes it 'hunt'. It is easier to switch it off and focus manually. The longer focal-length macro lenses have internal focusing, which means there is no physical increase in length when you focus; just turning the focus ring makes for very precise focusing. If, however, the length of the lens changes and you have to move relative to the subject each time you alter focus, use the focus ring just to get a larger or smaller image and focus by gently moving the whole camera plus lens as you rock forward. When the subject is in focus, squeeze the shutter gently, rock back, and move in again for a second go.

Depth-of-field issues In close-up work, you inevitably come up against depth-of-field restrictions unless you deliberately employ shallow focusing for artistic effect. In the 'macro' realm, depth of field depends only on magnification: whatever the focal length of the lens at a given aperture and magnification, the depth of field is fixed.

Careful camera position can make best use of depth of field. The secret is to think about what needs to be in focus, and ensure that as much of this (for example, butterfly wings) as possible is in a flat plane parallel to the camera back.

Field hints
- When using natural light, a focus slide is a useful accessory (see page xx), but when using flash, a tripod or anything else is unnecessary if you use the focusing method given above.

◀ *Pets provide endless opportunities for photography, and there are few animals more appealing than kittens.*
Nikon D100, 105mm f/2.8 Sigma AF macro, f/11 at 1/125sec, ISO 200, with on-camera flash

▼ *An eye, or any animal part that looks like an eye, must be in sharp focus since that is the immediate point of contact for us.*
Sigma SD10, 105mm Sigma f/2.8 AF macro, f/16 at 1/60sec, single Nikon SB23 flash used manually

- When photographing butterflies on film, I use an ISO100 film (Fujichrome Provia). At 1:1 and an aperture of f/16, there is enough light on a bright day for you to use a shutter speed of 1/125sec and a flash to capture the subject sharply and yet have enough light in the background to create a natural picture.

Digital macro

A digital SLR is an ideal tool for close-up and macro work. The advent of the digital SLR has put a level of immediacy and control into the hands of the camera user that revolutionizes close-up and macro photography.

▶ My TTL flash units would only function manually on a digital SLR – not the problem it seems if you use the camera LCD to gauge exposure. The first few guesses were wildly out, but now, using a Nikon SB29s on manual at quarter power, I usually get perfect exposures after one test shot at most.
Sigma SD10, 105mm Sigma f/2.8 AF macro, f/16 at 1/60sec, ISO100, Sigma flash adaptor and Nikon SB29Bs macroflash

Problems with close-up work

Traditionally, both close-up and macro work have been regarded as tricky because success demands overcoming restrictions on depth of field, controlling camera vibration, and careful lighting. A film SLR goes a long way towards making the task easier, particularly those that use TTL metering, and especially TTL flash. The perennial problem with close-up work is that depth of field decreases as the degree of magnification is increased: you stop down in order to improve matters and this means using slow shutter speeds with natural light, whereas much macro work is done with flash or tungsten lamps to provide enough light at small apertures.

With film, there is always that element of experiment and never quite knowing if something has worked until the film comes back. A digital body takes that element away and allows you to make changes quickly and easily until the result is exactly what you want.

The visual exposure meter With most digital SLRs, all metering switches off if you use the manual mode or anything other than a lens that couples electrically to the body. If you rely on a TTL flash meter for exposure then this seems like a near disaster. In practice, it does not matter, and the beauty of the try-it-and-see principle

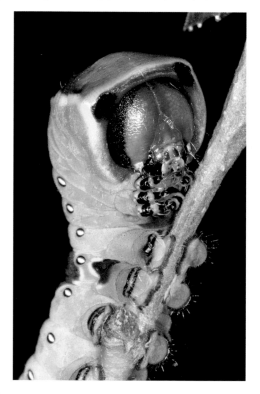

Digital sensor coverage

The diagram shows a clear portion representing the digital camera sensor compared with what you would capture with an SLR film body (the masked region) on the same lens at that magnification setting. In effect, the digital image receives a magnification boost that is extremely useful for close-up work.

explained below is that you can adjust lighting ratios to be exactly as you want and also see how your subject appears against the background.

First, make some test exposures using a small flashgun close to the subject to act as a broad source. Use a small aperture and see what happens on the LCD screen. If the result is too light or too dark, change the flash position, moving it nearer or further away as necessary.

In the field you will tend to use just a few standard magnification ratios, so with the flashes fixed (one main and one fill), you can alter aperture to suit. You can get

▶ *This is not digital image manipulation – it is a raindrop used as a lens to image a gerbera flower a few centimetres behind it. The drop and the image are not quite in the same place, so depth of field has to be controlled by setting a small aperture to get both in focus. There is a real challenge in doing this optically and it looks better. Where a digital camera is useful is that feedback is immediate, as it takes a lot of experimenting to get it right.*
Nikon D100, Olympus 80mm F/4 macro bellows lens, f/8 any

money – you can obtain exceptional results with two small manual units. If you try this with tungsten desk lamps as the light source, you simply adjust position and camera settings until the result is perfect.

Magnification factor Another aspect of digital cameras that works in your favour for macro work is the magnification factor, which is typically 1.5x or thereabouts if your camera is not full-frame. In fact, it is better if it is not full-frame, because a 1:1 macro lens will give you a 1.5:1 reproduction ratio.

That boost is very useful, especially as you retain the depth of field associated with the lower magnification. This is because the image is captured on the sensor and magnified electronically so it does not change any depth aspect of an image (a little like blowing something up with an enlarger). Similarly, when photographing at lifesize with a camera body that has a 1.5x factor, you need shoot at two to three times lifesize to produce this end image, and with the greater depth of field that is associated with the lower magnification.

everything right with a quick experimental shot before you move in on an insect or other subject. With practice, even when using high magnifications, you get the right combination of flash position and aperture in, at most, two attempts.

If you have a commercial macroflash unit, the chances are that it will not work with your digital camera anyway and you will end up using the method above. If considering the purchase, do not waste your

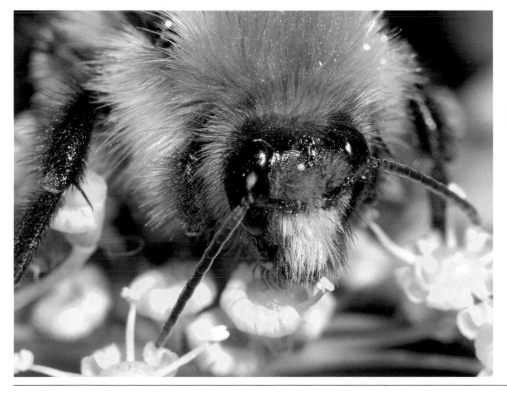

◀ *This shows how useful the magnification boost is. Normally restricted to lifesize with a Sigma f/2.8 105mm macro, the same lens setting gave x1.7 on a Sigma SD10 with superb sharpness.*
Sigma SD10 plus single SB23 flash, manual setting

In the field, it is never practicable to work with magnifications of more than 4x because the depth of field is tiny and the slightest camera (or subject) movement makes sharp focus difficult to set. There are various ways to overcome this problem.

Coupled lens technique The easiest way is to use the coupled lens technique, where a lens used wide open is reversed on to the front of another lens and acts like a very high quality supplementary lens. A simple formula gives you the magnification. You could also reverse a wide-angled lens directly on to a camera. You get the magnification, but the lens will be far too close to the subject and you lose all automatic lens functions: with coupled lenses, all functions of the lens connected to the camera body are retained.

Using bellows If true macro work is your goal, then a bellows is essential. It is possible to find specially designed and corrected lenses that each serve a magnification range where they are optimally corrected – the legendary Zeiss Luminars and Leitz Photars belong in this category. They are the very best of their kind, although comparable results can also be obtained with

◄ *This photo of the wing scales of a peacock butterfly was the first taken after securing an old Zeiss Tessovar coupling to a Sigma SD10 body and using just one SB23 flashgun. The results showed incredible definition and depth of field.*

Ways of getting higher magnification

Method	What is entailed	Range	Comment
Bellows and extension tube	The lens is separated from the camera, light rays spread and an enlarged image is produced on a film or sensor	From 1x to 20x depending on lenses used	Bellows come into their own in a studio where a different make of lens can be fitted to a camera body. Light is lost but a TTL camera will compensate for the exposure change needed. Higher magnifications restrict depth of field
Teleconverter/ multiplier	Used between lens and camera body	Gives a boost of 0.4x or 2x depending on the multiplier	Light is lost (1 stop with 1.4x and 2 stops with 2x), but in the macro realm you use small apertures; for rays close to its axis a multiplier is well corrected and gives excellent results
Coupled or stacked lenses	A lens is reversed using an adaptor on the front of another lens where it acts as a highly corrected auxiliary lens	Good up to about 4x before vignetting occurs	An excellent method for occasional field use since the front lens is used wide open and all lens connections are retained with the prime lens. No light is lost due to extension and a simple rule gives magnification: M = focal length of prime lens (attached to camera) ÷ focal length of coupled lens. So, with a 200mm prime lens and a 50mm reversed lens: $M = 200/50 = 4$
Reversed lenses	Using an adaptor that fits a filter thread, a lens can be reversed on to a bellows or extension tube for better correction of aberrations	Up to about 6x, after which there is a danger of vignetting with wide-angle lenses	Many lenses are designed to give optimum correction with a large object in front and a small image: in close-up this is reversed and lenses often perform better when turned round. Unfortunately, such things as electrical coupling and auto diaphragm are lost, but an adaptor called a Z-ring allows auto diaphragm with a double cable release

◀ Bellows are for studio use and mine form part of an optical bench. An urgent request for a picture led me to find the only damselfly around on a cold day, then take a digital picture with an 80mm f/4 Olympus bellows macro, and have it on screen and ready to send within 30 minutes.

▼ To photograph this horse fly focus was critical; I used a Canon 20mm bellows macro lens on an optical bench. Without digital to provide feedback, this kind of shot would have been hit-and-miss.

microscope lenses, cine lenses designed for 16mm film that have been reversed, and with the excellent macro lenses that Olympus made for its OM series cameras. These work especially well with a digital body where judicious use of Unsharp Mask at the file-manipulation stage can make the results indistinguishable from those taken with Zeiss Luminars.

One problem with macro photography is that at small apertures the effects of diffraction become more apparent as a softening of the image. With lenses on bellows you have to be careful not to use the smallest marked apertures.

Adaptors Macro photography is not something you can rush, but when you have a set-up that is easy and convenient to use, you can amass some useful optics by carefully searching the secondhand ads. Often the lenses you find will not be of the same make as your camera body, and adaptors do not seem to be available. There are two courses of action: buying an adaptor from SRB (see page 135) or trying to make your own (see pages 131–45).

The Tessovar Very occasionally, the Tessovar, a lens designed and built by Zeiss, appears for sale, but they are expensive. It is a zoom macro lens where four different magnification ranges (and working distances) are provided by auxiliary lenses on a turret. The ingenious design also couples zoom and diaphragm, so that as magnification increases the diaphragm opens to give a balance between depth of field and diffraction softening.

Basic photomicrography

Taking photographs through a microscope has never been easier. With the advent of the digital camera, many scientists working in biology and medicine routinely use cameras such as the Nikon Coolpix, whereas in the past they might have used purpose-built units from the microscope manufacturer. Not only is the definition good, but a relatively simple adaptor lens allows a non-SLR camera to be used.

One- and two-stage magnification The optical bench and the macroscope (see pages 66–67) use a lens to project a magnified image on to a film or sensor. This involves a single stage with the lens near the subject. Higher magnifications are possible using a microscope eyepiece as the second stage, thereby creating a two-stage process. When you look down a microscope you 'see' the image as being 'inside' the instrument – what is known as a virtual image. To get an image on film or sensor, the eyepiece has to be moved out slightly so that it projects the light rays to form a 'real' image. Exactly the same process is used with a telescope eyepiece.

Microscope adaptors SLR cameras can be fitted to most microscopes with a simple adaptor such as those available

▶ The author revealed. The Zeiss Tessovar is in the background with its fibre-optic light. The device in the foreground is a modified microscope – my 'macroscope' – that allows imaging with one stage.

▼ Here, backlighting is used to capture tumbling colonies of Volvox on a low-power microscope with a projection eyepiece to get about x50 on film.

from SRB (see page 135). This adaptor clamps the camera over the eyepiece and focusing is then through the SLR system. If you have a removable viewfinder screen, then make sure you use the finest ground glass available in order to make focusing that much easier.

Some microscopes come with a trinocular system and can be used for photography without affecting the eyepieces: a simple lever diverts light from the main optical path to the camera path.

Relay lenses are available for several models of non-SLR camera, notably the Nikon Coolpix; these fit over the microscope eyepiece close to the camera lens.

Lighting For high magnification work, intense light sources are necessary. Flash can be used, but you need to see what you are doing and this is where the cool light of a fibre-optic lamp is ideal. It takes small pools of intense light right where you want them, using internal reflections in a tube made from bundles of parallel glass fibres. New fibre-optic units are expensive, but I have found several secondhand for a reasonable price and then bought new goose-

Problem-free photomicrography

Digital photography has revolutionized basic photomicrography. The Nikon Coolpix and ancillary lens (see Techniques and suppliers) allows you to project an image from the camera eyepiece via the camera lens on to the sensor. Exposure is via the camera's internal system. This works so well that many medical labs use it for routine work. The eyepiece projection also allows the camera to be coupled to a telescope, with extraordinary results.

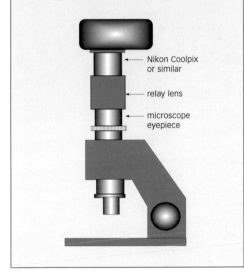

Nikon Coolpix or similar

relay lens

microscope eyepiece

Kohler Illumination Books on microscopy deal with setting up a microscope for a form of illumination where a lamp filament is focused on the subject via the substage condenser and provides a very bright image suitable for photography. If this is an area that interests you, then a great deal of extremely useful information is given in *Micscape* magazine; furthermore the online journal www.microscopy-uk.org.uk has an extensive back catalogue of articles and photographs.

Sharpness and vibration If you can use a flash source then there is little worry about vibration; the problem comes with incandescent lights where, because of the very small aperture of microscope lenses, exposures are relatively long. It is essential to use a cable release so as not to touch the camera in any way and create vibration – a mirror lock-up is ideal for just the same reason. Microscopes are engineered with rigid, heavy stands, and some older models are better than new ones in this respect.

▼ *The incrustation you see on some seaweeds reveals itself under a low-power microscope as a pattern with precise regularity. Pattern in nature and in mathematics has always been at the root of all my interests, and at this level there is much to astonish the beholder.*
Nikon Coolpix 5300 with ancillary lens

neck fibre optics. The problem is that with misuse the glass fibres crack – look at the end of a bundle with the other held up to the sky and you will see black dots where there is no transmission (don't be tempted to switch on the unit to do this – it can cause eye damage).

The light units themselves are simple, consisting of a transformer and a halogen lamp. These lamps have a pre-focus top, so there are no lenses inside to focus the light on the end of the fibre bundle. If you have any ideas of making a unit that combines incandescent light for focusing and flash for exposure (as some commercial units do) then you have to focus the flash discharge on the end of the bundle: it is easier to put a lamp in the flash position since the discharge of the flash is too brief to check focus.

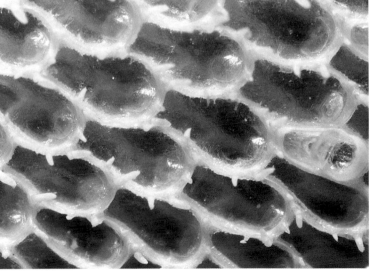

Portable table-top studio

If you intend to do a lot of close-up and macro studio work then a rigid table is an essential prerequisite to minimize vibration. Even when you intend using flash and cutting exposure times, vibration has to be reduced as tiny depth of field means that an object can move out of focus easily

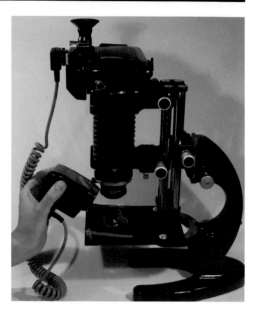

▶ This is a 'macro-scope' made from a Nikon bellows plus old microscope stand coupled to form a rigid assembly. Commercial versions are expensive and do nothing more than this unit does – the secret is high-quality optics. I use the special bellows macro lenses produced by Canon and Olympus to get a magnification of up to x30 with a digital body.

Minimizing movement Many wooden tables are surprisingly flimsy; I tend to build my own and, as a matter of habit, build chunkily, bolting lengths of timber together so that if movement develops it can be cut by tightening heavy bolts and nuts with a socket set. The more massive the table top, the less likely it is to transmit vibration: in professional optics labs, granite is often used. But assuming you don't have access to granite, then concrete paving slabs inset into an MDF top work well. You can even cast your own concrete top, making a mould from melamine-faced board and using the thinner reinforcing rods and mesh used for building work. I don't pretend that this is the complete answer but it works for me.

This set-up can be moved (with help if needed) into a greenhouse or even outdoors into a garden where, mounted in a workmate, it forms a very rigid support.

Supports You will often need to hold backgrounds, tungsten lights and flashes, and a whole array of subjects in front of your camera or on an optical bench. Anyone who has spent time in a chemistry lab will have come across a range of retort stands and clamps and lab-jacks. These are great for photography and available from many lab suppliers, though they are not cheap. Clamps are hard to make, but metal rods for stands can be bought from a supplier and cut to size, threads cut with a die and then screwed into drilled and tapped holes. If that sounds like too much to undertake, then the Climpex system of lab scaffolding is another option. This is well made, back-anodized equipment that can be assembled in any way you like, to hold all manner of subjects. They supply various clamps and sturdy goosenecks that are extremely useful when holding bottles or any other still-life subjects.

Special rigs For serious macro work, I use two purpose-built – or rather modified – stands.

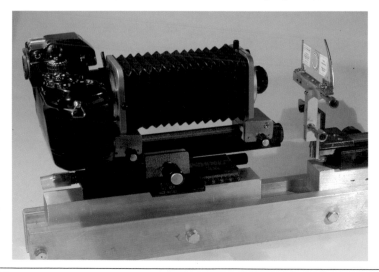

◀ This optical bench is built on a rigid girder made from three aluminium alloy sections. It works well and vibration is minimal, especially when using flash.

The macroscope This is made from a redundant Baker microscope stand to which a Nikon bellows is fitted. A fine focus mechanism comes from a much older microscope that had a micrometer screw for adjusting its condenser: secondhand sales and the internet are a great source of bits and pieces for making your own. The stand was in poor cosmetic state when procured, but the paint was stripped, car body undercoat was sprayed on first, and then several coats of satin black applied, allowed to dry between coats; this was then followed up by a varnish. It works extremely well up to about 30x. After that, I use a microscope.

The optical bench This is in effect a horizontal microscope that holds camera and subject stage on a rigid bar. Lacking heavy machining facilities, I have made several from good quality, aluminium-alloy bar to create a U-shape channel. The camera and subject mounts are built on the same section as the base (as shown in the diagram).

◄ A macroscope or optical bench with a 20mm macro lens brings a whole new world into range. This is the realm of a low-powered microscope in effect, and is easily capable of revealing these forams - the tiny shells that make up chalk deposits. Here, a digital camera body added a x1.5 boost to magnification, resulting in a x30 image on screen. Absolute rigidity is essential, as the tiniest movement sends things out of focus.

Optical benches

The optical bench couples subject and camera together via a rigid support – camera and subject vibrate together.

The construction is basic using square-section 38 x 38mm (1.5 x 1.5in) aluminium alloy for the main support and movable parts. The sides/ guide rails are 50 x 15mm (2 x 5/8in) bolted to the square rail via 8mm bolts into holes tapped and threaded. All that it needs is a drill stand plus electric drill and accurate measuring. In use, both subject and camera platforms are clamped to the main rail, ensuring absolute rigidity. Focusing is either by moving the camera or the subject. A microscope movable stage can be added at the subject end to position the subject in the field of view.

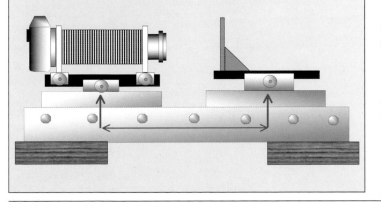

Fine control is provided by commercial focus slides and also by a redundant mechanical stage from a microscope. As with all these things, you have a basic idea and then modify according to what you can find easily (and cheaply). Very rarely do you have to build from scratch – the magpie approach is ideal.

Lighting At this scale, you can easily use small tungsten halogen desk lamps. However, although they have a heat filter, live material will still get too hot, so they are not ideal.

Used for focusing quickly they work well and you can see exactly where the lights give the effect you want. I tend to focus on a small area – on a leaf, say – and then, when a small creature comes into the field of view, fire small flashguns in the same position to freeze movement. These lights are much more intense than tungsten lights and you need to override them so that there is no colour cast when using daylight film. For higher magnifications, you can use a cold, fibre-optic light source (see pages 64–65) that creates pools of light where you want them.

moving outdoors

Winter sunset, Lake Bolsena, Lazio, Italy

B y now, you will be aware that this book takes a 'back to basics' approach to all photographic work. Getting the pictures you want can often take more than a bit of ingenuity, but if you work from first principles rather than relying on a formulaic approach you can always come up with solutions. Things might not work first time, but if you learn from your mistakes you can make adjustments and then try again.

Taking control of your photography works just as well outdoors as it does inside – the level of intervention possible is just that bit different. Whereas indoors you can 'play God' and impose conditions on a subject any time you like, this is not so easy when you are subject to the elements. You can achieve a great deal by working with the environment – learning when the light on a building or landscape is best and choosing a time of day, or even a time of year if you can. Most importantly, you have to seize the moment to capture those storm clouds, or the sudden appearance of the sun at sunset from behind clouds on a horizon. Many conditions are unpredictable, so you have to be alert to opportunity and seize the day.

This book is quite deliberately not a treatise on composition as it applies to landscape or close-up work, for example. It sets out to help you master the equipment you have so that you can forget about gadgetry and get on with the business of taking pictures.

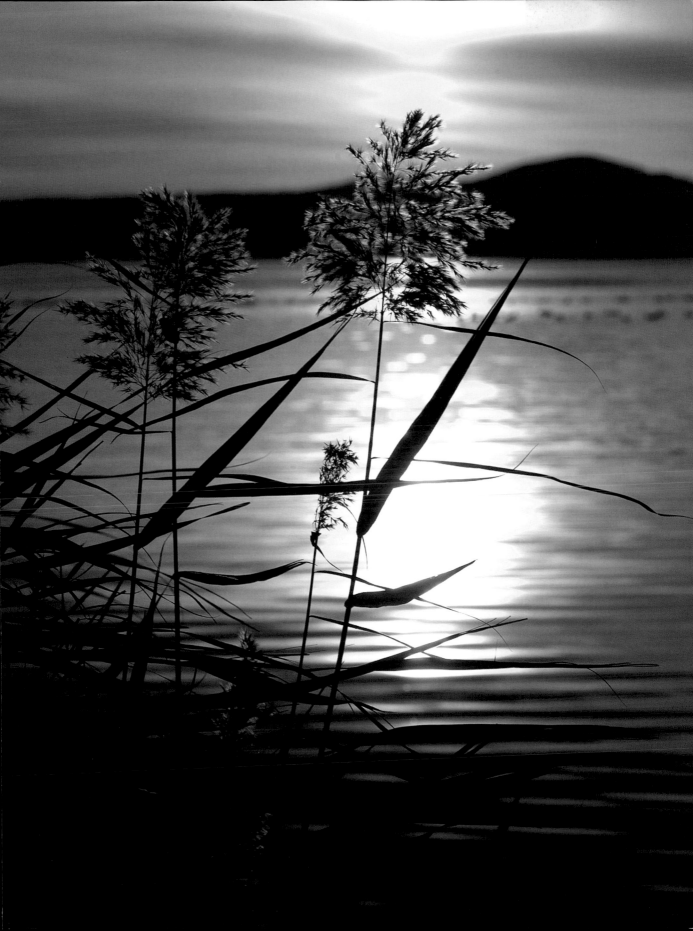

Reflectors and tents

The studio photographer has the luxury of total control over lighting; one of the problems (and joys) of outdoor work is the way that light changes, often suddenly and unpredictably with passing clouds. To a certain extent, you can control lighting outside on a 'local' rather than large scale.

flattened aluminium foil (the crumpling prevents mirror-like reflections). This silvered side will reflect more light than white. Boards are one more thing for you to carry, but the best solution is to use Lastolite folding reflectors; these are twisted to fold down to a size that you can put in a backpack or camera bag. They open to full extent with a flick of the wrist. The smallest circular size has a 30cm (12in) diameter when opened, and the largest 120cm (4ft).

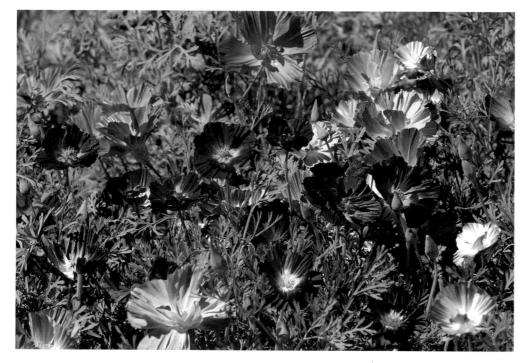

◀ *On an overcast day, a single burst of flash light was used about 2 stops below the ambient light level by setting the exposure compensation on a Nikon SB25 flashgun. Although daylight was the main source, the flash lifted the shadows and added 'punch' to the image of poppy hybrids.* **Nikon F4, Nikon 28-80mm F/2.8 AF, f/8 at 1/30sec, Fujichrome 100F with SB25 fill**

Reflectors Whenever you have a subject that dominates the viewfinder – a human face, a plant in full flower, or even individual flowers – you can 'throw' light on to the subject by using a reflector to pick up light from the sky. It is simply a case of pointing the reflector surface skywards and then turning it until light is cast on the subject. You move the reflector until you get the best result.

Types of reflectors Reflectors can be made of plywood, hardboard or rigid Styrofoam, with one side coloured white and the other silver. To create the silvered surface you can use lightly crumpled then

These reflectors are available in different metallic surfaces backed with white, so you can create light sources of differing colour temperatures:

- white (5600K) gives a soft white light that is good for portraits
- silver (5600K) gives a crisp light that is good for product shots and flowers, etc
- gold (3800K) gives a warm feel that is suitable for portraiture.

Small-sized reflectors can be used to create the fill light when you are using close-up flash. Some photographers fit these with a bracket to the camera.

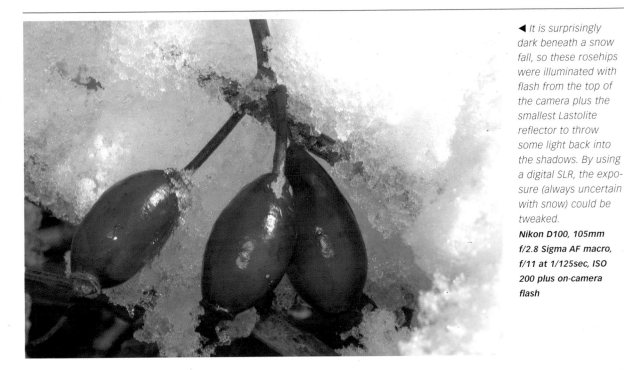

◀ It is surprisingly dark beneath a snow fall, so these rosehips were illuminated with flash from the top of the camera plus the smallest Lastolite reflector to throw some light back into the shadows. By using a digital SLR, the exposure (always uncertain with snow) could be tweaked.

Nikon D100, 105mm f/2.8 Sigma AF macro, f/11 at 1/125sec, ISO 200 plus on-camera flash

Tents Whenever you need a soft wrap-around light, a lighting tent can be used. Tents are ideal for photographing highly reflective objects (see pages 56–57). Some people use large tents to give a soft look to flower photography outdoors, but, as with any technique, it is worth ringing the changes to avoid your photography becoming too monotonous. Again, Lastolite produces excellent lighting tents as well as a 'cubelite' – as the name suggests, a cube of diffusing material that can be lit from outside; you can even fit a gradient-curve background inside. Small tents can be made from cones of diffusing draftsmans's tracing paper or film. This versatile item is equally at home in studio or outdoors.

Note: When you are using light tents, it can be difficult to avoid some element of the background (that is, the tent) creeping into your shot.

Fill-in flash A burst of light from a flash, set a stop or so below the ambient light, helps on dull days when colours lack 'punch', or on sunny days when your subject is in shade and dark, heavy shadows create too wide a range of contrasts for the camera to handle.

Graduated filters One of the perennial problems facing photographers in northern countries is the preponderance of grey, featureless skies, while bright white feature-less skies face photographers in summer in many Mediterranean countries.

There is inevitably a big difference in any exposure reading taken from the land or the sky. If you expose for the land to capture detail, the sky is burned out; if you expose for the sky, then the land is dark and all detail is lost. Wherever there is a reasonable horizon (or a line of separation between earth and sky that need not be horizontal – the vertical edge of a building, for example) a graduated filter (grey grad) can be used. This varies between clear and neutral density with a smooth transition across the boundary. Grads fit in holders that you can raise, lower or rotate to place the 'horizon'. To cope with differing light conditions, you will need several grades of filter.

▼ The fold-away reflectors produced by Lastolite are a boon for any photographer. Silver and white surfaces each produce a slightly different light quality, while gold offers evening warmth.

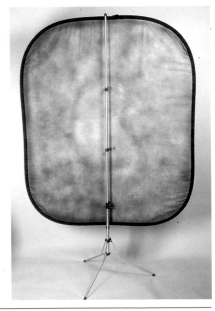

Flash and fill-in

Only when you are working in the close-up realm (or at night) will flash provide the sole lighting source outdoors. Flash can be successfully mixed with sunlight since both have a similar colour temperature. In this way, flash becomes a useful outdoor light source for larger-scale subjects or in the guise of a macroflash set-up for the small scale.

Using flash as fill-in One of the commonest uses of flash outdoors is as a fill light in daylight. It works by adding light to shadow areas. This enhances detail in shadow areas, reduces the contrast range and gives an overall 'punch' to the whole scene. Modern flashguns are sophisticated and allow a lot of control; in its fill-in mode, the camera's TTL meter reads the ambient light and sets the flash output at a lower level. You can set the difference on the flash; around one to two stops below the ambient light level works well.

Synchro sunlight shooting Synchro sunlight shooting is a way of using flash and sunlight together where the sunlight lights the background and the flash exposes a foreground subject. This works extremely well with subjects in woodland where there is dappled light through trees, for example, or for adding detail when objects are photographed against a bright sky so as not to end up with silhouettes.

Try a few experiments like these:
- First set the camera aperture to give the depth of field you want (check with the stop-down lever).

- With the meter mode set to manual, adjust the shutter speed so as to underexpose the background by a stop or so.

▶ To take this shot, an in-built camera flash provided enough light to show the photographer and the camera, whilst the ambient daylight took care of the background. This was used as the basis of digital manipulation where another image was put into the LCD area on the camera in Photoshop.
Nikon D100, 24mm f/2.8 Sigma AF, f/8 at 1/60sec, ISO 200

▶ Although growing in low light levels, fungi never look right when pictured with flash alone. I use the 'synchro-sunlight' method, employing a slow shutter speed to capture background lighting and allowing the flash to take care of the foreground subject.
Sigma SD10, 15–30mm Sigma f/3.5–4.5, f/16 at 1/8sec, ISO 200

◄ *The best leaves on the maple tree lay in the shade. Flash was used with a slow shutter speed to allow a daylight exposure of some light coming through the trees in this synchro-sunlight shot.*
Sigma SD10, 15–30mm Sigma f/3.5–4.5, f/11 at 1/30sec, ISO 100

■ Provided the subject fills enough of the viewfinder, the camera's TTL meter will control the flash for the foreground and expose it correctly. Although the flash exposure is short in duration, the shutter stays open long enough to record light in the background. I give slight underexposure only because I like the effect of a slightly dark background but one that still retains colour.

This method is only 'hit and miss' until you have tried a few experiments to see what works well for you. With a digital body, the immediacy allows you to fine-tune exposure through the compensation dial and obtain the result you want.

Black backgrounds and fall-off Black backgrounds can be used as a dramatic device to emphasize the foreground (ideal black backgrounds are discussed on pages 34–35). Light from a flashgun falls off according to the inverse square law followed by all forms of electromagnetic radiation (see pages 16–17). Double the distance from the flash and the brightness goes down by a factor of four; treble it and the drop in intensity is a factor of nine, and so on.

Ways around this include:
■ Using a more powerful hammerhead flash. This gives more light, but watch out for harsh shadows from an undiffused head as it acts as a point source.

■ Use the synchro sunlight method and run the shutter speed slow enough to light the background with the ambient light.

■ With close-up subjects where your flash is close enough to the subject to be a broad source, make sure the background is close enough to be lit to some degree, too. Leaves, twigs, stones and moss will often be rendered softly out of focus as a neutral shade and so will effectively enhance the subject.

Eliminating dark backgrounds

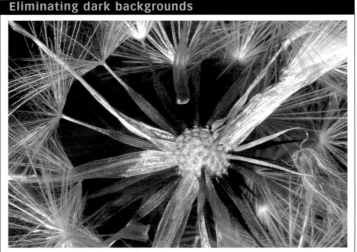

Large areas of black are obtrusive in some close-up pictures. The answer is to let aspects of the subject fill the frame and use this up. The dark areas occur through fall-off of light from the flash with this dandelion seed head, then provide a contrast accentuating the main subject.

Special flash set-ups

Many nature photographers want to try close-up and macro shots, but one of the problems involves finding reliable light sources that will allow you to use small apertures and get adequate depth of field. A suitable flash set-up can provide the answer, in the guise of a macroflash. These units are available from a number of camera manufacturers, as well as from Novoflex.

Macroflash units Macroflash units consist of paired flashguns on adjustable arms coupled to the camera's TTL system. Some allow you to vary the power output of the flashguns, making one the main source and the other the fill-in. The units are great if you can afford one, but you can easily make your own.

Users of digital SLRs are at an advantage, because the immediacy of the systems allows the camera to be used as a visual exposure meter. The fact that many digital cameras will only allow TTL metering with special DTTL guns does not then matter.

You can then set them to manual and check exposure on the LCD on the camera back. Guns with a power ratio control are useful because full power will be too much in the close-up realm and 1/4 or 1/8 settings bring them within range. It is essential that you use the guns close to the subject

▼ If you have a lot of pictures to take, a good macroflash coupled to a camera's TTL system lets you take pictures with the confidence that they will turn out without too much fiddling. This picture of tiny fungi was taken with a Nikon SB29s twin flash tube unit with the lighting ratio from the tubes set at 1:4.

▲ Perfect close-ups can be achieved using a single flash close enough to behave as a broad source – you just need a small gun. This is an ideal method with digital because the set-up has to be calibrated, and using the LCD screen to evaluate results gives you immediate feedback. *Sigma SD10, 105mm Sigma f/2.8 AF macro, f/11 at 1/30sec, ISO 100, Nikon SB23 gun on manual*

(10–20 cm/4–8in) so they become a 'broad' source and you don't get harsh shadows.

Flash distance and aperture You first set up a trial to get the flash distance you need for a particular magnification and aperture. If you keep the flashes fixed at this distance, then the set-up will work both at higher and lower magnifications with the same lens. For higher magnification, you move closer; this offsets the light loss on the sensor because of a smaller effective aperture (both are subject to the inverse square law). As you move away for lower scales of reproduction, so does your flash.

In practice, you will find that you need to open up the aperture a little if you move too far away or if you need to compensate

▲ *The small guns provided with a commercial macroflash do not provide enough light for you to use longer focal length macro lenses such as 180mm to capture butterflies such as this, high on bushes in a hothouse. The fact that you can set higher film speed equivalent with digital (say ISO 200) helps a lot, but with a slow film you have to make your own unit where even the smallest guns will be more powerful than a ready-built macroflash.*
Nikon D100, 105mm f/2.8 Sigma AF macro, f/11 at 1/125sec, ISO 200. Twin SB23 guns on a flash bracket

for highly reflective or very dark subjects. Close down a stop for light subjects; open up the same amount for dark ones.

Using a TTL system With a TTL system, you can use a couple of the lowest-power TTL units that are produced by the camera maker or go for independent guns as long as they can be coupled. The headache is the price you have to pay for cables. There is nothing particularly special about these – they are just five or six thin cores with patented connectors for which the camera manufacturer will make a handsome profit.

Adapt your own macroflash If you are familiar with electronics and not just a confident meddler, then it is possible to buy a

secondhand TTL flashgun and decouple the flash head from the body – that is all the macroflash units do anyway. Beware, however: there is a real danger when you open a flashgun, as the capacitors that store the charge for the flash run at 450–550 volts and can remain charged for some time. Touch one of those and it could fatally reveal the heart defect you did not know you had.

Trigger units and high-speed flash To capture flight-freezing pictures of birds and insects the easiest way is to involve a tried-and-tested flash unit that has been around for years: the Vivitar 283. These powerful guns do not operate via any TTL system, but they have a power control that, when set to fractional power, quenches the discharge in a very fast time – fast enough to freeze all sorts of motion.

Trigger circuits are outside the scope of this book, but they can be found on the web and ready-made units purchased from a number of sources (see pages 131–35). As an inspiration, read the works of the master of this area, Stephen Dalton.

In the same way you can set a flash to trigger for wildlife at night. The delay times between the interruption of the beam and the triggering of flash has to be minimal, so it is usual to work with the shutter open at night and let the flash catch the action as the subject crosses an infrared beam.

Macroflash set-up

For those happy to work with pieces of aluminium from a DIY store, building a macroflash inspired by commercial units is not hard. There are good commercial devices that hold two flashes and make the job easier. Units such as the Lepp (named after its designer, George Lepp) from Stroboframe or Novoflex will do the job and can be obtained from Speedgraphic.

Pinhole cameras

Pinhole cameras often appear in our early science lessons and so tend to be regarded in the same light as a telephone made from two tin cans and a piece of stretched string. But think again, because the pinhole camera is capable of some extraordinarily beautiful results, with a softness and mood that no other form of photography creates.

Natural softness the pinhole way

Pinhole images have a soft quality since there is no lens to focus the light, and the image is just created by diffraction at the pinhole. Here the two images were taken with a Nikon D100 digital camera on a tripod. Each was the best of a series with two separate pinholes, one punched with a needle in aluminium foil (left) and a 'ground' one (right).

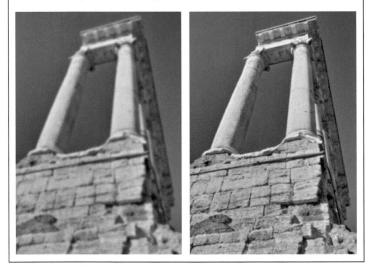

Understanding the camera obscura
The word 'camera' is the Latin word for 'room' and the first form of camera – the camera obscura ('dark room') – was just that. Popular from the Renaissance on, these were rooms in which you could stand while a light from a small circular hole projected an image on to the back wall. There is evidence to suggest that some Renaissance painters used these devices to achieve the extraordinary perspective effects in some of their works.

On a more modest scale, the pinhole camera may simply consist of a wooden or cardboard box with a pinhole at one end and a film at the other (this can be sheet or negative) to capture an inverted image.

Pinholes can also be fitted to a camera body cap with the centre bored out. This is then fixed to one end of a concentric tube that is painted inside and out with matt black paint.

Making a pinhole camera There is more to successful pinhole photography than punching a hole in a piece of card with a pin. If you do this and then look under a low-powered microscope, the hole edges look far from clean because of tears and fibres. There are several ways to get a good, round, clean-edged hole: you can buy a precision-made pinhole from Edmund Optical (see pages 131–35) or make one yourself.

Punched holes tend to tear: drilled holes are cleaner, but although there are some very fine drill bits available from model supplies they break very easily and take practice to use in a pin vice. Alternatively, you can use a needle held in the collet of a pin vice to bore a hole in either thin brass or aluminium.

The way that I have made accurate pin-holes is to place a small piece of thin brass or aluminium sheet on a block of hardwood and then use a needle as a punch: tap with a pin hammer to dent the metal but not pierce it. You then take some very fine wet/dry paper (600 grit or even finer), put the small brass sheet with the protruding bit of the depression down-wards, and move with a gentle circular motion to grind away the edges and reveal the hole.

Not many people have access to a vernier measuring microscope, so you just have to experiment and produce several holes of different diameters and mark them with an identifying letter.

Focusing with pinhole cameras No lens is involved and yet, because of small apertures, there is the phenomenon of Fresnel diffraction – an image can be focused but given the low brightness levels, this is difficult to see. It is possible to mount a pinhole on an SLR camera rather than a 'shoebox' with a sliding tube to allow focus.

fit your pinhole to an SLR you can use the shutter with a box; a piece of card has to be swung away from and then in front of the pinhole to create an exposure.

You can get some idea of where to start by realizing that a one-stop change is either halving or doubling shutter speed. The

Finding focal length

First, try focusing a window as your distant object. When focused, the pinhole-to-film distance is very nearly the focal length and will work for a distant scene. The effective focal length of your system will depend on the pinhole size, and the film plane will have to be sited at this distance from the pinhole for distant scenes. Consult the table below for further guidance.

needle size	hole diameter in mm	focal length in mm (approx) – use this distance from pinhole to film for distant scene	Equivalent f/stop hole diameter (mm) ÷ focal length (mm)
8	0.55 (0.022in)	200	f/360
9	0.5 (0.020in)	160	f/320
10	0.45 (0.018in)	125	f/275
12	0.4 (0.016in)	100	f/250
13	0.33 (0.013in)	60	f/180

Exposure with pinhole cameras Getting the exposure right is a matter of trial and error with such small effective apertures – and you will have to keep notes of exposure for different weather conditions. If you

f-number series goes on from the familiar figures in this sequence: 11; 16; 22; 32; 45; 64; 90; 128; 180; 256; 360. For example, f/360 is 10 stops down from f/11 (the number of spaces in the series).

Pinhole cameras

The pinhole sits at the front of the box, the film/digital sensor at the rear. A digital camera is perfect for experimenting with exposure until you get it right. To create pinholes, just punch the metal and rub slowly on fine wet and dry paper (600 grit or finer), checking frequently to reveal the hole. One more rub and the pinhole may be damaged.

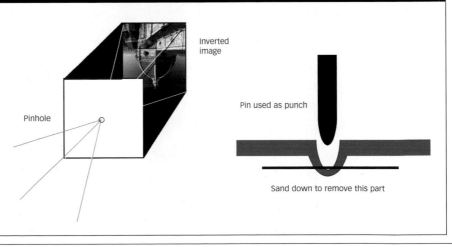

Inverted image

Pinhole

Pin used as punch

Sand down to remove this part

View camera and bellows movement

Many keen photographers aspire to the purchase of a view camera because its construction – a lens panel and a film back separated by a bellows – allows great versatility when it comes to squeezing maximum front-to-back sharpness out of a landscape or correcting converging verticals. Beware, this is not photography for anyone wanting immediate gratification: view cameras take time to set up and you need patience to learn the ways. Exposure must be spot on since sheet film costs far too much to waste. If you dream of getting a digital back (they work like scanners in this format) then think about re-mortgaging your home.

Using a view camera When you first use a view camera, it seems that there is far too much to adjust: not only can you rack the bellows in and out for focusing, but you can tilt back and/or front panels and also raise and lower them or 'swing' them relative to the camera axis. The secret to successful use relies on:

- knowing exactly what each movement does;
- not adjusting more than one movement at a time;
- making sure all controls are in the neutral or 'zero' position when you start – there are usually click stops to help.

Tilts An Austrian army officer called Theodor Scheimflug developed this eponymous principle at the beginning of the twentieth century and produced the key to understanding camera tilts. The concept is simple: a line drawn through the subject plane, lens plane and film or sensor plane meet at one point. When you select your subject plane, adjust the tilts to fit the Scheimflug principle and get the subject completely in focus on the camera screen. Many landscape photographers use lens and film panel tilts more than any other photographers.

Swings The lens and back panels can be turned on an axis through the centre of the standard (a tilt moves the whole standard) and the subject is viewed obliquely. This allows control of perspective or even image distortion for effect. Swings are like tilts but in another plane at right angles. This time, the Scheimflug principle works as you look down on the set-up from above: workers who have absolute familiarity with the camera might be tempted to try swings and tilts.

Shifts Displacing a lens panel upwards forces the image downwards and vice versa, as the diagram shows. It also changes the perspective, as it elongates the image circle into an ellipse. Vertical shifts allow correction of verticals so that convergence can be undone. The panels can also be shifted sideways to move the image circle and change coverage.

Smaller-format tilt and shift lenses

Any camera lens produces a circular image field that fades off towards the edges: we see a rectangular image in a viewfinder and this is captured on a film or sensor. The usable image circle is bigger than the format it is used for and movable fronts and backs make use of this. Although large-format lenses are most commonly used for shifts because of the larger image circle, even 35mm lenses used in close-up mode on bellows have enough coverage to fill a 6x6cm frame.

▼ *My ancient 35mm Canon TS (tilt and shift lens) was used on my first 'pro' camera – a Canon F1 – to get front-to-back sharpness with this coastal sandstone in northern Cyprus. This was achieved at a much wider aperture than you would attempt with a 'normal' wide-angle lens to get a similar result.*

good for architectural work such as correcting verticals. One firm, Zork, produces adaptors for 35mm lenses allowing tilt and swing as well.

For use in the field, a shift and tilt lens is the best if you want infinity focus. Here, Canon are the masters, producing three excellent optics (24mm, 40mm and 90mm). Some photographers, even if they use another system, buy a Canon body to go with these lenses. Nikon produce an 85mm tilt and shift close-focusing lens; many manufacturers produce a shift lens in 35mm and roll-film formats.

Using bellows For movements in the close-up realm, a bellows is the answer. Some 35mm bellows (Hama, the old Nikon PB4) have movement capability in-built. These are excellent if you do not require infinity focus, though of course all automatic coupling between the lens and the camera is lost. However, some of the roll-film format bellows are even better: I use a Mamiya 645 bellows complete with all its movements with a 35mm digital body. It can readily be adapted to fit the rear standard, and the longer back-focus of lenses for this format will allow infinity focus with 35mm.

Hasselblad users have two methods of gaining camera movements through the 'flexbodies' produced for use with the Hasselblad system.

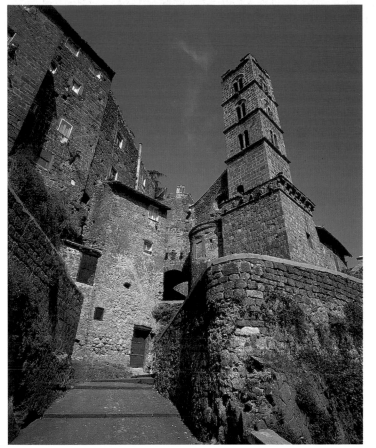

▲ *The one-time obsession with parallel verticals has largely passed and now convergence is accepted as part of the drama of an ultra-wide picture. Here, the superb Mamiya 43mm wide-angle on a Mamiya 7 II captures that effect. What matters is that it is rectilinear and that straight lines near the frame edge are not curved.*
Mamiya 7 II, 43mm f/4.0 lens, f/11 at 1/125sec, Fujichrome Velvia

Camera movements are possible in 35mm but you need a delicate touch for precise control. Shift lenses are common to a number of manufacturers. These just move lens groups perpendicular to the axis and are

View camera adjustment

This diagram shows the Scheimflug principle. It is a simple concept but very tricky to prove mathematically. By standing to the side of a view camera, you can line things up approximately and fine-tune using a focus magnifier on screen. The diagram lines show how film plane, lens plane and subject plane meet when the camera is correctly adjusted.

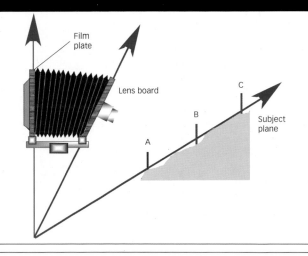

Film plate

Lens board

C

B

A

Subject plane

Wildlife photography

The welfare of the subject must be put first in any aspect of wildlife photography: do nothing to endanger or distress a subject. It is hard to walk away if it means missing that once-in-a-lifetime shot, but ethically, it is the right thing to do.

▲ *This shot of a coypu was easy to obtain since little or no cover was needed – it was visible from a bank above a pond. Silence is essential when photographing birds and animals. It is not a group activity and working alone will bring you far better results than if you were accompanied.*

Nest photography

There is a distinct risk of causing birds to desert a nest, even after young have hatched. In many countries any action that jeopardizes the welfare of a nest is a criminal offence – especially with rare birds. If you intend to take photographs, then do it with the utmost care and stay as far from the nest as you can: never move vegetation that makes a nest vulnerable to predators. You will not be granted a permit to photograph rare birds unless you have a proven record as a responsible bird photographer who puts welfare first.

If you have a garden with trees, then some years you might be lucky and be able to photograph activity at a nest from indoors where the birds will not perceive you to be a threat.

Photographing from cars A human in a car is not a case for alarm with many birds – but step outside, and things change. Bird photography from the inside of a car is made possible by supporting a long lens on a bean bag (see pages 82–83); the latter is made in two parts and sits over the window edge.

There are small tripods such as the Ergorest (www.speedgraphic.co.uk) that brace a camera against the door and the window top and keep it rock steady. Avoid using any clamp that fits a window; this puts a strain on the glass that might break even Triplex glass.

Photographing from boats In wetlands, a small boat in which you can lie can get you into places that are excellent for photography. You have to cover yourself in the bottom of the boat, so remaining comfortable is not easy. Coastal boat trips around islands can generate good pictures and birds are often unconcerned about your presence. Vibrations from an engine are transmitted though boat sides and floor, so you have to use a shutter speed high enough to negate the effect. When focusing a long telephoto on a monopod or tripod,

The hide

A good hide, such as this one from Wildlife Watching Supplies, is a worthwhile investment for any photographer involved with mammals or birds. It is important that you choose cloth designed for the environment in which you want to work – woodland materials in a desert make you stand out against the background, for example.

► *This golden oriole was photographed with a telephoto lens balanced on window bars. A digital camera permitted both higher ISO rating and shutter speed to help eliminate camera shake.*
Nikon D100, Sigma 300mm F/4 AF tele macro, f/5.6 at 1/500sec, ISO 400

should not be done lightly because it creates changes in behaviour and also a dependency on the food source. In reserves where there are large mammals, this is often done by the wardens and is best left to them.

Types of hide and their construction For ready-made hides or material from which to fabricate your own then Wildlife Watching Supplies (www.wildlifewatchingsupplies.co.uk) are highly recommended and well respected in the photographic world.

A hide is a foreign object – it has to be introduced gradually, maybe constructed piecemeal over a period of days. With a portable hide, you might be able to move progressively closer over a period of several days.

or handheld in a rocking boat, feelings of nausea can quickly develop.

Using hides The best wildlife reserves have well-managed habitats and walkways with permanent hides placed at good observation points. Birds and other creatures are used to the hides and act as if there is nothing threatening there (as long as the occupants are quiet).

When placing a hide, choose a site that provides clear, unobstructed views of a nest or feeding site: watering holes or lairs are ideal with mammals. Set up your hide over a period of days and establish it with a good background of vegetation. Just because it uses 'camouflage' cloth does not prevent it from looking rather obvious in an open location.

Lighting direction is important: make sure you are never shooting into the light at times you want to use the hide, and that your hide never appears in silhouette late in the day or in early morning. If bushes are in your line of view then a little 'gardening' – but not a chainsaw massacre of trees – is permissible (but never do this on a reserve unless the wardens do it). It may be possible to provide bait for an animal, but this

▼ *This black kite was photographed in captivity. A high shutter speed required an open lens aperture with restricted depth of field producing the out-of-focus background.*
Nikon D100, 180mm f/2.8 Sigma AF macro, f/5.6 at 1/125sec, ISO 200

Alternative camera supports

In an ideal world, photographers would carry a steady tripod at all times and use it whenever they set up a camera. But tripods can be heavy, inconvenient to pack, and tend to attract attention from people in locations who would like to charge you money because they think you are a professional. Resourceful photographers can find a variety of other ways for helping to support a camera.

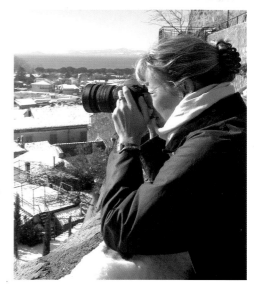

Body parts Bracing arms and legs against walls, trees, or even lying on the floor can provide a surprisingly steady camera support. It helps if you can hold the camera body with one hand and the lens with the

▶ Photographer Lois Ferguson uses her elbows on a snow-covered wall to brace a digital SLR.

other – perhaps supported by a knee if you are sitting. It depends on how supple you are – serious outdoor photographers might take up yoga first if they don't want to carry a tripod.

Columns, trees and rocks Walls and columns can provide firm support to a camera in building interiors. In places of worship it is important both to respect the dignity of the place and be unobtrusive as a non-worshipper. In the same way, tree trunks and large rocks can do the job in the wild.

Bean bags and camera bags The bean bag is simply a stout canvas bag that can be filled with lentils or dried beans. When a lens is laid on it, the filling allows it to form around the lens body and supports it on hard surfaces. Long telephoto lenses can be held steady in this way. The bag can be carried empty if you are going on holiday and then the choice of filling is up to you

◀ A strategically placed tree stump provided a ready made support for this evening shot across a lake. If you find yourself in a situation where you need a support, but don't have anything handy, look around – there's often something suitable.
Nikon D100, 24mm, f/2.8, 1/15 sec

when you get to the destination. If you use lentils and small dried beans you can always cook them later if you find you are short of rations.

Otherwise, a soft camera rucksack can provide good support, absorbing vibration if it is cradled between your knees, for example, whilst you are sitting down.

Ground spike and platforms For low-level shooting, the ground spike was once a favourite with plant photographers. They are available commercially, but it is an easy device to make yourself. Basically, it is a tri-pod head with a stout metal spike screwed into its base and sharpened at the free end. The only problem is getting it out of dried ground when you have pushed it in, so some sort of cross-bar to help lift it is useful.

Camera clamps Several sorts of camera clamps are commercially available and consist of a ball-and-socket head fitted to a large G-clamp. This can be fixed to tables, fence poles or similar, and provides a rigid support for a camera.

A variation on this is the window clamp for cars, though it never does to impose strains on glass, even when it is toughened Triplex. A better alternative for the car user is a bean bag designed to sit comfortably over the glass edge.

▲ Top wildlife photographer Chris Weston shows the ingenuity that gets him his award-winning shots. Over a period of five minutes, Chris used a tree trunk, knees and elbows, and a low rock to photograph ducks at a lake.

◄ Support holes provided in the fence of the Sangamo leopard project allowed me to track the inhabitants as they moved, while resting the lens front provided a stable support.
Nikon D100, 180mm f/2.8 Sigma AF macro, f/8 at 1/30sec, ISO 200

Careful thought before facing extreme weather or physical conditions can save you expensive repairs or even equipment write-offs. Wherever electronic gadgetry is involved there are risks, from exposure to dust (including sand), damp (fresh water and saline), very low temperatures and impact.

and connect externally via a cable. At just a few degrees above zero, your hands will get cold and you increase the risk of dropping your camera; wear gloves that are flexible enough to allow you to press a shutter for an exposure reading without firing it.

Hot and humid conditions Excessive heat causes colour casts on all films, buckles roll film, loosens lens cement

Volcanic regions Camera equipment needs special care and attention in any active volcanic region. There is the obvious effect of heat, although most people do not stay long enough (or get close enough to the action) for damage to occur. Far worse is the volcanic dust, with its abrasive particles. Sulphur dioxide gas is ever-present and dissolves in steam to form highly corrosive acids that will quickly damage metal parts on cameras and lenses.

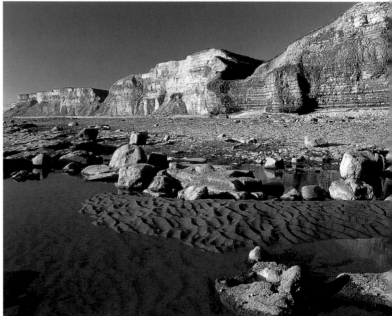

▲ *The hot acidic atmosphere where waters and volcanoes mix is capable of etching metal camera parts. Expose the equipment as little as possible and wipe with a damp cloth at the end of the day.*

▲ *Even on a calm sunny day there are tiny airborne salt and grit particles by the sea. Always wipe down your camera's metal parts with a wetwipe. Blow all dust or grit from a lens with a pressurized 'dust-off' spray before cleaning it any other way. If a focus movement begins to feel gritty, get it repaired before sand particles regrind the threads for you.*

and causes camera lubricants to run – and that is just for starters. Photographic equipment is best kept in reflective camera cases anywhere under bright sun: use those with a gasket-sealed rim and open them as seldom as possible. Never use black cases and even consider covering cases with a damp white towel that cools by evaporation.

In a dry climate, dust and grit particles are carried in the air – they get everywhere and are highly abrasive. Keep film in plastic canisters at all times – brush the film leader carefully to dislodge grit. If there is the slightest breeze, use a changing bag for loading the camera and even for lens changing. It might be inconvenient, but it

High mountains and low temperatures At high altitudes, cold can make batteries (rechargeable cells in particular) drain much more quickly than at room temperatures. With digital cameras and their dependence on a power source, you must carry charged spares and do the best you can to keep batteries warm. Many manufacturers provide plug-in battery packs that you can keep near your body

Mineral and algal deposits

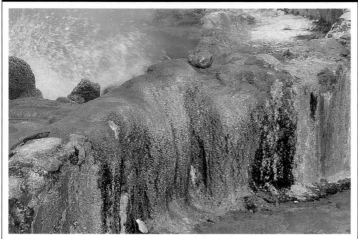

Some life forms thrive in warm volcanic springs. Cameras need protection against accidental slips as you move around.

A good camera case with gasket seals might seem expensive, but it is nothing compared to a ruined outfit.

iso-propanol on a photo tissue: cleaning internal elements is a job for a trained technician. Over a period of time, the fungus can damage coatings and even pit glass.

What to carry In any extreme environment, equipment weight is a consideration unless you are on an expedition with porters. Carry as little as you need. A great deal can be done with a minimal outfit such as a camera body, plus a couple of good zooms covering wide-angle to tele, a teleconverter, a polarizer, and UV filters. These protect lens elements but are also essential at high altitudes because of high UV levels.

Any large expanses of snow, rock or sand create erroneous readings, and a handheld exposure meter can be a bonus – you need to check the camera meters regularly against them.

▶ *Cells and batteries drain much more rapidly at low temperatures, so make sure you have spares and keep them close to your body for warmth. For polar conditions, a traditional SLR with mechanical shutter cannot be beaten and is essential back-up for electronic gear.*

helps prevent disasters. Some cameras claim to have O-ring seals and are waterproof, but taping over all joints is an extra precaution you can take.

Coping with humidity Much of the same advice goes for humid conditions, with the extra advice to keep all cameras, lenses and film in plastic bags with silica gel when not in use. Self-indicating silica gel is available from lab suppliers (blue when dry; pink when saturated). This can be regenerated by gently warming on a hot tray above 100°C to drive off water. Sew this into cotton bags and use it with your equipment.

Another enemy is the mould that grows everywhere under humid, hot conditions. The gelatin on a film surface is an ideal culture medium, and when mould has taken hold it pits the surface and ruins transparencies or negatives. Thin threads of fungal mycelia can find their way between lens elements, too. The best cure for this is prevention – when equipment is to be used for long periods in the tropics then it, too, should be stored in sealed cases with silica gel: use a solid camera case with a gasket. If fungus has already taken hold, it can be cleaned from an exterior lens surface with a proprietary lens cleaning solution or with-

Working in and near water

Working near freshwater lakes, rivers and streams is never a problem unless you are cold and liable to drop the camera in the water. The old advice when this occurred near mud, brackish or salt water used to be to plunge the camera into a bucket of fresh water and then get it to a repair shop. If the camera body is well sealed then you might be able to wipe it down carefully – total immersion means the ingress of water and ruin of electronic circuitry.

Sand and salt When at the beach, sand is an obvious hazard but so is a salt-laden breeze, as this carries potentially corrosive salt crystals and fine but highly abrasive silica particles. Quartz (silica) is a common constituent of sand and volcanic dust. You can scratch glass with a quartz crystal and very fine particles readily create micro scratches on a lens surface, and flare you cannot get rid of. Before you wipe or brush a lens, use a high-pressure aerosol cleaner to remove all surface particles.

Underwater photography Underwater photography is a specialization that deserves – and gets – whole books to deal with it exhaustively. You need extensive training and a heavy investment in diving (and photographic) equipment for photography at significant depths. However, immense pleasure (and beautiful pictures) can be gained from a suitable housing and shallow-water work with a snorkel and mask – particularly around reefs. All you need is the basic equipment for snorkelling – a good mask, snorkel, fins, a weight belt to achieve neutral buoyancy and a wet suit if you intend spending any length of time in cold water.

You have to become fastidious about checking when you begin to take photographs underwater, because accidents with equipment have dire consequences, especially with electronic equipment. Faulty O-rings beneath the surface spell disaster.

Underwater housings and cameras
There are many, simple 'disposable' cameras that can be used to experiment underwater. They give encouraging results and many people are smitten with this kind of photography once they have taken pictures with them.

Several firms make underwater housings, and the most sophisticated of these are specially engineered for specific makes and models of camera. Ewa-marine makes

▲ You don't have to dive to get every shot; I found this small octopus in a pool. To avoid surface reflections, use a polarizer and lower your camera at an angle of just over 45 degrees with the vertical.
Nikon D100, 105mm f/2.8 Sigma AF macro, f/11 at 1/125sec, ISO 200

Sea shells on the sea shore

Many of us are inveterate beachcombers – look out for assemblages of shells formed by the tides or even create a little composition yourself. If the shells are wet (a bucket of water will do) then their colours show much better.

flexible housings for a range of cameras that are ideal for close-up work in shallower water and reasonably priced.

The Nikonos was the first camera designed to be used underwater without a special housing – there is a full range of lenses and flashguns, and connections are sealed with O-rings to ensure they are fully waterproof.

Lighting and focus underwater A TTL flash system is a godsend underwater, where there is often little light. A housing that takes a 35mm camera with 50–60mm AF macro and has small waterproof flash-guns attached is a versatile piece of equipment for close-up work. The flash reveals strong colours you did not realize were there, and you can use it exactly as you would a macro system on dry land. For focusing, it is useful to have cameras with a high point viewfinder – that is, one where you see the full image with the eye a short distance from the viewfinder. A 24mm or wider-angle lens can allow you to create underwater vistas with fish and other foreground subjects.

▲ *Weeds and encrustations abound in any rockpool. Here, a flash was used at 45 degrees to one side of the camera to avoid reflections from the water surface into the lens.*
Nikon D100, 105mm f/2.8 Sigma AF macro, f/11 at 1/125sec, ISO 200, SB23 flash used manually

▼ *It is easy to miss smaller coastal inhabitants. These tiny sponges, however, were clearly visible because of their striking colour.*
Nikon D100, 105mm f/2.8 Sigma AF macro, f/11 at 1/125sec, ISO 200, SB23 flash used manually

Low light and night-time work

There is a special challenge for any photographer when light levels get very low. It is a question of exposure sometimes for minutes, necessitating a very firm tripod. With film, the idea of reciprocity (double the light energy, half exposure time) breaks down, and exposures need to be lengthened. However, the rewards are a diversity of shots and another chance to show your creative skills.

Moonlight When you use long exposures of an hour and more (with ISO 50 film and aperture of f/16) a full moon will show up a landscape as if lit by daylight – after all, moonlight is just reflected sunlight.

The moon is a moving target and every two minutes it appears to move a distance equal to its own diameter. For exposures longer than 1sec with a 400mm lens, the moon would be blurred. To freeze movement with a full moon, use an exposure of 1/250 sec at f/8 with ISO 100: for a crescent moon expose for 1/125sec.

Using a tripod photograph when the moon is high in the sky and there are no silhouettes in frame. The image can be scanned as stock and added to other pictures in a new layer. Often, including the moon in a shot is sometimes best done by double exposure. You can create a double exposure with a frame shot earlier to give landscape detail. It helps if your eyepiece has a grid – with roll or sheet film you can mark the viewfinder screen with a marker pen – and it helps to draw a rough sketch of the elements to ensure things are where you want them.

Fireworks The most impressive firework pictures let the light trace a path on film while the shutter stays open – in the space of 20–30sec a typical display might involve a number of fireworks and your photograph will capture them.

Unless there are reference points such as the outline of trees or buildings the extravaganza will create a coloured abstract. Use an aperture of f/16 since the individual fireworks are bright – many use burning magnesium powder for example, which was used explosively in early flash devices. Over time the moving points describe arcs on film.

Twilight There are residual reds and purples in the sky, particularly towards the west for the first thirty minutes or so after sunset. During this twilight time, you can create some of the most impressive 'night time' townscapes where the lights of buildings

▲ As a useful rule of thumb, a 100mm lens gives a 1mm diameter image on film and each extra 100mm focal length adds 1mm in diameter to the moon's image. So, to obtain a reasonable sized moon (6mm, say) on 35mm needs something like a 600mm lens. Here a 300mm lens plus x2 converter was used with a digital SLR – effective focal length 900mm.

◄ In countries where there is a festival spirit, loud fireworks are an essential part and offer you the chance to create your own abstracts. Here a tripod was used with the D100 self-timer set at 30sec– a wall or anything solid where a camera can sit will do just as well, though you cannot frame too easily – use a wide-angle lens (here a 15–30mm Sigma zoom lens) since you never quite know where they will explode.

A guide to exposures for low light and night subjects at f/16

For each full stop that a lens is opened you should halve the total times given – this works best with shorter times where reciprocity still holds – for longer times err on the side of increased exposure.

TYPICAL EXPOSURES	ISO 50	ISO 100	ISO 400
Cityscape – just after sunset	1/2sec	1/4sec	1/15sec
Cityscape – twilight	60sec	30sec	8sec
Cityscape – night	4min	2min	30sec
Buildings – floodlit	15–30sec	8–15sec	2–4sec
Landscape – twilight	60sec	30sec	8sec
Landscape – moonlight	1hr	30min	8min
Fairground rides	30sec	15sec	4sec
Traffic trails on motorway	60sec	30sec	8sec
Firework display – aerial	60sec	30sec	8sec
Bonfire (flames)	4sec	2sec	1/2sec
Bonfire lighting a face	30sec	15sec	4sec
Full moon	1/125sec	1/60sec	1/15sec
Crescent moon	1/60sec	1/30sec	1/8sec

▼ *The light reflective clays of this landscape picked up the light from the sky some 20 minutes after the sun had set; exposures were guessed – easy to do with a Sigma SD10 digital SLR since they were checked on the LCD screen. Best results were at 1/4sec at f/8 with the camera set to ISO 200. The potential problem was camera shake – fortunately the ruined walls in the ancient town of Civita di Bagnoregio that looks out over this eroded landscape served as a support.*

▶ *There is often a steely blue feel to pre-dawn light, especially over water. It has a much colder feel than twilight since it is reflected from the sky and any clouds act as a giant diffuser. If there are artificial lights present they create reflections when the water is calm. The effect can be enhanced by using a pale blue filter such as an 82B or 82C.*

and streets may have just been switched on. However, the artificial light can be swamped by light still in the sky if you begin taking photographs too soon after the sun sets.

Afterlight occurs a little later – some 30–40 minutes after sunset in summer, about 20 minutes after in winter. A lovely greenish to deep cobalt hue appears when reddish shades have disappeared from the skies, and ambient and artificial light levels are about equal, making this a good time to photograph buildings that are artificially lit. Typically, you need a 10sec exposure at f/4–f5.6. with ISO 50 film.

Columns of the Gymnasium, Salamis, North Cyprus

N ow we are in the era of digital photography, we can talk about two kinds of darkroom: the wet darkroom, for traditional film chemistry and printing; and the digital darkroom – the process of enhancing digital files on a computer.

There has been a flood of amateur photographers moving to the dry, odour-free security of the digital darkroom, because it offers unprecedented levels of control and superb results, and all from a home computer. As a result, traditional darkroom equipment is readily available for low prices secondhand – but the sad thing is that people will miss out on the magic of watching an image appear on photographic paper as it is gently agitated in a dish under a safelight. There is a difference between the prints achieved by the two methods – although neither one could be said to be better than the other.

You will have to learn to follow 'recipes', reliably and carefully, to get consistent darkroom results. Colour processing, in particular, is not at all difficult – you just need to be methodical and to keep temperatures within fine limits. Fortunately, there are now plenty of affordable accessories to help you achieve this. If you are new to photography, you will miss out by not going through the darkroom stage. The digital route has made high-quality printing more accessible to a wider range of people. It takes up less space and you do not need a special room set aside for it. Then again, the constraints imposed by wet chemistry have led to great ingenuity in creating blacked-out areas – under stairs, in bathrooms, in corners of bedrooms – it's all part of the fun of photography.

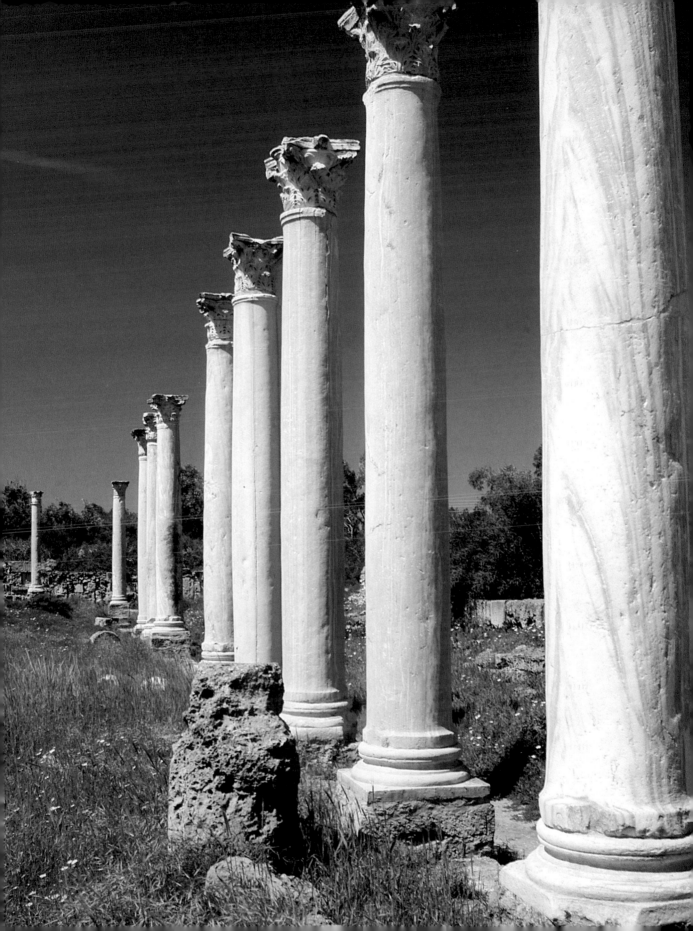

Designing darkroom spaces

A darkroom often has to be an adaptation of an existing room such as a bathroom or a spare bedroom, although the ingenious might try to fit everything into a large cabinet with a pull-down table.

Possible darkroom areas In order to preserve harmony with family members or housemates, think about converting an area of the house that is not generally used (or missed) by other people. Under-stair closets are a popular choice because they can be left permanently blacked out with all equipment left in place between processing sessions.

Setting up a darkroom

Separate areas for wet work (processing of film and paper) and dry work (enlarging and mounting) are a priority in the darkroom. Here they are set on opposite sides of the room. However, when space is at a premium, compromizes have to be made – a dark, dry area for enlarging is essential, but some chemistry can be carried out in normal lighting. You can also produce enlargements digitally from negatives and transparencies.

Basements and attics also seem obvious choices. Basements usually have a good, solid floor and a stable temperature even in the extremes of winter and summer, whereas attics often do not. Some enthusiasts build a self-contained darkroom within a basement, creating insulated partition walls to isolate it from storage areas. Electricity is not usually a problem, as an enlarger or processor can be run from an extension lead. Having running water on hand is a luxury, but many people manage without it.

Black-out Making sure you can achieve black-out in your darkroom space is vital. Even when you think doors or curtains are light tight, you will be surprised at light spill through cracks that only become evident after a while spent in darkness as your eyes readjust their focus. Seal edges with black gaffer tape.

Processing Although black and white processing is less complicated than colour in terms of the number of steps involved, it takes up more space if you are doing wet-tray work. Most people working with colour use a processing drum. In this case, the only time you need complete darkness is when you are loading the drum.

Colour in the darkroom Don't be tempted to paint an entire darkroom matt black, although it is a good idea for the walls around an enlarger. In a wet area, white laminate tops are ideal, and are easy to make from melamine or Formica-coated board. They wipe down easily and reflect any safelight you use.

Ventilation Ventilation is an important issue to consider when deciding on your darkroom area. Fixers contain sulphites and metabisulphites and quickly make your throat feel uncomfortable from airborne sulphur dioxide, and many colour chemicals are downright unpleasant and harmful when inhaled. If you are using toners such as sepia, the hydrogen sulphide (with its distinctive stench of rotten eggs) is poisonous, so an extractor fan is essential.

Work surfaces What work benches you end up with in your darkroom will depend on your handiness with a saw, drill and screwdriver. In a society where people frequently update their kitchens, you can often pick up secondhand floor-standing kitchen cabinets and wall cupboards extremely cheaply, and these units are ideal for work surfaces and storage. Pay attention to what height they are – if you are tall, then bending over surfaces that are too low becomes uncomfortable over the time you need to spend making prints.

Safety in the darkroom Water and electricity at mains voltages can provide a lethal combination if you are fumbling around in the dark:

- never have trailing leads;
- keep all wet areas well away from any electric wiring;
- make all light switches cord-operated and know exactly where they are;
- make sure that all equipment has an earth lead and that all plugs have fuses of the correct value – have these checked by a competent electrician if you are in doubt.

In addition:
- wear gloves when you are handling colour-processing chemicals as they can irritate skin;
- store any chemicals in well-labelled bottles and keep them securely locked away from inquisitive children when the darkroom is not in use.

Filling the space available

It is usually easier to fit a darkroom into a space than to be given carte blanche to design the ideal. Some people have better visio-spatial capability than others, so if you are stumped ask friends for comment. Wet chemistry has inspired extraordinary ingenuity in some enthusiasts, who have turned bathrooms, cupboards, attics and under-stair spaces into darkrooms. You will spend some time cooped up in there, so attend to safety and comforts. Good ventilation is essential, and all water and electricity should be kept well separated. Try to avoid conflict of uses unless you live alone – it is very easy to erode the goodwill of the other people in your house if you use the bathroom for processing and occupy it for hours.

Enlargers and accessories

With black and white or colour in either negatives or positive transparencies, the enlarger functions as a projector, creating an enlarged image on its baseboard. You focus this using a grain magnifier to produce a sharp image.

Buying an enlarger For any darkroom work involving printing, an enlarger is the single most important piece of equipment. It can't effectively be improvised, whatever grandparents tell you they did with shoeboxes and a lightbulb.

There has never been a better time to buy pre-owned darkroom equipment because of the number of people trading in their traditional equipment for digital kit. Forget fancy features and buy the most sturdily built enlarger that you can get for your money. Integral dichroic heads are great,

▶ So many people are moving to digital that there is a flood of bargains to be had with enlargers. Doom merchants spell the end of film, but many will work with both film and digital as the novelty wears off. When looking for a secondhand enlarger go for a rigid stand, smooth focusing and the best lens you can afford: with names such as Durst and Leitz you won't go wrong. A built-in colour head with dial-in dichroic filters becomes a must if you have spent time messing with gel filters in drawers that gradually become finger-marked however careful you are.

but you can either fit one later or use filters. Makes such as Durst and Meopta are recommended, as the equipment is made to last.

Vibration Enlargers often use extended exposure times, during which vibration can be a problem, especially in modern houses where walls and other structures are often surprisingly flimsy. For example, if you are working beneath a staircase, you don't want a problem every time someone walks up or down the stairs, so make sure your enlarger bench is heavily made – double the thickness of the top and bolt the bench to the wall permanently, for starters. In many professional darkrooms, an enlarger column will be fixed to a wall as a matter of course.

Optics Good enlarger optics are essential; if you have expensive camera lenses then you cannot expect inferior enlarger lenses to produce the best prints. Be prepared to spend as much on an enlarger lens as you would on a prime, fixed-focus camera lens. Nikon and Minolta produce excellent, reasonably priced lenses. Many people aspire to Rodenstock since their Rodagon lenses are legendary for darkroom work. You may be lucky with budget lenses, but often they simply do not provide edge-to-edge sharpness until they are stopped down, creating extended exposure times and images that are difficult to see and focus on the baseboard.

Condenser lenses When buying secondhand make sure you check the condenser lenses; these should not be cracked or chipped. Slight edge blemishes don't matter to the final image, but they show that the apparatus has not been well treated. You may have to adjust condensers to give uniform edge-to-edge light coverage to the format of negative or transparency you intend to use. This is done by raising or lowering the condensers with the adjustment provided by the mounting screws. If you are uncertain about doing this yourself, a camera repairer can easily do it for you.

Useful accessories Along with your enlarger, you should budget for a number of ancillary items.

- Enlarging easel
 This holds paper flat and makes the creation of prints to various sizes (with or without borders) straightforward.

- Focus finder
 This simple but useful accessory enables you to focus on the grain and get pin-point sharpness on the base-board by magnifying an aerial image.

- Timer/exposure meter
 An enlarger timer is essential. Buy one that is easy to read and can be simply set to create reliable and repeatable exposures. If you can afford to buy an exposure meter as well, then this is useful for taking the drudge out of printing where you need to do repeat orders. It is also useful when dealing with negatives that are either light or dark but still capable of yielding good prints. Some exposure meters are combined with a colour analyzer that, after the setting-up, can be used to quickly assess filtration for prints.

- Colour head
 If colour printing intrigues you, invest in a colour head. The lamps produce light of a given colour temperature (the control is voltage-stabilized) and the strength of magenta, yellow and cyan filters can be dialled in for particular negatives or transparencies and corrections readily repeated. The novelty of making a test strip (see page 100) each time wears off, and many people think twice before setting things up in the darkroom because of the time taken: do everything you can to reduce the repetitive work and facilitate the business of producing prints. Performing colour corrections with an assortment of gel filters is not nearly as easy as having a colour head with three dichroic filters.

◀ All enlargers use a condenser lens to ensure even illumination. These have different covering powers; one for roll film will cover 35mm, but not vice versa. Usually, different focal length lenses are used. The longer the focal length, the longer a column needs to be to project the image.

—— 6x6cm
—— 6x4.5cm
—— 35mm= 36x24mm
—— 6x7cm

A black and white film can be developed with a few basic items of equipment. You will need a developing tank; a timer with a large, easy-to-read dial; a changing bag for film loading if you do not have a darkroom; a set of measuring cylinders; a photographic thermometer; and the chemicals (developer, stop, fixer and wetting agent), either as a kit or bought separately.

Developing tanks Opinions are divided as to the relative merits of plastic or stainless steel spirals: both types do the job and each has its aficionados. Plastic spirals are easier to load in the dark, but metal tanks and spirals are easier to keep dry and clean. A plastic 'universal' tank is a good buy, as it allows you to develop both 35mm and 120 film together using separate reels.

Loading the film As long as you have a changing bag to load film into the tank in complete darkness, the rest of the development can be carried out in the light. Loading the reel is a skill you acquire with practice. If you have never developed a film before, beg an old film length from a friend or photo store, and practise. Look at what you are doing at first, and then try to feel your way in a changing bag.

Developing the film All it takes to develop a film is to follow the manufacturers' instructions, but perfect results depend on getting things right consistently each time.

1) Pour the developer into the tank and start the timer; once settled, tap the tank to dislodge any bubbles that can impede chemical reactions in the film layers.
2) Agitate the film for 10 seconds every minute. You do not need to shake the tank vigorously, just invert it with a finger over the lid in case the top is not secure.
3) Ten seconds before the development period ends start to pour the solution out of the tank and into a jug. Pour in stop bath and agitate for a minute then return the stop bath to its container.
4) Pour in the fixer and agitate for 15 seconds, then for 10 seconds every minute for 3 minutes. Return fixer to its bottle.
5) Wash film under running water for 30 minutes .
6) Before removing the film, place a couple of drops of wetting agent in the final rinse to ensure even drying.
7) Attach a clip to the first few inches of the film and draw out the rest of the film.
8) Remove excess water with a squeegee, attach a clip to the other end of the film and hang to dry for at least 12 hours.

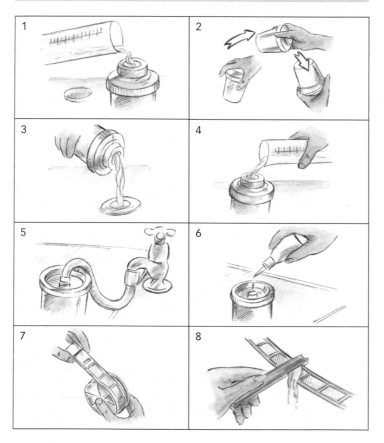

▲ *Successful film development is a question of following a recipe. The diagrams follow the sequence in the text – and for perfect results pay attention to the following: use colour-coded measuring cylinders to avoid contamination – one for developer and one for fixer – and do not mix them up. A few drops of a wetting agent in the final wash will help when you remove film carefully, and then squeegee. The film emulsion is highly vulnerable to damage at this stage – check there is no grit or film substrate on the rubber blades (wash before use) and apply with even pressure and one continuous movement before hanging the film to dry. Use a drying cabinet – homemade or otherwise to speed up the process and avoid drying marks.*

◀ This sepia photograph of my grandmother (right) and her sister was made in 1893. The print was damaged but the old negative was perfect, having been properly washed. It was in a pocket at the back of an old album and was used to make a new print in the style of the old.

Temperature control Development is affected by time and temperature, but only the development stage is temperature-critical. I like to keep all solutions at the recommended temperature – usually 20°C (68°F) – by standing the mixed solutions in their measuring cylinders in a bowl of water at the correct temperature. If you are working in a cold room, the bowl needs to be checked and topped up with hot water from a kettle, stirring to promote even temperature (don't stir water with a thermometer as they are easy to break and expensive to replace).

Washing and drying Film emulsion is made from soft gelatin that scratches easily when wet (and also when dry). If you want to avoid a lot of work later in touching in prints, be very careful at this stage. Regularly wash the blades of squeegee tongs; they collect dirt and particles of film substrate and cause scratches that you see only later as parallel lines down a film.

Try to dry a film uniformly in a dust-free atmosphere – a few drops of wetting agent in the last wash help. Don't try to accelerate drying the film with a hairdryer, since this can 'cook' the emulsion and lead to cracking. Drying cabinets are easy to make or to buy if you do a lot of processing.

Chromogenic film Some black and white films are processed in C41 colour chemicals. They produce the dyes during the development process and not from silver deposits. You can use the same system as for colour film development (see pages 98–99), but temperature control is much more critical than with traditional silver halide films.

◀ Afga Scala is a superb film that can only be processed by the manufacturers. With it, you can create black and white transparencies with a level of detail that is hard to match. Here, intricate carvings on the Alhambra Palace in Granada show the kind of subject at which monochrome excels.
Nikon F4, 60mm f/2.8 AF macro, f/8 at 1/60sec, ISO 200

Developing colour film

Developing colour films, both negative and transparency, is something that many photographers avoid. However, all it takes is a methodical approach; it is essential to obey manufacturers' instructions exactly to achieve optimum results. First, you have to give some thoughts to maintaining temperatures, because this is the only way that you will obtain consistent results without colour casts when it comes to the E6 process.

How to develop colour film

1 Mix chemicals according to instructions. Place in a thermostatically controlled water bath to reach working temperature.

2 Load the tank in a changing bag and place with chemicals in the water bath to reach processing temperature.

3 Pour the first developer into the tank and start timing.

4 Remove the tank periodically and invert to agitate and bring fresh chemicals into contact with the film. Keep ambient temperature around the same as the water bath and little heat is lost.

5 According to the process (C41 or E6), carefully drain and refill according to instructions. After a few attempts you will feel confident and will work methodically. Replace the tank in the bath.

6 Wash thoroughly as instructed using a jet connected to a tap. Add a few drops of wetting agent to the final wash.

7 Use tongs with rubber blades to squeegee dry before hanging up in a drying cabinet. The tongs must be washed well and be free of all grit and film fragments that can scratch a wet emulsion.

Colour film processors You can manage with a developing tank and water baths, but a small self-contained processor is a worthwhile investment if you intend to process colour film regularly and consistently. With a self-contained processor, you can deal with colour negatives, E6 process transparencies and chromogenic films. With the simpler units, chemicals are kept in bottles at constant temperature and you add them as the process demands. With the more complex units, the whole process is automated and a change of program can be made for any film.

You can also cope with up- or down-rating (changed exposure times when a film is exposed at anything other than the recommended ISO rating) by changing the recommended development time, though these films must be processed separately.

Tank processing You should always use a water bath if you are attempting to process colour films with a developing tank. You can immerse the chemical solutions in this some hours before use in order to bring them up to the required temperature. The tank can be placed in the water bath during use and then lifted for agitation.

Water baths Any substance will lose (or gain) heat if the surroundings are at a different temperature. The heat loss is greater the bigger the temperature difference between your developing tank (for example) and the outside. A water bath minimizes this difference and reduces heat losses. If you can get the water bath and room temperature to the same level, it is much easier to keep solution temperatures within the manufacturers' tolerances.

A large plastic washing-up bowl will work well as a water bath, preferably with a lid made from thick polystyrene in which you have cut bottle-sized holes.

Maintaining water-bath temperature

Water is a bad conductor, so to obtain a uniform temperature throughout the bath you must stir the water occasionally. It also helps to pre-heat the water bath using water from a kettle and stirring.

Small thermostatic heaters are available from aquarium stores and places that sell wine-making kits; with a little bit of experimentation, you can use these to keep your water bath at a constant temperature. The role of the heater is not to heat cold water from scratch, but to offset any heat losses.

It is a good idea to invest in an easy-to-read digital darkroom thermometer with a probe – it is much easier to use than a mercury-filled one.

The chemistry of colour film
development The chemistry of colour film development has evolved through various processes to leave two that are currently in general use: E6 for transparency film, and C41 for negative film and for chromogenic black and white films.

Users have the option of using chemicals from film manufacturers (Kodak or Ilford, for example) or buying kits from independent manufacturers (such as Paterson Tetenal) that might involve fewer steps. You will see little difference in results, and these are most likely caused by slight variance in technique.

Ultimately, the choice you make will come down to the cost per film. This can be greatly reduced if you buy in bulk – camera club members, for example, often share the expense since chemicals have a limited shelf-life.

▲ *Colour negatives, with their complementary colours and a colour mask, are nigh-on impossible to assess for anything other than density by examination alone. The top row taken from a contact sheet shows just how different the colours on negative and positive can be. To look for colour casts, etc, one must always make a contact print.*

Black and white printing

There is an art to black and white printing. Photographers like Ansel Adams give us an idea of the quality that it is possible to attain: fortunately, with care, most of us can turn out pleasing, if not completely perfect, prints.

Exposure test strips The key to good printing lies in making test strips for exposure. Even if you use a darkroom exposure meter, you will need to use test strips to calibrate it. Various gadgets are available, but a piece of card and a timer are all you really need.

1) Clean the negative using an antistatic brush or blower to remove any dust, which will show up as white spots on the print. Place the negative emulsion side down in the enlarger's negative carrier.

2) With the negative carrier fitted back into the head, focus a bright, sharp image on the baseboard with the enlarger lens wide open for the size of print that you have chosen. Use a grain magnifier to produce a sharp image.

3) For optimum lens performance, close the lens down to about f/11. The slight increase in depth of field compensates for possible focusing errors.

4) Insert a sheet of grade 2 paper into the easel, emulsion side up, with the safelight switched on. Set your timer to 5sec.

5) You produce strips by holding a piece of black card over the paper to reveal just one quarter of the total width. Expose for 5sec. Move the card along to expose the next quarter, expose, and repeat until the whole paper is exposed for 5sec. The first exposed strip has had a total exposure of 20sec and the last 5sec. You can use more strips if you feel that you want to assess smaller changes in exposure time.

Assessing negatives

With practice, you tend to develop an eye for which negatives will make a good final print. As a rough guideline, thin negatives will print very dark and not have detail in shadows, while dark negatives may reveal a surprising amount of detail but exposures must be greatly lengthened. It is not always easy to assess negatives, so it is worth making contact sheets by arranging negatives in a frame and printing them using the white light from an enlarger. You can store this as a positive reference sheet with the negatives from a particular film, together with any notes made whilst printing. This saves time for future use and makes results repeatable. If you use an exposure meter, you just dial in the times.

Producing prints However long you have been doing darkroom work, there is still a

How to develop black and white film

1 To produce prints, you will need three developing dishes filled with developer, stop bath, and fixer. Avoid contamination and keep the temperature at 20°C (68°F).

2 Take the paper and slide it, emulsion side down, into the developer. Start timing, and press with tongs to immerse the paper and wet the emulsion thoroughly.

3 Turn the paper and allow to develop for 90sec. Rock the tray gently to agitate the developer and bring fresh chemicals in contact with the paper.

4 Remove the paper with the tongs. Let the excess developer run back into the dish before transferring the paper to the stop bath for 10 seconds. Avoid contaminating chemicals.

5 Remove the paper from the stop bath and drain the print. Transfer it to the fixer and rock gently.

6 Remove the print from the fixer after 10 minutes.

7 Wash prints thoroughly to remove fixer. Resin-coated papers can be washed more quickly (4 minutes) than paper-based ones (which need at least 15 minutes).

8 Squeegee the print to remove excess liquid, and place in glazer.

9 Transfer to a drying rack.

a suitably sized piece of card fixed to a thin rigid wire.

Grades of paper Printing papers are available in different grades, from 0 to 4, according to the contrast they produce; 4 is the hardest. You can either change grade to compensate for different negatives, or use hard or soft papers for different effects and image types.

Papers are of two main types: the traditional paper-based ones, and the more modern resin-coated ones. The latter washes more easily, but is harder to retouch with dyes to remove blemishes. Different weights of paper are available. Double-weight papers do not crease so easily and are preferred for 'art' prints. There is also a wide range of surface textures and tints available, including matt, glossy and various stippled finishes. Gloss paper produces the best blacks.

▲ *Two examples made with different exposures show how negative density is affected. Get the exposure right and there is detail held in the shadows and the highlights underexpose. If the negative is too light it is overexposed; if it is too dark you should be able to show some detail if you then lengthen exposure. The second picture shows overexposure. All is not lost, however, because dramatic effects are produced when you then print on a hard paper.*

thrill in seeing an image slowly appear as the paper is developed in a dish. You can switch on the lights after about two minutes – any sooner and you run the risk of exposing undeveloped parts of the print and creating an unintentional Sabbatier effect (see pages 104–05). Colour developing is done in total darkness, often in a tank, and you only see the final result when the tank is opened.

Dodging and burning Often you will notice some areas on the print that are darker than you would like, and others that are lighter and lacking detail. You can darken light areas by giving extra exposure to them alone ('burning'). A piece of black paper or card with a hole works well. You move it gently in circles, to avoid creating hard edges where it lingers too long. Similarly, you can hold back exposure ('dodge') from a dark area using

▲ *Traditionally, printing papers have been available in various grades. 0 is the softest and 4 or 5 are the hardest and have more punch. Now, a single paper type, developed for different times, can act in the same way. A hard negative can be softened by printing on a 'soft' paper, and vice versa. Part of the art of black and white printing lies in the selection of appropriate paper to match the negative, along with immaculate technique at the chemistry stage.*

Colour printing

The first time you use your darkroom for colour printing, create a test strip to assess exposure for the negatives from which you are going to create a contact print. This is no more difficult than making a black and white test strip; there are just more steps in the processing. Use the test strip to assess contrast – forget about colour at this stage. Once you've made the test strip, you can correct exposure using the table below as a guide.

Colour printing The first time you use your darkroom for colour printing, create a test strip to assess exposure for the negatives from which you are going to create a contact print. This is no more difficult than making a black and white test strip; there are just more steps in the processing. Use the test strip to assess contrast – forget about colour at this stage. Once you've made the test strip, you can correct exposure using the table below as a guide – with practice it becomes easier to guess the amount of correction, although at first this is hit and miss.

Correcting exposure

Action	Neg/Pos	Reversal – Pos/Pos
Increase exposure	darkens final print	lightens final print
Decrease exposure	lightens final print	darkens final print
Dodging (holding back)	area lightened	area darkened
Burning in (print in)	area darkened	area lightened
Covering edges	white borders produced	black borders produced

Additive and subtractive colour

Film colour cast	Neg/Pos	Reversal – Pos/Pos
Too red	reduce cyan	reduce magenta and yellow
Too green	reduce magenta	reduce cyan and yellow
Too blue	reduce yellow	reduce magenta and cyan
Too cyan	add cyan	reduce cyan
Too magenta	add magenta	reduce magenta
Too yellow	add yellow	reduce yellow

You will sometimes find slight variation with the paper you use, so make a test strip with each batch, particularly to assess the basic filter pack you use (see below). In this way, your contact sheets will be correctly exposed and you can get the colours to a stage where, looking at your ring-around (see below) you can make fine adjustments for a print.

Colour casts and filtration Your test strip can be used to provide a guide to filtration. However, you have to remember that with negative printing, filters work subtractively.

To remove a colour cast the principle is to reduce the colour with reversal but increase it with neg/pos (or, alternatively, decrease the complementary colour with neg/pos). For example, you need to add a yellow filter to reduce a yellow cast. When printing from transparencies, you would decrease yellow filtration to correct a yellow cast. Correcting cyan and magenta casts is easy and the process is the same as for a yellow cast.

Cyan, magenta and yellow, used in pairs, behave as red, green and blue – for example, a cyan filter is red and green, so using them together is like having a green filter – the common colour that they transmit. Similarly, magenta and yellow produce a red filter, and magenta and cyan produce a blue one.

At first, the differences between negative and positive colour printing can be confusing. The table, left, shows what actions you need to take.

Getting colour right A useful aid for getting colour right is a ring-around (a set of prints with the perfect result at the centre) that shows how filters affect the final print in both additive and subtractive mode. Each of us has different likes, dislikes and styles, so the best answer is to make your own ring-around from a negative where the print shows a wide range of colours and tones. Colour casts in the test print can

then be assessed and removed by filtration when the final print is made.

Making a colour print The easiest and most reliable way of making colour prints, both negative and positive, is to use a colour drum mounted in a heated water bath with the solutions. A handle allows the drum to be turned to agitate the chemicals.

1) Insert the exposed print into the drum in total darkness. Replace the drum lid and continue in room lighting.

2) Pour all the chemical solutions into their respective colour-coded containers and set them in order of use in the water bath with

the drum. Use hot or cold water, stirring well in order to get the water bath temperature right.

3) The developer temperature must be exactly right. Check it, and then pour it into the drum. Start the timer and rotate as recommended in the instructions for your processor.

4) Drain about 15 seconds before the end of each stage; then replace the drum and repeat the routine.

5) Finally, remove the print from drum and wash it thoroughly in an open dish. Add stabilizer and then air-dry on a drying rack.

Assessing filtration in colour prints

A useful aid to make (or buy) is a display that shows the effects produced by small changes in filtration to create a colour cast. To correct a cast, match the colour cast on your print with one on the chart and subtract a filter of the value shown, or add the value of the complementary print.

20R · 10R · 10M · 20M · 20Y · 10Y · Correct · 10B · 20B · 20G · 10G · 10G · 20G

Traditional effects

With a little effort, it is possible to get some eye-catching and arresting results with traditional effects. Two of the best known are the Sabbatier effect and toning.

▼ *Top left is a lith negative used to make a lith positive (top right) by contact printing. These sandwiched and printed produced the result (bottom left). A normal print is used for comparison (bottom right).*

The Sabattier effect This is sometimes wrongly called solarization – exposure to the sun. It relies on exposure to light partway through development, to create a mix of positive and negative aspects on film. Undeveloped areas are darkened, while some intermediate tones are reversed.

For an idea of the results possible, you can flash white light over a development

dish when printing – it is easy to do this accidentally by switching the room lights on. More controlled results can be achieved with lith film. To produce the Sabbatier effect, create a negative (make a test strip first) and note the time. Then develop for half the recommended time, and then expose the film to white light from the enlarger whilst in the developer using the time you noted previously. Continue the development and other steps normally.

Sabattier-effect prints Your solarized positive can be printed using a hard grade of paper, or you can make a contact negative on sheet lith film. Combinations of negatives and direct-print positives can be made. You will find when printing from them that you can create quite distinct results. It is easy to get carried away in a darkroom, so you should make notes from the outset; it is often difficult to remember exactly how you achieved a particular result. Lith films need special developer. Further techniques, like posterization (where blocks of tone replace gradation) can be generated from sandwiches of normally exposed, under- and overexposed lith film.

Darkroom chemistry Toning does not appeal to everyone and some chemicals have unpleasant odours (particularly sulphides for sepia toning), so ventilation is essential. If you do not like the idea of lab work, then ask a chemist to make up the solutions, or share the costs with someone who is lab trained.

Always take care when handling chemicals:

- Wear rubber gloves to avoid skin contact and possible allergic reactions.

- Wash your hands well before touching food even if you have been wearing gloves. Wear safety goggles when mixing chemicals to avoid eye damage from accidental splashes.

Never add water to concentrate acids – they splutter as heating occurs.

Toning recipes

The process of toning using chemical baths replaces the metallic silver in a print. It is essentially darkroom cookery and brings out the latent alchemist in photographers.

▶ The tower picture began as a black and white negative for an excursion into toning with chemicals – something I had not done for a decade or more. Prints produced on multigrade paper were then subjected to toner baths. There is a depth of tonal gradation that the digital process does not produce which not even book production can do justice.

Type of toner	Sepia (sulphide toner)	Blue (iron toner)	Reddish/pink (nickel toner)
Effect	Print with full range of tones	Light density print (the process darkens tones	Contrasty print (the process reduces contrast)
Solution recipes	*Bleach* • Potassium ferricyanide 50g • Potassium bromide 50g Dissolve in water to make 500ml Dilute 1 part bleach to 9 parts water for use. *Toner* (can be re-used) • Sodium sulphide 25g • or thiourea 0.1g • Sodium carbonate 50g Make up to 500ml. Use undiluted.	*Solution A* • Potassium ferricyanide 1g • Sulphuric acid (concentrated) 2ml Dissolve in water to make 500ml *Solution B* • Ferric ammonium citrate 1g • Sulphuric acid (concentrated) 2ml Dissolve in water to make 500ml Mix equal parts A & B before use	*Bleach A* • Nickel nitrate 25g • Potassium citrate 75g Dissolve in water to make 500ml *Bleach B* • Potassium ferricyanide 20g Dissolve in water to make 500ml Mix equal parts A & B. Acidulate with a few drops of citric acid solution *Toner* • Dimethylglyoxime (saturated solution in alcohol) 50ml • Sodium hydroxide (0.4% solution) 50ml Make up to 500ml by adding water Fix the image after bleaching with 5% hypo (sodium thiosulphate) for five minutes.
Comments	Bleach first to convert silver to silver bromide. The print will be light straw – rinse. Darken it with sulphide or thiourea. You can selectively tone by bleaching only certain parts or partially tone by diluting toner.	The toner converts the silver to iron salts producing the colour by creating Prussian blue. Remove the print before the effect is too pronounced. Wash thoroughly. Store in the dark.	Dimethylglyoxime turns pink in the presence of nickel ions and is used in the lab to test for its presence. Print a nickel-toned negative on neg/pos colour paper to get a green-toned effect.

The digital darkroom

The beauty of digital work is that you can arrange equipment to suit the space available: in fact, your workspace need be little more than a desktop. With time, as you purchase a scanner, printer, extra drives and perhaps a second screen, you will need a larger space. There are several things to bear in mind, however you set up your workspace.

One solution Everyone will solve their problem in a different way, but I and my partner have had to contend with a period of several moves when the same system had to fit different spaces. A single computer desk, though a good way of siting a small system, just does not work for two people and two computers, one of which has twin screens. On the basis that you can never have too few filing cabinets, we set up several workspaces where a substantial length of heavy ply (a post-formed kitchen worktop will work well, too) sits on top of three filing cabinets: between each pair is the leg space. In this way, you create a generous work surface and the set-up sits along one wall. It is an easy solution – but not the only one, of course.

Power supplies You will need several electrical outlets as computers and ancillary equipment proliferate leads like a spaghetti factory. Power consumption is low with computers and related equipment, so you can safely run things from extension leads with four or more outlets – but don't wire more than two items into a single plug. If you live where power supplies are at all uncertain, then a back-up battery is essential: this allows you time to shut down the computer and other hard disks without losing data or getting that heart-stopping message 'disk unrecognized' when you next switch the machine on.

Work surface Any desk should be rigid enough to hold a monitor. A 15in monitor is heavy enough; a 19in monitor weighs much more. If you have two monitors, you will need substantial support. I use a wood surface over filing cabinets set against a wall so there is no risk of wobbling. If you have a flatbed scanner then a vibration-free surface is essential – sudden knocks can ruin a scan and vibrations can be transmitted from fans in computers. For this reason, my scanner is set on a wide shelf fixed to the wall above the computers.

Lighting Screens should not sit opposite windows or lamps. Curtains or blinds prevent direct light from falling on to a screen and help to improve image contrast. Many people work with a screen that is too bright, and this affects images when it comes to printing. Place desk lamps on a shelf above, where they can provide light on the desk alone.

Seating Buy a decent typist's chair that places you at the right height, supports

▼ Twin screens are not essential but we would miss them for working with Photoshop. The set-up shown with its table set on three filing cabinets has now had three homes – with only a slight amount of sawing needed to adjust to Italian walls that were never straight when made two hundred years ago....

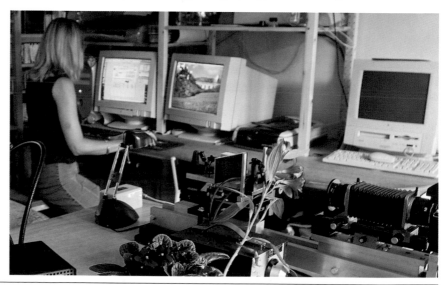

your back and legs and keeps your fore-arms horizontal (or even inclined down-wards slightly) when at the keyboard. If you use an old kitchen chair, for example, it's fine for a while but then the aches start. Make sure there is sufficient space for your legs under a desk; some computer desks use this area for storage. Fortunately, image processing involves irregular keystrokes and mouse movements, rather than the stressful keyboard work that leads to repet-itive strain injury (RSI). However, working with on-screen images is seductive and you will spend more time than you think sitting – which is not a good thing.

Working comfortably Leave the screen to get up and walk around at least every hour. After two hours, give yourself a much longer break. Many people find that moni-tor work at close quarters causes eyestrain – this is where gazing out of the window at distant objects is an essential rather than a wasteful activity! If you feel uncomfortable or start to ache, then do something else. Niggles such as a dirty screen, a sticky mouse, and keys that will not respond add to stress: cleanliness might not be next to godliness, but it helps to preserve sanity.

Computers for digital photography

The rate of change of computer systems is astonishing. As newer versions of software appear they become ever more memory-hungry; image files get larger; and hard disks that you thought had vast storage space when you bought them, fill up quickly. Thus, although a large-capacity hard drive is useful, the most important factor for imaging work is to buy as much RAM (Random Access Memory) as you can reasonably afford.

Connections Although you may start with a basic computer, you may soon want to connect add-ons such as extra hard drives, scanners and printers. You will need to transfer information (files from cameras and scanners, for example) to and from your computers as quickly as possible. There are several options.

SCSI (Small Computer Systems Interface) Just a short time ago, this was

the standard used for connecting printers and scanners. SCSI's heavy and expensive cabling has made it unpopular, but it can handle data transfer speedily.

USB (Universal Serial Bus) USB devices interconnect quickly and easily, and the data transmission speeds are fine for print-ers and for smaller cameras. For larger files from digital SLRs an upgrade to USB2 is advisable, and that usually means fitting a new card into the computer to provide higher transfer speeds.

FireWire (IEEE1394) This provides very high data transfer speeds and is favoured by top-end digital cameras, external hard drives, etc.

Macintosh or PC? A touch of opportunis-tic genius on the part of Bill Gates led him to focus on developing an operating system rather than a computer: the rest is history, and now the majority of the world's computer users sit in front of a PC using Windows. However, most professionals working in design, and in other parts of the media where imaging is vital, use Apple Macintosh computers. Macs are much easi-er to use and their operation is more intu-itive than Windows-based computers. From the viewpoint of a digital photographer, the system from camera through manipulation to output is beautifully integrated; related programs work seamlessly, allowing you to drag files from one application into another.

▲ A transitional period and a move to Italy left us with basic equip-ment – an iMac, back-up hard drive and digi-tal camera. With inter-net access, the system worked perfectly. The subject, a kitten pho-tographed many times since, was used for the test shot in the set-up.

▶ *When choosing equipment that involves the down-loading of image files, you need the fastest connection you can get. Here, the portable hard drive has two FireWire ports on its rear, allowing fast data transfer to and from the computer.*

▼ *However much you believe that the computer you buy will meet your every need, it will not. As imaging files get larger, software becomes more memory-hungry and you rapidly fill drives. A portable hard drive is a way of expanding your computer's own capacity for storage.*

Usability Macs are more expensive, but I and most other Mac users would unequivocally recommend the system: with PC users, that is not the case. Peripheral devices are easy to add to a Mac and memory can be increased without fuss. With a PC, it is often necessary to re-install software after doing this. Macs simply connect together to network; Mac users can connect two monitors and divide the screen (see page109), while PC users have to buy a separate video card. Macs did once suffer from a frustrating inability to run several programs simultaneously. With the UNIX-based OS X system, that is no longer a problem. In addition, Macs can run any Windows program through Connectix Virtual PC software and read Windows-produced image disks of any type. The converse is not true.

Colour management Colour calibration and management, an essential part of successful imaging, is easy and reliable on a Mac through Colorsync, so that the image on a transparency, on screen and on the printer can be made to match painlessly. For many PC users, the business of achieving such compatibility takes a long time and a lot of fiddling.

Laptop or desktop? A laptop offers portability with no decrease in performance but an increase in price. When working away from home for several weeks, a laptop is a wonderful editing tool. If images need to be transmitted to a publisher a laptop is perfect as long as you can secure a fast internal connection. You can burn sets of images to CD for extra security, as laptops are often targeted by thieves.

Software For the home user, the regular introduction of new versions of software can be a headache, especially when the designers seem to avoid backwards compatibility so that you eventually have to upgrade. It is hardly surprising, given the high prices charged, that many people resort to using illegal copies of the best known and most used software programs, but this practice is to be condemned since it drives up prices.

There is a wide choice when it comes to image-editing software. At the top of the tree sits Adobe Photoshop, which is used by professionals worldwide. It is not the most intuitive program to use, but its potential is inexhaustible. Photoshop Elements is the cut-down version. It is bundled with many scanners and printers and is excellent for home use. It is so widely available that all processes in this book are described in relation to it and it offers extra features such as panorama creation. Other programs will give equally good results: JASC Paint Shop Pro (Windows only), PhotoRetouch Pro from Binuscan and Corel's Photo-Paint Core all have their aficionados.

Monitors

A monitor screen is central to all your digital photography, so you should buy the best you can afford if you want to do justice to your images. Best need not mean biggest, as you can use two screens to split the viewing field (see below).

Monitor requirements A screen of 15in (38cm measured along the diagonal) is the minimum for image manipulation with a cathode-ray tube (CRT) monitor. Screens of 17in and 19in are even better. The screen should support a resolution of 1024x768 pixels or, better still, 1600x1200 pixels. It should also offer 'millions of colours'. If your existing computer does not allow this, then a new video card might well be a sensible purchase.

CRT flat screen monitors

These tend to be better for imaging than slightly curved monitors as they reflect less extraneous light and are usually of higher quality. They are more expensive because they are harder to manufacture.

Liquid crystal display (LCD) screens

These have become increasingly popular. They are still markedly more expensive than CRT monitors, but their prices have come down (and driven down CRT prices, too). They are lightweight and their slim design takes up very little desk space. The flicker-free images are bright and easier on the eye than CRT monitors, although some people maintain that for critical work they do not yet match CRT screens.

Managing colour Getting realistic colours that match the original scene with that on screen and then the output from a printer is essential for all successful imaging work. The key to getting it right begins with the monitor.

Calibrating a monitor sets up brightness and contrast to an accepted standard and also gives a 'colour profile' of the monitor that can be appended to image files or used with printers. You can either use utilities supplied with your system or buy one such as Adobe Gamma. This can be used with a Macintosh or a PC. If you are not a Photoshop user, you can still access it from any trial version free with a computer magazine or from Photoshop Lite. ColorSync, a utility present in Mac systems, allows you to match scanner input, monitor appearance and printer output to a high degree simply by turning it on.

▶ Mac users can set up their computers to power two screens via the Monitors control. With PCs, this facility is available through graphics cards. This is especially useful if you want to, for example, display a whole image and work on part of it with Photoshop. A single large screen with a small monitor to handle menus is also worthwhile – when you upgrade your equipment, keep hold of your old monitor.

▶ *The iMac is a design icon, often seen in the offices of the cognoscenti and the hip in films. It also happens to be a superb computer, because, as with many flat screens, the directionality is disturbing. View them from the same front-on position each time when making image adjustments, since veering from this produces changes in image brightness and you can easily make mistakes in assessing the brightness/contrast corrections.*

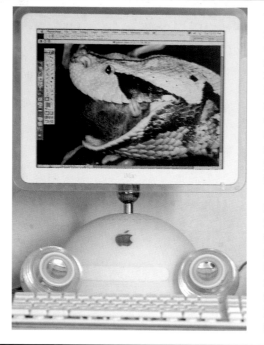

The twin screen approach Before you go to the expense of buying a 20in monitor capable of handling a double-page A4 spread, you could have the equivalent of a 30in-plus screen much more cheaply. With PCs, a video card will give you a second monitor outlet. With a Mac, it is a question of using the outlet already provided. If you open the monitor's control panel and select 'arrange', you can decide whether you want your main monitor left or right by dragging the image.

Many people have a 17in or 19in screen for the main work in Photoshop and have all the control panels on a 15in screen at the side. You just drag from one to another as if you are passing the pointer out of one monitor into the next. When you have worked in this way for imaging purposes, it is hard to imagine going back to just a single screen.

Monitor calibration

Monitor calibration depends on your visual judgment (which may welldiffer from someone else's) unless you use one of the calibration devices now being marketed.

■ When asked by the utility, set gamma = 1.8 and white point = D50. This corresponds to a colour temperature of 5000K, although many graphic artists use a white point of 6500K because it looks better on screen.

■ Make the monitor only as bright as the calibration allows.

■ Balance the colour by judging when plain squares merge into the line background.

Getting the best from your monitor
■ For the best line of vision, try to have the monitor top just about level with your gaze or slightly higher.

■ Always make sure that no light from windows or from interior lamps shines directly on the monitor screen. This will reduce the contrast of the image, and you might make the wrong corrections to a file that does not appear bright enough on screen.

■ Don't be tempted to turn up screen brightness or contrast: when your scans are sent to someone else with a properly adjusted monitor they will look very different from what you intended.

■ Hoods for monitors are easy to make and effective as long as they are at least 20cm deep. Usually they can be tapered down towards the monitor base. Twin screens can be encompassed under a single hood to form a convenient unit, free from unwanted reflections.

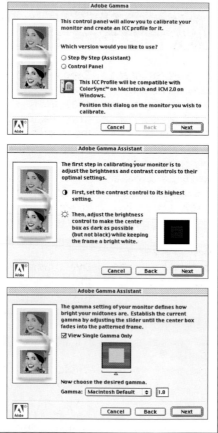

Printers

The last step in the chain that begins with a camera or scanner is the printer. At a reasonable cost, you can find one that produces prints that are every bit as good as a high street photo-processor.

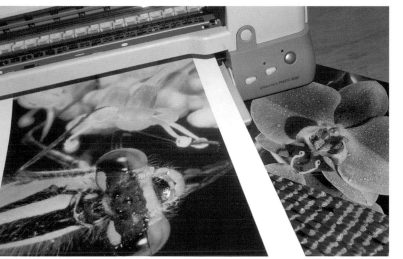

▲ *The excitement at seeing high-quality inkjet prints appear on your desk top with a minimum of fuss is great. Just a few years ago, top-quality prints were produced with a lot of wet chemistry by skilled amateurs and pro labs. Now, exhibition-quality inkjet prints can be produced by virtually anyone with just a little care.*

Types of printer Although there are various types of colour printer available, most photographers will opt for an inkjet printer since they bring superb print quality within the range of anyone. Other types of colour printer to consider are:

Colour laser With these, coloured toner is picked up by the paper after passing over an electrostatically charged drum. The toners are built up one at a time, making four passes for a complete print.

Dye sublimation These produce results that look most like photographic prints. Dyes from a ribbon 'sublime' (change from solid to vapour) when heated and are deposited on to paper. The quality is excellent, but equipment and running costs are high.

Choice of paper An inkjet paper is a sandwich of layers designed to allow controlled ink absorption: if drops spread too far they are not fine enough to depict detail without a drop spreading. Papers vary in weight, expressed as 'gsm' (grams per metre squared). The higher this density, the greater the paper thickness.

Surfaces vary from matt through to glossy or even metallic, with a range of canvas and other material effects, too. It is not an easy choice, because different makes can show quite disparate colour response to the same colour file and printer settings. Different types of paper absorb colours differently and you have to make your own tests.

Before using any of the 'heavier' papers, check to see that your printer has a thickness adjustment and can accept the paper – it is an expensive mistake to make.

Inks Some informed commentators maintain that manufacturers of printing systems sell their printers almost as loss leaders at a low price on the basis that you will spend a great deal on inks and paper later on when hooked by this process. When manufacturers' prices are inordinately high, should you use those from an independent source? First, accept that using anything other than the manufacturer's inks will render your printer guarantee worthless, and that printers have a finite life. That is an important point when your printer is hard-working. A manufacturer's inks are (usually) proven in terms of light-fastness. All you can do is try a set – for example if you are producing a set of leaflets that might drink one cycle of inks – and see what the result is like.

Continuous ink systems For photographers who do a lot of inkjet printing, and for anyone selling prints on a regular basis, the initial cost of a continuous ink system is soon recouped over savings on individual ink cartridges. Furthermore, you can refill colour bottles individually and don't have to throw away a cartridge when just one reservoir is depleted.

Output resolution Simply because a printer claims to offer 2880dpi does not mean that its results will look any different from a 1440dpi printer, though it might work more slowly. The truth is that a printer might lay dots one on top of another (to simulate grey tones) and not separate them to give more detail.

The only way to test output resolution is to make a test print. Take a file containing a range of colours and plenty of detail. Produce an A4 (8 x 11½in/20 x 30cm) or larger print at 300dpi, and then reduce the resolution to 180dpi but keep the print dimensions. The chances are that you will see little or no difference if you view this print from normal viewing distances of a metre or so. A quick calculation shows that 180dpi is pretty close to the eight lines per millimetre that has long been accepted as the yardstick for capturing detail on a photographic paper, since the human eye cannot resolve more detail than that at normal viewing distances.

When supplying digital files for use in magazines and books, you will usually be asked for images of 300dpi, but this has more to do with matching the frequency of the dot screen they use when printing, and making sure that a file is big enough to have captured details.

▲ *The drive components of all inkjet printers are a marvel of plastics engineering. The few metal parts seem to be screws and the rail on which the printer carriage moves. They are seldom repaired; malfunctioning components are simply replaced. Built-in obsolescence seems inevitable, with an estimated life of three years before you will want to change to the latest and greatest.*

◄ *I never know what a picture will be used for. However, I usually know where it is intended and shoot at the highest resolution (usually RAW) to retain as much data as possible. On a day when one card failed, I set the resolution to JPEG fine. The 2MB file expands to 17MB, and, to be honest, I can never see the difference between this and the largest TIFFs.*

Tone and dpi

There is no doubt that dpi (dots per inch) is used as a selling point. The size of the ink blotch on paper is controlled by paper absorption characteristics, drop size, ink surface tension, and so on, so there are physical limits. Where high dpi scores is in the way the ink is laid down by dots made in a cell (there are 16 dots per cell). To fill every one black produces the darkest tone: one dot is 6% grey, 4 dots 25%. In theory, with high dpi, greater subtlety in the tonal gradation of greys and colours is possible.

Destination	Image size	File size	
Web pages	480 x 320 pixels	0.45MB	
screen resolution 72dpi aspect ratio 3:2 (as for 35mm frame)	600 x 400 pixels	0.7MB	
	768 x 512 pixels	1.12MB	
	960 x 640 pixels	1. 75MB	
Print Media		**Ink-jet Print 200dpi**	**Magazine 300dpi**
	3x5in (7.5 x 12.5cm)	1.7 MB	3.86MB
	4x6in (10 x 15cm)	2.75MB	6.18MB
	8x10in (20 x 25.5cm)	9.16MB	20.68MB
	A5 5.85 x 8.25in (14.85 x 21cm)	5.5MB	12.45MB
	A4 8.25 x 11.7in (21 x 29.7cm)	11MB	24.9MB
	A3 11.7 x 16.5in (29.7 x 42cm)	22.1MB	49.7MB

Alignment and nozzle clearing Most inkjet printers function better when used regularly since this keeps the nozzles clear. If you notice lines across a print or poor colour this may indicate that one or more nozzles are clogged. All printers have cleaning routines that flush ink through – the disadvantage of this is that it uses a lot of ink wastefully. A final test print enables you to tell if any nozzles remain clogged. After periods of non-use in warm weather you might have to go through this routine twice or more.

Inkjet printers are highly sophisticated electromechanical devices and moving parts can become misaligned. Close examination of a print might show colour fringing at the edges, for example. This can be corrected with a 'routine' built into the printer. Some up-market models will do this for each colour; others align black.

Printing with profiles Colour profiles that can be accepted by photo-manipulation software and printers offer a very good way of matching the output from your printer to a screen image. Epson, for example, provide profiles for all their printers. Some people offer to make them for you according to the equipment you use – the payment can save you a lot of hassle.

How many inks? Basic inkjet printers use a four-ink process (magenta, yellow, cyan and black). More sophisticated inkjets have two extra tanks, of light yellow and light magenta, enabling more subtle rendition, particularly of light tones with detail. The cartridges are, needless to say, more expensive.

Different colour ranges With film there are great differences between what prints and transparencies reveal. The former you see by reflected light and the latter by transmitted light, which allows a much greater range of tones, or colour gamut, to be reproduced.

Monitors that work by illuminating red, green and blue phosphors on a screen; colour printers that deposit drops of magenta, yellow, cyan and black ink; digital cameras; scanners; and your eyes all deal with different ranges of colour. You will never get a perfect match for all stages, so opt for one that pleases you. The result may not be quite what you think you saw, but on the other hand it looks good. Accept that and save yourself a lot of grief searching for image perfection.

▲ *For best performance, you will need to check the printer output regularly – a clogged jet will create lines across the paper. This often happens if a printer is not used for some time. When I printed this shot, the edges came out blurred although they looked ultra-sharp on the original roll-film transparency. Further examination showed that dots of different colours had shifted. Most printers have an alignment routine for you to correct this.*

◀ *A good test of any printer is the way it handles the subtleties of shading in snow. Snow can also show up the differences in colour rendition between monitors, scanners and printers because you will see colour casts easily on the white.*

Scanners

Many people have made their first forays into digital manipulation by purchasing a scanner that allows digital files to be created from film (either positive or negative) or from prints. The top of the range is the drum scanner: this has the highest resolution and a price to match. For the home users, the options are the flatbed scanner or the dedicated slide scanner.

Flatbed scanners Cheap flatbed scanners are little more than toys, but there are now some excellent flatbeds available, such as the Epson 4350, which is capable of dealing with film formats from 35mm to sheet film. These produce detailed scans of wide contrast range that compare favourably with those from dedicated slide scanners.

Dedicated slide scanners Current models have come a long way since their introduction, and the home user can easily produce files suitable for publishing or for printing to A3 (11½ x 16in/30 x 40cm) and larger. Some units have lenses made with low-dispersion glasses, and the results look beautifully crisp. Supplied software will often identify and remove scratches and other blemishes, though at the expense of a tiny degree of sharpness that can later be restored via an image-manipulation program. If you need only 35mm scans, then a dedicated film scanner is the answer.

Noise and artefacts Scanners introduce 'noise' (random pixels) into an image; I find that 17MB files from a six megapixel digital SLR are at least as clear as those of 25MB and above from a slide scanner. Transparency scanners that can deal with roll film and sheet film in various sizes are prohibitively expensive. Here, a good flatbed is a reasonable proposition for the home studio.

The flatbed as a camera Some scanners have a hinge arrangement that allows books and other thick objects to be placed on the glass. If you can support the lid with small wooden blocks or something similar to avoid squashing whatever you place on the scanner, then you can use the flatbed as a camera with surprising results and good depth of field. It is important to shield the scanner from extraneous light by covering it with black felt or similar whilst scanning. If you are scrupulously clean (use soft optical cloths and a blower brush to remove dust) this will mean less 'tidying up' of the final image.

Your scanner as a camera

Placing fairly flat objects on a scanner surface allows you to take photographs. If the object is a flower or something that will leave a mess when squashed, raise the lid slightly on strips of wood and place a black cloth over it when you scan. On a quality scanner, the results are astonishingly good. They have appreciable depth of field because of the way the image is produced and focused in strips.

▲ *Scanner Software (here Epson's) will either operate on an 'auto' basis or allow you to make adjustments to density, colour and so on. You are presented with a preview that then allows a series of transparencies (four in this case) to be scanned to the size and resolution you want – make sure the scan is large enough for the use you intend: if in doubt scan to a high rather than lower resolution.*

transparency records detail over a six-stop range; black and white has a nine-stop range; and digital cameras cover around seven stops. A dedicated film scanner has a dynamic range of around 4.2, while that of many flatbeds is much less. To record as much of the original as possible, go for a dynamic range of at least 3.4.

Bit depth Bit depth refers to the captured colour 'palette'. For example, 24-bit depth means a palette of 16 million colours, while 36- and 42-bit depth runs into billions of colours. Whether you will see any difference between 24- and 36-bit depth with your inkjet printer is debatable, although marketing spiel might try to persuade you so.

▲ *A good slide 35mm scanner is expensive and essential for the maximum detail from your transparencies – for roll film the cost is prohibitive for most of us. Most libraries want the best and will drum scan: you cannot compete but a good flatbed scanner will let you produce scans that do justice to your work and are more than adequate for use both in books and in magazines.*

Interpolation The high values quoted for scanner resolution are gained by interpolation, a process where the software adds pixels according to the values of adjacent pixels. Although it can make images look 'smoother' in the sense of there being less abrupt colour transitions, no more detail is added. There is a huge difference between a genuine 4000dpi scan from a slide scanner and an interpolated one from a flatbed when you produce king-size enlargements, so make sure you know the true resolution of a scanner before you buy it and be sceptical about any exaggerated claims.

Input and output file sizes If you purchase a scanner that has a genuine optical resolution of, say, 2700dpi then you will produce files of just over 20MB. These will give high quality 300dpi scans for A4 (8 x 11½in/20 x 30cm) magazine pages and decent A3 (11½ x 16in/30 x 40cm) prints if you output at 180dpi. With any scanner, you have to keep an eye on the input and output file sizes. If the output is larger than the input it means the scanner creates data by interpolation (see right). Up to about 50%, this is not noticeable at normal print viewing distances.

Dynamic range The ability to handle a wide range of tones and contrasts keeping detail in shadows and highlights alike is known as the dynamic range. A colour

▼ *Until recently, dedicated slide scanners produced far better results than flatbeds unless high prices were paid. Times change rapidly, however. Scanners are now available that will scan a group of 35mm transparencies or roll film and produce files capable of generating prints of A3 and larger. This is ideal for those people who work in several film formats.*

Basic digital manipulation

There are innumerable ways in which a digital file can be manipulated on screen and then on the final print. Here, we review the processes that are genuinely useful to a photographer rather than playing around with filters and effects on screen. Photoshop Elements is widely available bundled with scanners and printers, so all the suggestions below are based on it. These processes can also be duplicated in other programs with little difficulty.

▼ Versions of Photoshop later than 5.5 have a file browser utility. Tap at the top right of the screen, click, and select the folder to open and all the photo icons appear. Click on any that you want to open.

Getting an image on screen The first step in any photo manipulation is to open an image on the computer desktop. If you work with any photo-manipulation program and the file does not open automatically, a dialog box should come up stating that the program that created the image cannot be found and offering you a choice. Many people working on files open Photoshop first and then open individual files using File > Open. Some computers are preset to open files through whatever image program they are bundled with and you can waste a lot of time trying to change this.

Browsing When Photoshop is open, the file browser tab appears in the top right-hand corner of the screen. Clicking on this brings up thumbnails of whatever files you might want to work with. Even better, you can then rename files and rank them in any way you choose – this strategy makes access much easier.

Cropping and resizing Files can be cropped to any square or rectangular shape you want, or, using marquee tools, to elliptical and circular formats. In Photoshop you can set a colour for the cropped area to show exactly what you are doing. Pictures can be resized via Image > Image Size. You can work in inches or centimetres (for prints) or pixels (the most convenient for web pictures).

If you want to scan to crop to a fixed size for use on a website – say, 600x400 pixels at 72dpi – you can set these dimensions on the toolbar in Photoshop and other programs.

Picture size and file size When you change picture size, the resolution changes as well. The computer does the arithmetic; if you are making big enlargements but trying to keep to 200dpi print resolution, for example, then the computer increases the file size by interpolation (see page 115). Up to 50 per cent increase and you will see virtually no change. Even with exhibition prints, at normal viewing distances you will see no discernible difference between prints produced at 200dpi and those at 300dpi. However, the file size is much smaller with 200dpi, as the dialog box shows. Remember that reducing overall file size means cutting pixels and thus losing data. If you see that the file size drops in the dialog box, then consider whether you need the data in the original file. Use Save As for the new size file and name it before you hit the OK button.

◀ As well as allowing you to crop to different rectangular sizes, most imaging programs let you rotate the scene to get horizons straight. You then re-crop to a rectangular shape. Don't set too many degrees in the box even if you think the picture needs it; just try to increase by small increments until it looks right.

Rotation Using Image > Rotate, pictures can be rotated by 90˚ clockwise or counter-clockwise to change them from a horizontal to a vertical format and vice versa, or through 180˚ to turn them upside down. By flipping an image horizontally you can create a mirror image, while flipping an image vertically turns it top to bottom. When a horizon is not straight, a picture can be rotated to any extent you like (using Image > Rotate > Arbitrary) and the result then cropped to produce a rectangular frame.

History palette The history palette records the steps that you make in any manipulation and allows you to go back to any point in the process and modify it. You begin again from that point. Unfortunately, the history – the way you have created a file – is lost when you close the file. You cannot open a file again and go back to an earlier point in the creation process. However, if you have worked in layers (see pages 118–19) for each step then each layer can be preserved and changes made without starting again. Working with layers greatly increases file size, however.

Cropping to landscape

Imaging programs generally produce a mask where the area to be cropped becomes highlighted. Clicking generates the hand tool, which you can use to move the mask up or down to change the balance of a crop. Maybe you'd like one-third sky, two-thirds land, or vice versa – you can have anything you choose.

Working with layers

Whenever you need to make a selection of a subject to blur it, change its colour, to work on the background, or even to introduce another scene, the best method is to use layers. Each layer is a separate file. Think of them as acting like individual acetate sheets that can be mixed, blended or moved relative to one another as you choose, while keeping the original image unaffected. Layers make the possibilites for image adjustment much greater.

■ Adjustment layers. These permit you to vary tones and contrasts and make corrections and text layers.

■ Text layers. These allow you to add titles for slide sequences or create watermarks for your pictures.

All of these layers can be blended to any extent you choose, because you can adjust their opacity individually. The final image is flattened to save file space – working in layers increases the size of files dramatically and you will find you need all the RAM you have on your computer. Layers remain adjustable until the flattening process.

Options with layers The layers menu presents an array of possibilities. There are too many to detail here, but the most useful for the practical photographer are:

■ Duplicate layers. These leave an original untouched.

Backgrounds: blurs One useful process uses selection to create a layer in which you work on the background independently of the main subject. First make a selection and then use Inverse to select the background. A blur can be created by a filter, for example: Filter > Blur > Gaussian Blur;

Making colour adjustments

Colour adjustments are best made in a separate adjustment layer either using the Curves or Levels controls. Curves (Image > Adjustment > Curves) allows you to control contrast between tones in a given range moving a point on a curve. Levels (Image > Adjustment > Levels – illustrated here) shows the tonal range as a histogram – a statistical map showing the relative proportions of tones. There are three movable pointers:

The end pointers (left = dark point, right = white point); keep the white slightly below maximum to keep highlights from burning out. With black slightly higher than minimum, shadows detail is retained. Move them closer to increase contrast. The centre slider changes density overall. The auto button makes the brightest pixel white, the darkest black and spreads values between a useful start.The sequence from a to e shows:

a the original image

b The sliders have moved closer, producing a very contrasty image

c A single channel – blue is selected

d Moving the central pointer right enhances the complementary colour (yellow)

e Moving the slider right enhances the blues

a

b c d e

this looks much like the effect that you get by opening up the aperture in order to make depth of field shallower. It is easier to work by creating a layer into which you paste the background.

Backgrounds: fills You can cut out the background selected and fill instead with any colour you want from the colour circles. Cut-out images are now a feature of many books: they start with a carefully selected, cut and feathered image. For a white background you either pick what you think is white from a colour display, or set the following numerical values in the dialog boxes: red 255, green 255, blue 255.

Selective sharpening It sometimes happens that parts of an image need more sharpening than others. To do this, you create a separate layer, select the required area and then sharpen it in the new layer. The layers are then blended. Burning and dodging can be effected in the same way, or directly via the special tools in the tools palette.

Cleaning and correcting images

However carefully you keep negatives and transparencies, you will find dust marks and blemishes after scanning (the greater area of a flatbed scanner makes these worse culprits than dedicated slide scanners). Most digital cameras will pick up dust on the sensor, and you will find you need to do a great deal of 'spotting' of your images to clean them.

By creating a duplicate layer, rather than working on the original in high magnification, you can remove dust spots and repair scratches using the healing brush or the even more versatile clone tool (see below). You can also press a button and let one of the filters do it for you – but this way you abandon the subtlety of fine control.

Clone tool For general image repair work, the clone tool is unbeatable. After selecting the tool from the tools palette, you define the pick-up point (Option + Click) and by clicking can drop pixels from this point (and adjacent points as you move around using the mouse) to repair scratches and other

blemishes. The pick-up point can even be in another file. You can also clone whole images from one picture to another.

Effective image repair takes a good eye and some care. Work on small areas. Use a brush with a fuzzy edge, and change the sample point when working on a long scratch, for example, otherwise you will see the repair.

▼ *To create covers and cards, many imaging programs allow you to add type. Here, the original was slightly colour-corrected and a duplicate layer (in which to place the type) was created. Everything else was done with the type tool from the face selected to the bevel edges and the curve.*

Digital black and white

Many photographers who had been shooting almost entirely on colour film have rediscovered the delights of monochrome by removing colour from digital files. There are quite a few ways of doing this in image-editing software, as discussed below. Another option is to use inksets that provide a cartridge with different grades of black ink for each of the colour inks of an Epson printer, allowing you to print superb monochrome directly from a colour file.

Desaturate This first method of creating a monochrome image is simple and effective – you use the desaturation command (Image > Adjustments > Desaturate), which simply leaches all traces of colour out of the original.

Colour channels With RGB colour (red, green and blue), a picture is made up from an array of dots of phosphors on a screen. There is a different channel in most photo-manipulation programs that contains information for each of these primary colours.

Each colour channel also contains quite different monochrome information from the others. In black and white photography, you can intensify tonal depth by using a filter of a complementary colour to the subject; for example, green for a magenta flower, blue for a yellow one. You can view each of the channels on screen and decide which gives the monochrome you want. In Photoshop, you can create a monochrome file for that channel under a new name using File > Save As. You can then print directly from this new file as you would from any other. For more control of tones, you could place each monochrome file in a separate layer and then experiment with sharpening them in turn or blending in different proportions.

Color Range Color Range offers an alternative way of creating a grayscale image (Select > Color Range). It creates startling results, from negative through to a strong posterized effect, where blocks of tone replace subtle gradations.

Grayscale and toning Creating a grayscale image produces a monochrome image and offers you other possibilities, such as toning. First, remove colour using Image > Mode > Grayscale. Then convert to RGB mode (Image > Mode > RGB), which will allow you to add colour via Hue/Saturation (use Image > Adjust > Hue/Saturation). Check the Colorize box and vary the slider positions to set the tone, the extent to which the greys are tinted, and the lightness or darkness of the final image. You can create a very good representation of all degrees of sepia or platinum toning like this.

If you want to remove all vestiges of black and white (as would happen with a chemically toned print) then desaturate after converting to RGB and use levels to lighten the image before introducing colour. Alternatively, convert to a duotone via Image > Mode > Duotone. This allows one or two inks (specified as Pantone colours) to be mixed with the grayscale images. There are presets that generate sepia, platinum, and other colours.

Creating a grayscale image

For dramatic monochrome results, select a colour file with contrasting or complementary tones (for example, the yellows of sand and the blues of the sky shown here). The resulting grayscale image will then have high contrast and rich tones.

◀ By examining each colour channel in turn, you find that different monochrome information is contained. Here, in the first image in the series, the red channel darkens the green parts, giving a more dramatic result – much as would occur with a red filter in black and white photography.

Posterization and Sabattier effect

Techniques familiar from wet chemistry can be recreated digitally. Posterize is found under Image > Adjustments, where the dialog box allows you to control the extent of the replacement of tones by blocks of colour. It is a much less hit-and-miss process done this way, and results are easily duplicated.

The Sabattier effect and solarization can be simulated through the Curves control by making the curve into a parabolic shape. No internegatives and sandwiches of positives and negatives are needed, and the degree of the effect is easily controlled on screen.

Mimicking lith and line film

The extremes of contrast typical of lith and line film can be effected via the contrast and brightness controls. Often these adjustments are better carried out on one colour channel leaving the others untouched; you have to experiment to see which works best for you.

The filters palette is well worth exploring for line effects. For example, if you create a monochrome image as above and then convert to RGB mode, the sequence Filters > Stylize > Edges produces the sort of coloured line film effect that could only have been achieved before with extensive work involving several different colour separations and sandwiches.

Creating monochrome effects

You can create a number of monochrome effects with digital imaging programs. The strongly contrasting tones on the skin of this young leopard produced a striking monochrome original from a colour file. This can be subtly tinted, as detailed on the previous page, via Image > Adjust > Hue/Saturation. Alternatively, you could posterize the image and turn detail into blocks of tones via Image > Adjust > Posterize.

Making selections

Much photo manipulation involves making accurate selections of parts of an image or of a whole subject with all its fine edge details intact. Not only subjects can be selected: you can invert the selection to select the background and change its colour, replace it with another image or blur it. Selected areas can be held back or burned in; tones can be colour corrected or changed entirely. Selections are made with a palette of tools.

The lasso The lasso tool creates a selection as you click and drag around the edges of an object. The magnetic lasso, a variant of the lasso tool, searches for edges of contrast; the polygonal lasso builds a selection from straight edges. Using a lasso can become exasperating: it assumes that you have finished when you lift a finger from the mouse button and closes the selection with a straight line back to the start. You can lift your finger from the mouse or reposition it as long as you hold down the Alt key with your other hand. If you miss bits in your selection you can add to it when completed using Shift + Drag (lasso or marquee tools) inside or outside an area; alternatively, you can remove bits from the selection using Option + Drag.

Magic wand The magic wand is ideal for removing large areas of similar tones from a background. You can adjust the tonal range acceptable in a selection. By holding down Shift, you can add areas to the selection with a single mouse click (or remove them with Option + Click). Finally, you can tidy up the edges of a selection with the eraser tool or memory brush to bring back lost parts.

Pen tool With the pen tool, you set anchor points along a path to create an accurate selection with a magnified screen image. Modifications can easily be made by zooming in on the image and adding or removing points by clicking icons in the pen menu. With a single spacebar click, the relevant

▼ *The magic wand tool is good for selecting large areas where there are strong contrasts, such as this black background. The sensitivity of the tool can be varied to encompass a wider range of tones.*

selection tool becomes the hand tool so you can move the image to continue the selection without running out of screen.

Feathering Any selection you make can be improved using additional processes. Feathering softens the edges of a selection, making it look less stark against plain backgrounds. You choose an edge width (in pixels in a dialog box) over which it acts. Feathering is a useful tool for smoothing out tiny errors.

Quick mask The screen appearance of the boundary to a completed selection is often called 'marching ants'. You can fill the area within the selection by a transparent, coloured mask using the quick mask tool. This way, you see both the selection and degree of feathering; this is not apparent with the 'marching ants' border.

Extract tool For those who struggle with lasso and pen tools, then the extract tool, which is available in Photoshop from

Masdevallia ignea.tif @ 16.7% (RGB)

Using the extract tool

Extract is used in our studio more than any other means for selection. In versions of Photoshop from 5.5 onwards, you find it under Filters (Filters > Extract).

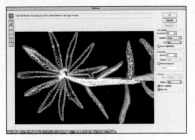

1 Select Extract and your image fills a separate screen where you can adjust such things as the highlighter pen width and feathering.

2 Trace around the item to be cut out, keeping roughly half-way over the edge and the background (the program makes the selection in this region by contrasting pixels later).

3 Preview marks your enclosed selection with a purple mask. At this stage, dramatic mistakes can be corrected with the eraser tool.

4 Before making the extraction you can work on the result by zooming in and restoring any damaged edges with the edge touch-up tool.

5 For ultra-fine work, there are a number of add-ons to Photoshop that allow the use of masks to make even more accurate selections.

version 5.5 onwards offers a somewhat easier way to make complex selections accurately.

You can find it under the filter menu (Filter > Extract). Once selected, a separate screen appears on which you can draw an outline around the selection with a 'marker pen'. Not only can you stop anywhere, but you can change the width of the pen and erase errors with ease. If you keep an even overlap between subject and background, the extract function can better determine what pixels to keep or discard. The selected area is then filled to show the parts that remain intact. A preview lets you see the result and any bits that need

correcting. Where there are hard edges, checking Smart Highlighting makes the brush follow the edge automatically. To correct mistakes, select the eraser tool from the extract icons and remove the green pen or use Option + Z (Mac) or Ctrl + Z (PC) to undo the last action as you go along.

Fine correction For even more accurate work, it's possible to make fine corrections after extraction. Zoom in on the selection and carefully work around the edges with the edge touch-up tool to restore any detail you have inadvertently removed, or with the eraser to remove anything unwanted.

Sharpening

No matter how sharp your original transparency is, scanning softens the image slightly. The extent of the softening becomes apparent when you see the same shot originated directly by a digital SLR. Digital cameras are not immune to softening, however; this is done deliberately by using an anti-aliasing filter. Image-manipulation programs allow several ways of increasing sharpness. Unsharp Mask (USM) is one of the most effective.

▶ *For web images of 600x400 pixels at 72dpi, use amount 80, radius no more than 1.5 and threshold 8 and above. If the effect is too great, results appear over-contrasty and 'gritty'.*

Unsharp Mask Unsharp Mask is, like other sharpening methods, a high pass filter – it holds back low-frequency information and allows high-frequency information to pass. It improves edge definition by operating on a grid of pixels that the user defines by setting values via the on-screen controls.

The dialog box allows three adjustments:
- **Percentage** This governs the strength of USM.

- **Threshold** This controls the number of pixels that are affected by sharpening by assessing relative brightness of neighbouring pixels. If this is above the threshold you set, then USM accentuates it.

Radius Increasing This makes edges more contrasty – a little like changing the feathering of a selection.

◀ The Unsharp Mask dialogue box presents you with different choices of setting. With larger files a heavier degree of sharpening can be sustained.

For large files (20MB and above) typical settings might be:
- Amount 160% (scan) to 200% (digital camera)
- Radius 1.2–2 pixels
- Threshold 0–4.

For 600x400 pixel images at 72dpi to be used on screen, typical setting might be:
- Amount 80–90%
- Radius 1.5–2 pixels
- Threshold 5–8.

Using USM When you intend your images to be used just on screen (on a website, for example), then sharpen them until they look right to you. For printing, however, the best results are obtained by slight over-sharpening, since the inkjet process tends to reduce sharpness. Just how much you over-sharpen is something you discover by experimenting.

In Photoshop, USM is found under the filters menu (Filters > Sharpen > Unsharp Mask). Advanced workers often perform USM on just one of the colour channels or with black, creating a separate layer for it and then blending this with the original.

USM and macro photography With macro photography using small apertures to create depth of field, there is a softening created by diffraction (see pages 62–63). As you increase bellows extension, the effective aperture becomes much smaller. The use of USM can offset slight image deterioration due to the diffraction that occurs with extreme macro photography, and restore apparent sharpness. This works

Changing variables with USM

The picture sequence of a Dragon-Headed Katydid shows the results of changing variables with USM. A preview box lets you see the result before committing to changes.

1 This shows our usual starting point for a 25MB file; files originated with a digital camera can take a much higher degree of USM. Unfortunately, it cruelly enhances the artifacts from many scanners.

3 Raising the threshold then softens the visual effect. Increasing the radius too wildly produces over-the-top results, strongly emphasizing contrasts, with black lines around everything.

2 Increasing Amount increases the sharpening, making it more gritty in appearance.

4 It is a case of what looks good to you. USM is the last stage and cannot be undone after saving to disk. If you over-do it, the pictures will look awful at publication stage.

particularly well with the clean images generated by a digital camera. In practice, it can effectively undo about a couple of stops' worth of deterioration.

Unsharp Mask in scanner or camera

Most scanners and cameras offer some sort of sharpening facility that uses an USM algorithm. If you want maximum control at any one stage, then you should use it only in Photoshop, because it changes a file in an irreversible way. In practice, you will find that using it in a scanner or camera it can offset the softening effect of the anti-aliasing filters and restores lost sharpness just enough.

Tips on using USM

■ It is best to leave USM to the last procedure in any chain after resizing,

colour correction, and so on. It causes changes that can only be undone with great difficulty. Also, dust and scratches are exaggerated by USM and need to be removed first.

■ Always consider storing your digital files on CD without USM. They may not look quite so good on screen, but the application of USM is not reversible. You can apply USM after opening and resizing.

■ If you intend to use additional software such as Genuine Fractals in order to produce scaleable enlargements, then do not sharpen first – it works better if nothing is done to the original file before it is converted to the genuine fractals format.

Displays and slideshows

The success of any presentation, be it an exhibition or an illustrated talk, can be assured by careful planning and preparation.

Presentations

- Think of your audience: always consider that you have a moral obligation to entertain and inform if people have come to see you, whether they have paid or not. Never feel that you are doing them a favour – you are not, and such arrogance shows.

- With pictures you have a huge advantage – your images are props, they prompt you and allow you to be that bit more spontaneous. If you become tongue-tied, move on to the next. It is much harder to speak without pictures.

▼ With a film slideshow, only a very expensive multi-format projector allows you to mix roll-film and 35mm results. With this in mind, I always backed up roll-film pictures with 35mm, such as this shot of the mists over Kantara Castle in northern Cyprus.

- Plan your sequences: ideas must flow logically and include plenty of establishing shots and links. When you have points to make, do so, and let people have time to take them in with an appropriate image. Humour is a great aid to getting things across effectively but it must not appear contrived. If

talking on emotive subjects, allow for relaxing periods – we all become emotionally numbed by heart-rending images of humans or animals that are depicted in distress.

- Don't labour the start; the sooner you get into the flow, the better your presentation will be. There should be, like all good stories, a beginning, a middle, and an end.

- If you slip up, lose your place or get tongue-tied, acknowledge it and make light of it. People will then laugh with you, and not at you, because you are in control.

A personal note We all know people who are natural exhibitionists and who want to be the centre of attention. For most of us, the first time we had to get up in public was excruciating – we felt totally and utterly exposed. But on the whole audiences are well disposed and you can get them on your side with warmth and laughter.

The secret is to know your stuff – there is no substitute for it. As a teacher and lecturer there were times when I skipped into classes unprepared and had to wing it, but somehow children especially seem to recognize that and started asking awkward questions. Those same children grow to be awkward adults and they might be sitting in front of you.

It is easy to become unstuck when you try to be the fount of all knowledge. Never believe that admitting ignorance is a weakness; it is actually a strength. If you don't know, say so – but try to find out, and explain that you will do so. You can always email the questioner later. Occasionally, I take along pictures of things I cannot identify – there are all sorts of areas of expertise hidden away: ask your audience and you could be surprised.

Slide sequences can be meticulously prepared beforehand. I have a list (in large print) of the points for each section and

▲ *The beauty of a digital display is that you can mix formats. This early morning picture of Orvieto in Italy started as a digital file with standard 3:2 proportions. It worked better in a landscape format, so that is how we use it.*

that acts as a talisman. Without it I would be lost, but if it is there I never refer to it. I tend not to speak from notes, since constant referral interrupts the flow.

Digital presentation With the huge variety of functions available in computer programs such as Powerpoint, the great favourite of businesses everywhere, you can make fascinating displays. However, no amount of gimmickry can disguise weak

material. No one need feel disadvantaged by not using such a complex package – simplicity and clarity with first-class images win the day every time. If you want to use a certain computer package, then go and see people who have already mastered it and learn that way.

We tend to use Extensis Portfolio for the creation of slide sequences because this is what is used to keep track of digital files in the studio. It is then a simple matter of dragging and dropping the files into the slideshow. Titles, maps, points to make can all then be inserted into the sequence. Images of the right resolution are stored on a portable hard drive.

◄ *Our senses are so assaulted by the visual cleverness and subterfuge of program makers and advertisers that we often switch off. Pictures of horrors and suffering make little impact. Here, the idyllic beach scene has plastic jetsam in the foreground – pretty but noxious on a sunny day. We can use humour, sarcasm, shame – anything in order to make people think…*

Storing and archiving

Storing and archiving is a problem when technology evolves so quickly. We can make prints, but we cannot be sure of the archival life of these, and most of us accumulate images at a rate too great to justify printing off any but the best. At least with transparencies you can store them in filing sheets and look at them occasionally with no ancillary viewing equipment apart from a window. What seems like a solution now, may not be in five years' time.

Storing negatives and transparencies

Film emulsions are delicate. Negatives and transparencies are easy to scratch just taking them in and out of filing sheets; exposure to light for any length of time causes fading; other people never handle them with the same care as you do; and the gelatine substrate is a perfect culture medium for fungus. So, how can you best protect them?

Special slide cabinets are available that have sliding racks, but these are out of reach for most people. Like many people, I use A4 (8.5 x 11¾/20 x 30cm) slide filing

▼ *If you send digital files on CDs, a feature of the automated tasks with Photoshop is the ability to generate a contact sheet (File > Automate > Contact II). You can specify the size of sheet (for later printing) and the array of images to generate a size that enables you to recognize them or to keep them as a visual record.*

sheets in archival (PVC-free) plastic. PVC molecules migrate from the plastic into your slides, and chemical reactions take place that accelerate deterioration: the small extra cost of buying PVC-free plastic is worth it.

When you have few slides, then slide boxes can be useful, although you have to take slides out to view them – with slide filing sheets you simply hold them up and the collection becomes much easier to handle as it grows.

Archival prints When making archival prints, then, like museums and galleries, you must use acid-free papers. Light will always cause fading – particularly the more energetic frequencies of UV light. Any print hung on a wall should be positioned out of direct sunlight at all times.

Filing systems When it comes to filing, I am the worst person to advise anyone: my partner will bear this out, having taken over the running of our library. Whatever system you use, implement it before your collection grows out of hand, and make it so that it is easy to expand.

In setting up a travel library or travels section, for example, you would need to consider categories and subdivisions such as Country > Region > City or Town > Topic. These can be expanded as you collect images in each category, and these categories can be subdivided. Cross-referencing is always a problem – where do you put an insect shot that shows pattern, colour, and behaviour? Best of all is a system into which you can put key words – your pictures can be stored anywhere as long as the filing sheet number is known, and you can then assemble lists of pictures according to wants.

My collection of 20,000 pictures of some 5,000 orchid species was originally filed by scientific name. The binomial classification proposes a main or genera name and then a species name; for example, with the Bee orchid *Ophrys apifera*, *Ophrys* is the genus

Contact Sheet II

Source Folder
[Choose...]
☑ Include All Subfolders

[OK]
[Cancel]

Document
Width: 42 cm ⬍
Height: 29.7 cm ⬍
Resolution: 72 pixels/cm ⬍
Mode: RGB Color ⬍
☑ Flatten All Layers

Thumbnails
Place: across first ⬍
Columns: 6 Width: 6.93 cm
Rows: 4 Height: 6.197 cm

☑ Use Filename As Caption
Font: Helvetica ▼ Font Size: 10 pt ▼

◄ *On countless occasions in the murk of a Welsh winter, I have felt my spirits soar as brightly coloured transparencies became a reminder of the fact that the sun shines somewhere. There is nothing quite like the sight of a collection of larger transparencies backlit with a colour and depth that digital cannot match. Whatever the advantages of digital in some arenas, film is far from dead for many of us.*

and *apifera* the species. This was fine until commercial markets developed and I began to be asked for yellow or magenta orchids.

The digital filing system based on Extensis Portfolio copes with this. Transparencies are still effectively in 'drawers' devoted to particular areas of interest. I happen to like the program because it is easy to use and I can generate galleries or CDs easily. Like many filing programs, it functions as a relational database – the files do not exist in tangible drawers as in a cabinet. Their data entry allows them to be assembled in collections to suit requirements; for example, you might type in key words such as 'Portugal' and 'churches' and an appropriate collection will be called up. Apple Mac users have iPhoto, a very powerful tool that allows you to assemble pictures for personal albums and exchange them over the Internet or to generate web pages.

Digital: the library dilemma When affordable slide scanners appeared with a 2400ppi resolution, many libraries got a chain of them and began an ambitious and lengthy program of scanning. And then scanners got better – so do you begin the process again? What happens when the next level overtakes? In many ways, it is easier for photographers to scan and produce moderate file sizes that can be viewed on screen or distributed with a watermark for protection on a CD and then offer to scan to demand and provide whatever file size a customer or end-user requires.

However large the hard drive you purchase, you will see it fill at an alarming rate as you steadily amass image files. As a guideline, the larger the capacity of a drive or storage medium, the lower the price per megabyte of storage.

If you are travelling with your camera, then a laptop offers more than sufficient capacity and a viewing screen on which you can edit. But, it is another thing to carry, and loss, theft or damage is all too frequent.

Storing images There are various options for storing images in camera and after.

■ Cards
The most popular digital data storage card is the CompactFlash card. Storage capacities vary from 8MB to 1GB and more. The higher capacities are expensive and the same storage can be achieved from several smaller disks.

▼ *Even having lugged three full cabinets up and down far too many stairs over the years, I still love being able to open them and examine filing sheets full of images. As a collection grows, it is tedious to file returns and so easy to 'lose' images...it just has to be done, however reluctantly.*

■ SmartMedia
Wafer-thin and compact. They are also fragile and their storage capacity is governed by (and restricted by) the circuitry in a particular camera.

■ Microdrives
These are ingenious miniature hard drives that fit into CompactFlash II slots. Capacity is high – up to 1GB – and they are a favourite with pro users.

Portable hard drives Relative newcomers are portable CD writers that sport a viewing screen and can write in sessions enabling you to record a day's shooting on CD until a disk is full – and then maybe make a copy for security's sake on a long trip.

CD A CD can hold up to 700MB of data. If you buy CDs in bulk, this is the cheapest way of sending a collection of images to friends or for publication – you can send up to 28 TIFF files of 25MB and many more JPEGs. High-quality CDs such as Fujifilm CD-R store 650MB of data and claim a 70–100-year archiving capability. They may cost more – but then your images are precious.

DVD DVD-RAM offers 9.4GB of storage when used double-sided, which is the equivalent capacity of 15 CDs. For archiving images, this is the most cost-effective technology available for memory-hungry image files. The only downside is that reading and writing speeds are slow compared with CD – but that will change. The best of all worlds is a DVD-RAM drive that will read and write both DVDs and CDs.

▼ *Although traditional relational databases such as Filemaker Pro can be used with images, the purpose-designed Extensis Portfolio is our choice. You can assemble images into CDs, DVDs or slideshows with the ease of drag and drop: key words let you build screens of images that can then be emailed as a PDF and put on the web.*

Making things yourself

With a bit of effort and practice, most of us can muster the skills to build studio items – from sturdy benches in wood and MDF, to optical benches in aluminium alloy, or small aquaria in glass and Perspex (acrylic) sheet. We live in a society where, when people want something they throw money at it and then miss out on the sense of achievement at producing and using something that they built themselves. It's a bit like being an instant gardener and always going to the local garden centre for a tray of ready-to-plant items rather than growing from seeds.

Tools

There are plenty of excellent books available that deal with use of tools and general DIY skills – some are recommended in the bibliography. Precision metalwork such as cutting threads and tapers on a lathe needs skill and training: there are still plenty of exceptionally able people around in small workshops who, with the aid of a drawing, will produce the precision part of what you want if you cannot make do or adapt from secondhand items.

Measuring

When working with wood you can, with a bit of judicious trimming, often get things to fit and many skilled woodworkers do things purely by eye. When working with metals, precision is paramount. The secret is patience: always measure out with set squares (for accurate right angles with metal, use an engineer's tri-square) and firmly secure work with clamps so that nothing moves or wobbles and you can cut or drill accurately. Use an electric drill in a rigid stand or with any jig that ensures vertical drilling. Hobby stores have saws with guides for cutting mitres that enable near-perfect right angles in wood and metal: even better if you have a saw bench to use.

Your tool list will grow as you need it, but there is much you can do with a basic selection of hand tools such as hacksaws (small and large), a bench vice, drill vice, screwdrivers (a variety of heads and jewellers), hexagonal wrenches, a set of taps and dies for thread-cutting, and various measuring implements such as an engineer's square, carpenter's tri-square, steel rules, a spirit level and a good stock of 'wet & dry' abrasive paper in grades from 200 to 1200 grit. An electric drill (with variable speed) and drill stand (or pillar drill), and a miniature modeller's hobby drill for fine work are also useful.

Sawing

When cutting sheet materials, some people can cut accurately with a panel saw: whenever I use one, I can hear my father's voice intoning 'let the ***** saw do the work', and the advice holds good, as forcing leads to tiredness, wobble and inaccuracy. For convenience, speed and accuracy, a table saw is a better bet for the rest of us – or at the least a handheld electric saw run against a straight edge that can be clamped to the work piece.

Drilling

An electric drill is a tool that few home handymen could do without: accurate drilling is another matter. If you are drilling metals where the drill needs to be as accurately at right angles to the surface as possible, then clamp the work piece and use a

▼ An accumulation of useful small tools. Clockwise from top left: an engineer's square for accurate right angles; vernier callipers for precise diameters; pin vice for small drills; micrometer screw gauge (a useful luxury); and taps with a holder – essential for cutting threads in holes and bolting equipment together.

drill stand. Better still, if you are going to make a lot of things yourself, then a pillar drill is a worthwhile investment. Your projects will go together quickly and line up accurately.

Carefully drilled holes of exactly the right size are essential when you aim to fix things using bolts – the latter you can buy, but to get them to function you will need to tap threads into holes. The drill required is a fraction less than the tap size – it is worth buying the right drill for this (taps, drills and dies are often sold in sets), because if you drill too small a hole, the tap will need to be forced, and although hard enough to cut, they are brittle and break.

Don't try to be ambitious; just advance a half a turn or less at a time, backing off to expel the metal fragments (swarf) and use a lubricant. Ordinary three-in-one oil is better than nothing.

Many pre-packed bolts are sold in metric sizes, but the standard photographic thread for base plates of cameras and B&S joints is 1/4in Whitworth and, for larger cameras, 3/8in Whitworth.

Adhesives

Modern adhesive can provide a bond of almost weld-like strength provided a few rules are observed. Make sure that all surfaces are clean and grease-free, particularly when using superglues (cyanoacrylate adhesives). I usually wash parts after working on them with a dilute detergent, swilling in hot water and drying in an oven heated to above 100°C.

Surfaces also need to be flat and 'keyed' with a fine abrasive paper before gluing. Line things up carefully (such as when making adaptors) and even make jigs to ensure this: you get no second chance with these adhesives.

If you want room to manoeuvre, then use a quick-setting two-part epoxy adhesive. If you have an adhesive that takes longer to set, you can hasten the reaction by warming metal parts, for example.

Adaptors

By looking in secondhand camera shops, car boot sales or on the Internet, you can secure all sorts of useful lenses for experimenting with high-magnification work. The problem lies in getting them to fit your camera outfit. Here is where the bellows (see pages 78–79) comes into its own. You can fit your camera as normal and then pay attention to the lens end. Failing everything, cardboard or plastic tubes painted matt black and secure with gaffer tube can be used. Far safer and more secure is a purpose-built adaptor.

Essentially, you need something that fits the bellows – a lens bayonet mount. Potential sources are reversing rings made for different camera makes; parts of old extension tubes (the bits unscrew); T2 mounts or Tamron adapt all mounts. You will need just the part that fits the bellows and possibly any length of tube that comes with it. At the other end you need to fit a lens.

For microscope lenses there are standard RMS threads – these came as inserts in the nose-pieces of some microscopes, so it is worthwhile contacting dealers to see whether they have anything in their box of tricks. With other lenses, you can use parts of extension tubes or, when reversing the lenses, all you need is a filter thread. Buy the cheapest filter you can find in the right size and with the glass in place (to keep its shape) rub it gently on a flat sheet of 400–600-grit wet-and-dry paper to flatten the edge. The glass is then removed and the ring can be glued to the other part of the mount. It might be necessary to have a short length of metal or plastic tube since things protrude from lens backs (stopped down levers) and you must avoid fouling the front of your camera at all costs. For this reason I only use bayonet mounts that have come from manufacturers of quality and are well machined.

I often use 35mm-format lenses on a roll film (645) SLR – for enlarged images the image circle will easily cover roll film. My two adaptors (one to fit Nikon, the other Olympus to Mamiya) rely on either a

Mamiya body cap with centre cut out or a reversing ring. The other end is the 'female' mount of an extension tube.

When using the coupled lens technique that involves reversing one lens on to another, you can get adaptors with two 'male' threads. For odd sizes, you can mount two Cokin filter thread mounts back to back, fixing them with superglue after lining up carefully.

Some people have neither the time nor the inclination to fiddle, so there is no better firm to contact than SRB Luton – they are artists with lathe work and make all sorts of adaptors for the film industry. They supply sets of tubes and mounts that can let you adapt a microscope for photography or just about anything else: I know of no firm like them anywhere else in the world.

Tanks
Small aquarium tanks for photography are another item that the home builder can readily fabricate (see pages 54–55) and in a range of sizes that might be difficult to secure off the peg.

Gantries and rigs
You can make your own gantries and rigs by visiting a large DIY supermarket where they sell metal rods and sections. You can either use a commercially made boss that secures tubes at right angles, or make your own from a bar of aluminium – the drill stand and thread tap again. Look at your local paper where labs are having closing sales and grab yourself a few retort stands with clamps and bosses.

Work benches
If you have even a small space that you can dedicate to table-top photography – a corner of a garage or shed, for example – then a heavy, rigid bench is worth its weight in the precious metal of your choice (and is much cheaper). Use ready planed and prepared timber such as three-by-two for the frame, which you fix by drilling and bolting with washers on each wood face to prevent wood splintering. Tighten everything with your car socket set and draw satisfaction as it becomes rock steady. The

◀ If you can achieve precision in drilling so that holes are at right angles to a surface, then you are half-way there. Small bench drills or a power drill in a rigid stand are a great investment.

secret is to stabilize with a good solid surface (heavy MDF or thick ply) and to put side pieces (and even cross braces) in.

With a little ingenuity, you can simply make a rigid top with a large wood block fixed rigidly beneath: the whole thing then fits into a 'work mate'.

For your digital darkroom, I can recommend two-drawer filing cabinets as the base support and a sheet of heavy, good-quality ply. You can ask the supplier to cut to size, and then you just run a sander around the edge to remove splinters, varnish with a coffee (and red wine-resistant) coating, and you are in business.

Suppliers
You will begin to see bits of metal, wood, old darkroom equipment and camera parts as being potentially useful, though such a hoarding instinct might not make you popular when space is at a premium. Many large camera stores have junk bins that might be a treasure trove to you. Local camera repairers often accumulate useful bits and

▶ *If you want to photograph exotic creatures but cannot get to tropical rainforests then visit places that are set up to educate such as the Living Rainforest (www.livingrainforest.org)* **Nikon D100, Sigma 105mm f/2,8AF macro, SB29B macroflash**

might be worth approaching – especially if they can make items for you. Most hardware stores have limited ranges of hardware and often in blister packs in sizes you don't need. This is where your local telephone directory or the Internet comes in useful in locating supplies. This is the only way to get aluminium alloy in sizes to assure rigidity – and many suppliers will have a 'cut off' bin.

The following is not an exhaustive list of suppliers, but they are all people who have proved helpful over the years: many will supply to a world market (or have local agents listed on their web sites). A permit is need from the Department of Agriculture for the import of any insect livestock to the US and Canada.

Metal suppliers

Check in the back pages of model engineering magazines, where there are people who deal in screws of every sort, small tools, and metals in sensible quantities. I have used Twyford Metals in the past; they have an excellent 'off cuts' bin and are very helpful – it is a pity they are a bit

◀ *When planning your holidays use the internet to see if there are local festivals – here the 'Infiorata' in Bolsena was literally outside our front door. We helped and were rewarded with lots of picture opportunities.* **Sigma SD10 15–30mm f/3.5-4.5 AF zoom f/8 at 1/125th sec**

far from central Italy, but there are metal suppliers here, too, as there are in most countries. Explain what you are trying to do and you will often get a great deal of help from people with skills you do not have or ones you would like to acquire.

Insects – resources, livestock and breeding equipment

Arthropod. NET www.arthropod.net
Costa Rica Entomological Supplies (CRES)

▲ You cannot plan a sunset – those from late autumn into winter are often the best so make sure you have some sort of camera with you all the time just in case. And remember that the colour balance and distribution changes almost by the second so keep shooting – if you have a digital camera keep only those you want.
Sigma SD10 15–30mm f/3.5–4.5 AF zoom f/8 at 1/30th sec

http://centralamerica.com/cr/butterfly/bfly-bus.htm
Entomology Texas A&M University http://insects.tamu.edu/
Kipepeo Project www.kipepeo.org
London Pupa Supplies www.oxfly.co.uk
Mantis UK www.mantisuk.com
Southern Scientific www.southernscientific.com
Worldwide Butterflies www.wwb.co.uk

◄ When visiting ancient sites don't forget the details as well as the views of soaring columns – the market is flooded with classic images, but the more unusual ones are often over-looked. At Herculaneum near Naples the walls and their decoration offer the best photographic opportunities.
Mamiya 7 II 80mm f/4–f/5.6 at 1/15th Fujichrome Velvia

◄ *Seizing the moment and being in the right place at the right time is integral to photography but being creative to order it is not so easy. I make mental notes of areas that would make good images so I am prepared when the right conditions come along. Bolsena with its ever-changing light is a venue high on the list for me and ten minutes from home.*

Collecting equipment
Watkins & Doncaster
www.watdon.com

Microscope equipment (including adaptors for digital)
Brunel Microscopes
www.brunelmicroscopes.co.uk
Zarf Enterprises www.zarfenterprises.com

Information on Photomacrography and Photomicrography
Micscape magazine
www.microscopy-uk.org.uk

Camera bits and pieces
Speedgraphic www.speedgraphic.co.uk
SRB Film Services (Adapters)
www.srbfilm.co.uk

Optical equipment
Edmund Optics www.edmundoptics.com

High-speed flash triggers
Shutter-beam, infrared and sound
www.woodselec.com

Mumford Micro Systems: the Mumford Time Machine trigger and time lapse
www.bmumford.com

Clothes and hides
www.wildlifewatchingsupplies.co.uk

FURTHER READING

Books

Ang, Tom *Digital Photographer's Handbook* Dorling Kindersley ISBN: 0-7513-3679-3
A comprehensive and well-written 'bible' of digital techniques and procedures by a photographer who really knows what he is talking about.

Ang, Tom *Silver Pixels Argentum*
ISBN: 1-902538-04-8
An intriguing and well-written book that shows how digital techniques can mimic the best of darkroom work and print-making.

Aronoff, Janee and others *Photoshop 7 Trade Secrets* publ friends of ED.
ISBN: 1-903450-91-8
The are far too many inadequate books on Photoshop techniques. For those with some knowledge, this is a wonderful collection of hints and short cuts about using the program and not just playing with it.

▲ *If you have money to throw at things then buy new equipment by all means. If not then junk shops, car boot sales, local newspapers and the internet can all yield treasures, This is an old microscope stand, modified with a Nikon bellows to become a macrosope that I have used to take hundreds of published pictures.*

Davies, Paul Harcourt *The Complete Guide to Close-up & Macro Photography* David & Charles. ISBN: 0-7153-1276-6
A book with a heavy slant towards the aesthetic, but with a thorough grounding in both technique and theory necessary to achieve results, however ambitious.

Davies, Paul Harcourt *Small Things Big* David & Charles, UK ISBN 0-7153-1688-5 (also as *Nature Photography Close-up* Amphoto, USA ISBN: 0-8174-5019-X)
A new approach to close-up and macro work to take account of the potential of digital photography and encourage users to make their own forays into the close-up world.

Davies, Paul Harcourt *Compete Guide to Outdoor Photography* David & Charles.
ISBN: 0-7153-1304-5
Everything a busy travel and outdoor photographer could think of putting in a

▶ *Flowers often have tiny hairs on stems that are revealed by back lighting – so always consider this option as well as frontal lighting – often a subtle mixture of both works well, even if the front lighting is from fill-in flash.*
Nikon D100, 105mm Sigma f/2.8–f/16 SB29s macroflash with sunlight behind

book – intended to be a source of information and ideas for photographers at all levels.

Davies, Paul Harcourt *Photographing Plants and Flowers* Collins & Brown. ISBN: 1-85585-930-0 (hbk) and 1-84340-241-6 (pbk) Thorough coverage of everything to do with flowers and plants from macro to landscape, and gardens.

Freeman, Michael *The New 35mm Handbook* Quarto. ISBN: 1-56138-662-6 Latest and much-modified edition of a tried and tested work covering everything in 35mm.

Hedgecoe, John *Complete Guide to Black and White Photography* Collins & Brown. ISBN: 85585-217-9 A good guide to studio and darkroom techniques.

Langford, Michael *The Darkroom Handbook* Ebury Press. ISBN: 0-85223 Well compiled work on darkroom techniques, profusely illustrated with explanatory diagrams.

Shaw, John *John Shaw's Business of Nature Photography* Amphoto, USA ISBN: 0-8174-4050-X One of the best wildlife photographers around. All his books are well worth buying, but this one gives the intending 'pro' photographer an insight into how it can all run – great not just for nature photographers.

Acknowledgments

Books seem to take on a life of their own from their conception through gestation to 'birth' and beyond. For all sorts of reasons, this volume has had its share of ups and downs. I have greatly appreciated the direct involvement of Sara Domville, Publishing Director, and the skilled professionalism of both Freya Dangerfield and Ali Myer, who have worked on my previous books for David & Charles; also the sensitive and sympathetic edit by Nicola Hodgson: my deepest thanks and appreciation go to them.

For extra pictures, I am extremely grateful to Steve Benbo of Photolibrary Wales (www.photolibrarywales.co.uk), a seasoned 'pro' and very good friend, and to Sian Trenberth, a super portrait photographer who set up and provided shots for the section on portraiture when I had left the UK. Again, my thanks to David Johnson of Speedgraphic (www.speedgraphic.co.uk), a company in a million, for service and stock who supplied a number of equipment shots when my hardware looked too well-used for a book illustration; to Kevin Keatley (Wildlife Watching Supplies -www.wildlife watchingsupplies.co.uk) for pictures of his excellent hides; and to Fran Yeoman for pictures of my son's band.

Finally, my deep gratitude and love to Lois Ferguson, my partner in the move to Italy, and in so much more. It is a luxury to have a soulmate who can lift the spirit when I am feeling disillusioned and who gently cajoles when there are deadlines to meet and then makes me look at my work through fresh eyes when things get jaded. Oh lucky man...

▲ *Studio props need not cost anything – here a piece of creeper from a tree was found on a walk. Similarly beach exploration in winter produces pieces of driftwood, all useful for using as 'stands' for items such as jewellery, ornaments...*
Nikon D100, 105mm Sigma f/2.8–f/8 built in flash

◄ *Bright colours appeal to most people and the pictures stand out on a light box where more 'arty' shots might not. When you try to sell pictures you have to think what people want even though that might not be quite the same as what you like...*
Nikon D100, 105mm Sigma f/2.8–f/16 SB29s macroflash with sunlight

Index

Author's Biography
Paul has written sixteen books; four of them for
David & Charles. Although he originally trained as
a physicist at Balliol, Oxford, his lifelong passion
for the natural world quickly won through and
has guided life since. Paul writes for various UK
photography magazines and, for Hidden Worlds,
leads wildlife and walking tours and short
courses (www.hiddenworlds.co.uk) with partner
Lois Ferguson. They now live in Umbria, where
life is complex mix of photography, writing, tour
leading, carpentry… and all manner of things
that go with restoring an old farmhouse.

Acknowledgements
Pictures by Paul Harcourt Davies with the
exception of:

Fran Yeoman: 45 (top and bottom)
Lois Ferguson: 35 (bottom), 64 (top), 122, 123, 130
Sian Trenberth: 29 (top), 36 (top right), 37 (top
 right), 40 (top, bottom), 41 (top), 44 (top)
Speedgraphic: 13 (middle), p30–31 (all), p71
 (bottom right), 75 (bottom right), p115 (top)
Steve Benbow: 26, 2,7 29 (bottom) 32, 33